LANDSCAPE
Drawing and Painting

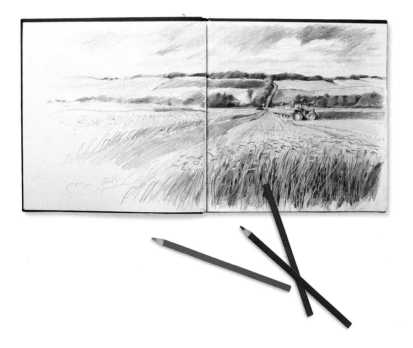

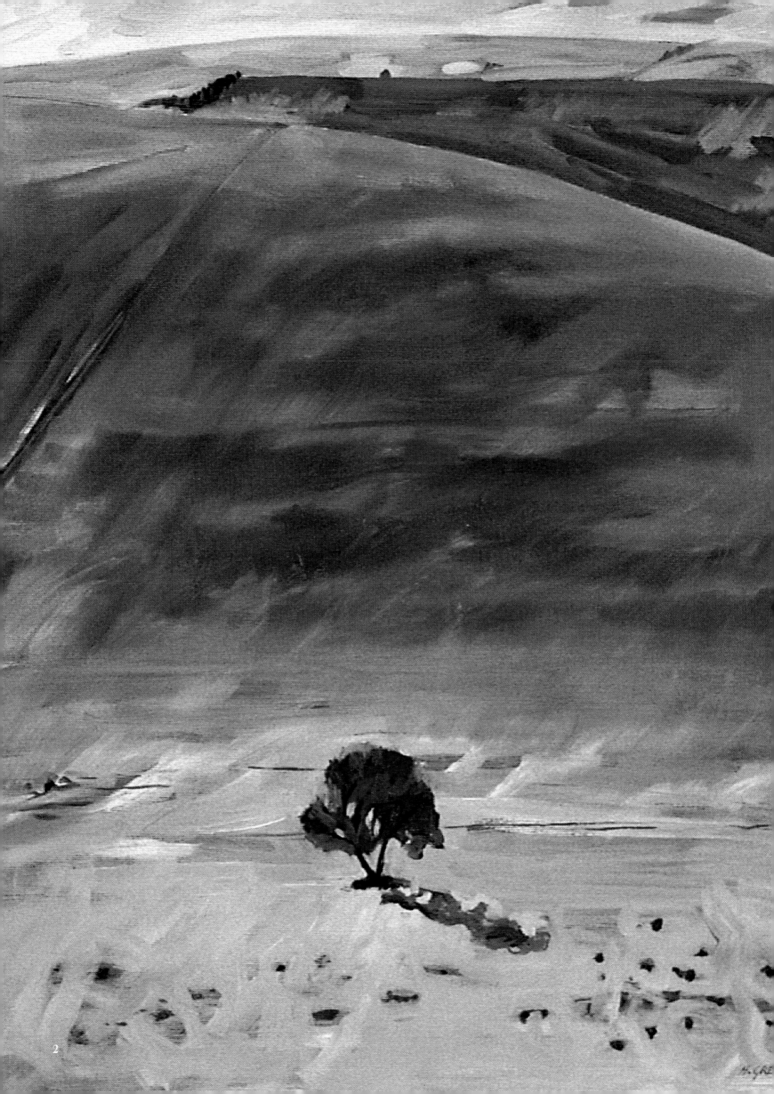

LANDSCAPE
Drawing and Painting

PATRICIA MONAHAN

 Reader's Digest

PUBLISHED BY THE READER'S DIGEST ASSOCIATION LIMITED
LONDON • NEW YORK • SYDNEY • CAPE TOWN • MONTREAL

A READER'S DIGEST BOOK

Published by
The Reader's Digest Association Limited
11 Westferry Circus
London E14 4HE

ISBN 0-276-42359-3

British Library Cataloguing-in-Publication Data:
A catalogue record for this title is available from the British Library.

Conceived, edited and designed by
Collins & Brown Limited
London House
Great Eastern Wharf
Parkgate Road
London SW11 4NQ

Editorial Director: Sarah Hoggett
Editor: Katie Bent
Art Director: Roger Bristow
Designer: Helen Collins
Photographer: George Taylor
Illustrator: Ian Sidaway

Reproduction by Grafiscan, Italy
Printed in Italy by Officine Grafiche De Agostini
Bound by Legatoria del Verbano S.p.A.

Contents

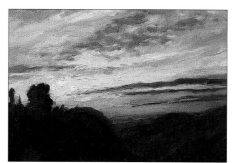

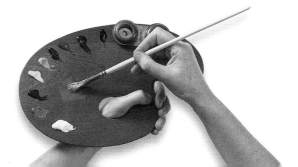

Introduction

P AINTING AND DRAWING *the landscape entails many pleasures and challenges. Begin by simply enjoying the beauty of the countryside, and you will be inspired to explore new themes, approaches and techniques.*

To the artist, the landscape is endlessly absorbing. It can be interpreted in many different ways, and presents a wide range of subject matter from which to choose. The variety of natural forms, topography and vegetation provides constant opportunities and challenges. The same scene can be transformed by weather, light, season and time of day. It can be realistic or you can assemble and rearrange elements to produce an invented landscape. By playing with form and colour, you can create decorative or abstract images.

You can use any medium to paint the landscape – in this book there are projects in coloured pencil, pastel, watercolour, oil, acrylic, charcoal and collage. Different materials offer a range of expressive techniques; some are particularly suited to describing light and weather effects.

There are many ways of working. You can work on location by making rapid sketches in your favourite medium, or paint a landscape in a single session. You can begin working on location and finish in the studio, or return to the same location to work directly from the subject. If you choose to work in the studio you can develop sketches or refer to photographs made on location, or use a combination of imagination and your memory. You can work in any style and on any scale.

Although the picturesque qualities of the countryside are

Garden still life
By looking closely and cropping imaginatively, you can find stimulating subjects on your doorstep.

obvious, remember that you don't have to travel far from home to find stimulating material; sometimes the most unlikely places – the green oases along railway tracks, city parks, the view from a window and even your own back garden – will provide inspiration.

Sketching and painting the landscape encourages you to look intently, and begin to see the world through artist's eyes. The more you look, the more you will find to fascinate and intrigue you.

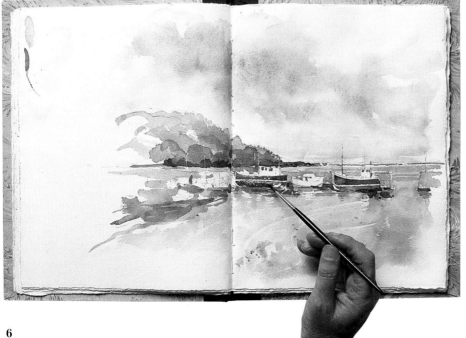

Using watercolour
Watercolour is a quick, expressive and portable medium. With just a small box of colours, you can work on location to capture the effects of rapidly changing skies and the play of light on water.

About this book

This book explains how to choose materials, how to use colour and how to achieve successful compositions, step by step.

Throughout the book, drawings and paintings by professional artists are used to illustrate a wide range of subjects, techniques and media.

The first chapter, 'Materials for Landscape Artists', introduces the variety of materials that are available, and discusses their particular characteristics and uses for painting out of doors and in the studio. In chapter 2, colour theory is explained and demonstrated by using the colour wheel together with a selection of colour mixes that you can try. To help you to understand how colours work, examples of suggested colour mixes are given in the practice exercises and projects throughout the book.

Chapter 3, 'Composing Landscapes', explains how to organise your picture area to make a successful composition.

Using mixed media

Using mixed media adds an individual and often three-dimensional effect. Here, painted papers are combined with acrylic paints to create a dramatic collage.

Using the practice exercises

The practice exercises (see chapter 4) show you how to build up the different elements of the landscape, step by step. These skills will help you when you work directly from nature, and will encourage you to draw and paint confidently.

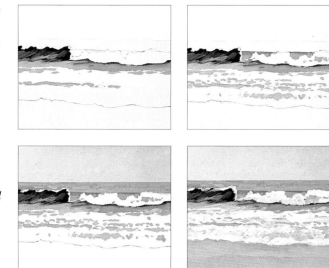

In chapter 4, 'Elements of the Landscape', the characteristics of the different components of the landscape – trees, skies, water, light and weather – are discussed and analysed. The practice exercises will help you to master each element, so that you can combine them with confidence in finished paintings and drawings.

The projects in the final chapters show the theories and techniques at work. You can use the projects in three ways: follow the project precisely, reinterpret it in another medium or find a different subject and draw or paint it using the techniques described in the projects. For example, the alla prima technique used for the sunset painting on p. 114 is ideal for making studies in changeable weather conditions.

Whatever technique, medium or project you choose, this book is sure to inspire you to create paintings that are pleasing, lively and uniquely your own.

7

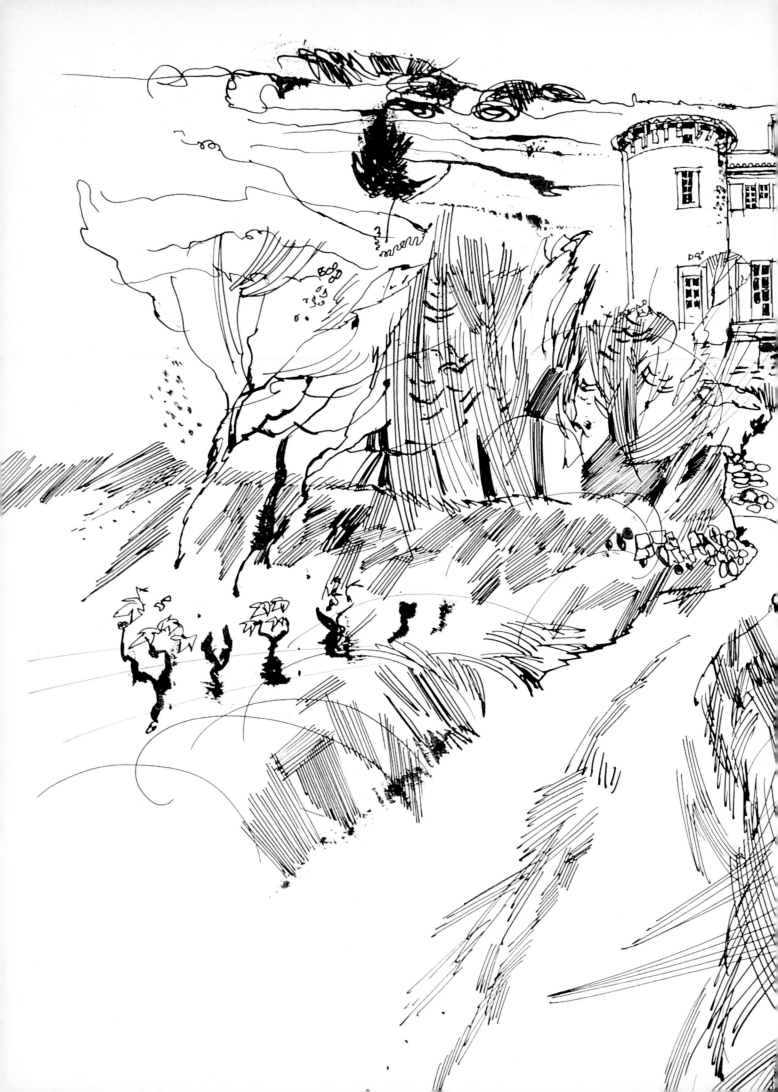

MATERIALS FOR
LANDSCAPE ARTISTS

T HIS CHAPTER REVIEWS the most commonly used drawing and painting materials, and considers their advantages in and out of the studio. It also provides an introduction to the principal techniques appropriate to each medium.

When you choose your materials for landscape painting, remember that you will be working on location as well as in the studio. Decide whether to use the same medium for both situations, or choose a different, more portable medium for outdoor work. A basic sketching or outdoor painting kit should be simple, light and easy to carry.

Start with a limited selection of good-quality materials, adding new items as the need arises. It is worth experimenting with a new medium from time to time – it will keep your work fresh by giving you new challenges.

Drawing materials

A WIDE VARIETY OF *materials is available for drawing landscapes. Each can be used for sketching, developing ideas in the studio, trying out compositions, laying in underdrawings, mixed-media projects and finished works.*

Drawing materials are convenient and versatile: you can change the medium to suit a particular mood or to vary your style. Start with pencil, as it is cheap and easily correctible; it is precise and good for working on a small scale or for sketching. Charcoal gives immediate, bold marks and is suitable for working on a larger scale to convey atmosphere. Pastel can be used to add smudged colour, create delicate studies or produce powerful images with blocks of vibrant 'expressionist' colour. Pen-and-ink works are naturally linear but can be softened by washes.

Hatching
The use of parallel lines to create areas of tone. Vary the density of lines to control the depth of tone.

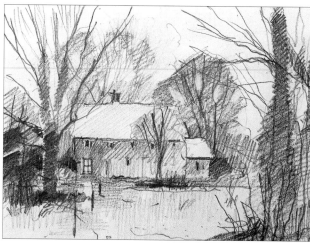

The qualities of pencil
Pencil can be used in a variety of ways. In this sketch, John Lidzey used a 4B pencil to draw the house and bare branches. Holding the pencil at an oblique angle, blocks of tone were laid with loose, even hatching (see detail).

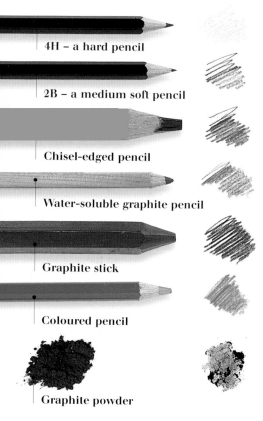

4H – a hard pencil

2B – a medium soft pencil

Chisel-edged pencil

Water-soluble graphite pencil

Graphite stick

Coloured pencil

Graphite powder

Pencil

Pencil is a highly responsive and appealing medium. It can be applied in a variety of ways, such as hatching, stippling or blending (see p. 140), to create areas of line, tone or texture. The type of mark is determined by the hardness of the pencil, the sharpness and shape of the tip, the paper texture and the degree of pressure applied.

Pencils are graded in 20 grades from hard (H) to soft (B). Start with a small selection: HB, 2B and 4B will give a good range of marks and tones. A water-soluble graphite pencil enables you to blend tones and soften lines. The tip of a chisel-edged pencil is good for broad lines and bold hatching. Use graphite powder for large areas of tone.

Shaping pencil points

The shape and sharpness of the pencil tip dictate the type of marks you can make. For soft marks, blunt the shape of the tip by rubbing it on scrap paper or fine sandpaper.

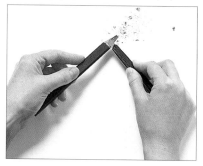

Sharpening with a craft knife gives you better control over the shape of the pencil tip than a pencil sharpener. Work the blade away from your body. Square tips make bold lines; sharp points make crisp, thin lines.

Charcoal

Charcoal is made from burnt vine, willow or beech twigs. It is available as natural sticks, compressed sticks and in pencil form. Natural forms are soft and give a lovely flowing line. Compressed and pencil charcoal are harder and produce a more controlled line useful for detailed work or hatching (see p. 10). Vine charcoal has a brown cast, while willow and beech charcoal are blue black.

Charcoal can be used as an underdrawing for oils and acrylics, or in its own right. It skims over the surface, encouraging you to work quickly and freely. You can use a variety of techniques to create tone (see below). It is especially effective when used on medium-tone paper with white chalk highlights.

Charcoal is very powdery and requires a surface with tooth. Use aerosol fixative to prevent the powder from smudging.

Thick willow charcoal

Thin willow charcoal

Vine charcoal

Compressed charcoal

Charcoal pencil

Stump

Tortillon

Putty rubber

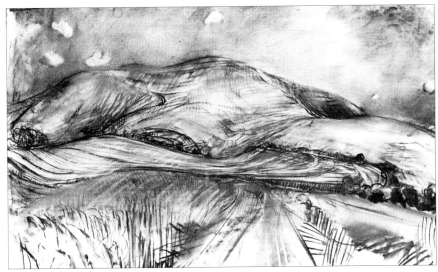

The qualities of charcoal
Charcoal can be used to create landscapes that are powerful and expressive. Here, Tessanna Hoare exploited charcoal's tonal and linear qualities. The sky was laid in with smudged and blended tones, from which the soft clouds were lifted with a putty rubber. Elsewhere, gestural marks made with the side and tip of the charcoal stick contrast with more controlled marks.

Charcoal materials
Start with a box of willow charcoal in assorted thicknesses. A soft putty rubber is useful for lifting out highlights and correcting mistakes. Stumps of compressed paper or smaller tortillons of tightly rolled paper are useful for blending tones and softening lines without dirtying your hands.

Charcoal techniques

Charcoal is an ideal medium for conveying tone, as it is easy to blend. Marks can be varied by simply changing the pressure as you go. Charcoal can be easily rubbed out or removed. Blending produces a smooth, matt effect.

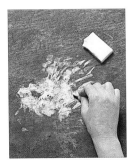

Lifting out
Use a putty rubber to correct errors, lift out highlights or draw back into the dark tones by pulling off charcoal.

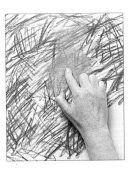

Blending
Draw a series of lines. Using your finger, or a paper stump, gently rub the lines together. Create lighter or darker tones by varying the pressure.

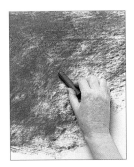

Laying in solid tone
Gently rub the side of a thick stick of charcoal across the paper surface. This is especially effective on textured paper.

Pastels

Pastels provide the landscape artist with clear intense colour, which has an appealing powdery bloom. They consist of pigment mixed with varying amounts of chalk and binder. Pastels are produced in a wide range of tints and shades.

Soft pastels are powdery and inclined to crumble. They cover the paper quickly and can be smudged and blended in a similar way to charcoal (see p. 11). Large round pastels are good for laying broad areas of colour.

Hard pastels and pencils, generically known as Conté after their original French manufacturer, are ideal for detailed or line work, and for sketching. All varieties of hard pastel can be sharpened to points or edges to produce fine lines. All these forms of chalk and pastel are used in the same way and can be combined together.

Storing pastels

Pastel dust can contaminate other colours. To keep your pastels clean, store them according to their colour in a box lined with corrugated card or dry rice.

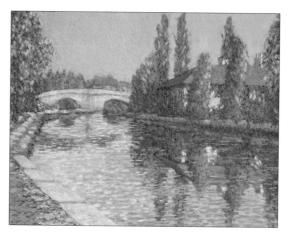

Broken colour
Small strokes of pure colour are laid side by side so that they mix 'optically' in the eye of the viewer.

The qualities of pastels
Here, Derek Daniells used a variety of 'painting' techniques. He scumbled a pink tone to warm the cool grey surface and then applied a thin glaze of blue. Elsewhere he used strokes of broken colour (see detail).

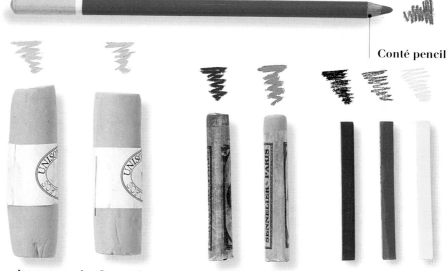

Conté pencil

Large round soft pastels **Soft pastels** **Conté crayons**

Watercolour pencils and water-soluble crayons

Watercolour pencils combine the precision of a pencil with the soft edges and washes of watercolour. On a damp surface or with a moist tip they create blurred effects and subtle gradations of colour and tone.

Water-soluble crayons can be used in the same way as watercolour pencils, but are less precise.

Watercolour pencil

Water-soluble crayon

Blending water-soluble marks

By working over the mark with a wet brush you can blend colours and create washes. Alternatively, you can use the pencil or crayon to draw directly on a damp surface for soft marks and lines.

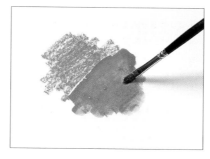

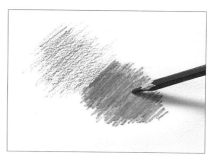

Blending with a wet brush
Work over the mark on the paper with a damp or wet brush to build up bold colour.

Working on a damp surface
Create a different effect by applying pencil to a damp surface. The lines will be softer than those drawn dry.

Pen and ink

Many drawing tools use ink in some form, ranging from traditional drawing instruments, such as quill and reed, to modern inventions, such as ball point and fibre-tipped pens. Each has its own unique characteristics. All of these drawing tools are inexpensive, simple and versatile. Choose between those that have an ink reservoir and those that require a separate ink supply. The former are simpler to use on location, but the flowing lines of the various 'dipping' pens are very appealing.

Pen-and-ink drawings can be controlled and precise, and are ideally suited to urban landscapes with architectural details. Build up tone by careful stippling and hatching (see p. 10). Pen and ink can also be spontaneous, with flowing lines and tones laid in washes of dilute ink, either mono-chromatically or in brilliant colour.

Ink

Indian ink is waterproof when dry and has a gloss finish. The line will not bleed when a wash is laid over it. Water-soluble inks can be used for line work and for laying diluted washes. Inks are available in a wide range of colours, from muted earth tones to vibrant shades.

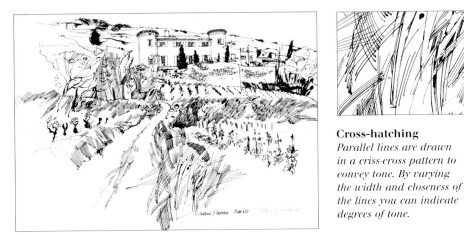

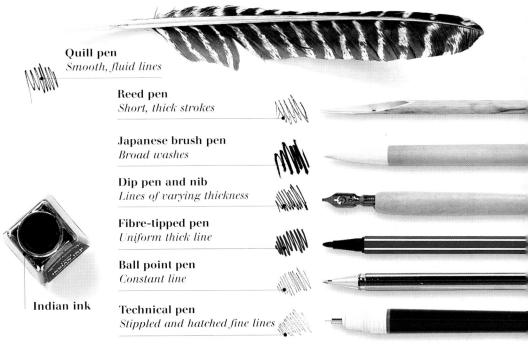

Cross-hatching
Parallel lines are drawn in a criss-cross pattern to convey tone. By varying the width and closeness of the lines you can indicate degrees of tone.

The qualities of pen and ink
By changing the nib size of a dip pen and by turning the nib you can create a range of marks and lines. Here, Albany Wiseman used hatching and cross-hatching to describe the grasses and vegetation (see detail). For the building he used a fine, precise line.

Quill pen
Smooth, fluid lines

Reed pen
Short, thick strokes

Japanese brush pen
Broad washes

Dip pen and nib
Lines of varying thickness

Fibre-tipped pen
Uniform thick line

Ball point pen
Constant line

Technical pen
Stippled and hatched fine lines

Indian ink

Paper for drawing

Different media suit different drawing surfaces. Sugar paper and cartridge papers are good all-purpose drawing papers. Hard pencil and pen and ink work best on a smooth, non-absorbent surface, such as a coated paper. Powdery media need a paper with a textured surface or 'tooth', that will hold the pigment or powder. Use a textured watercolour paper or an Ingres pastel paper for pastel or charcoal.

Sugar paper	Cartridge paper	Coated paper	Watercolour paper (NOT)	Ingres pastel paper

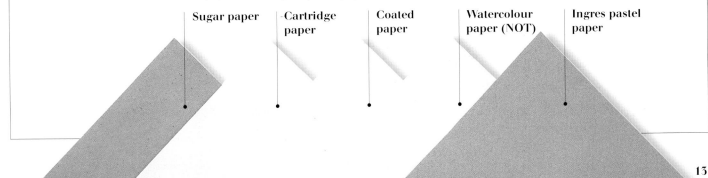

Watercolour paints

FOR ARTISTS WHO *want to paint the landscape directly from nature, watercolour and gouache are probably the most convenient of all the painting media. The materials are light and compact, which makes them easy to take on location.*

Watercolour is a versatile medium that can be used to create a range of effects (see right). Because the paint is transparent, each layer of wash makes the surface darker in tone so that you work from light to dark. When using pure watercolour remember that the white paper is the only white and the brightest highlight. Watercolour paintings must be planned carefully to ensure that areas of local white and highlights are preserved.

Paints

Watercolour is available in pans or half pans of semi-moist paint or in tubes, in two qualities: a students' range and artists' colour that offers more choice of colours. Pans are useful on location; you can see all colours at a glance and can mix colours instantly. Tubes are useful if you work on a large scale: it is easier to mix a bigger wash. Liquid watercolour is exceptionally transparent and brilliant.

The qualities of watercolour

The luminosity of pure watercolour can be used to suggest the effects of light. Here, artist Trevor Chamberlain applied washes wet into wet to capture the blurred effects of billowing dust, and used wet on dry to define the figures (see details).

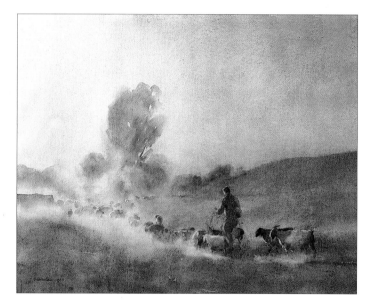

Wet into wet
Applying paint to a damp surface results in soft edges and delicate blendings of colour.

Wet on dry
Applying paint to a dry surface results in crisp edges for precise details.

Brushes

Brushes are made either from natural fibres, such as sable, or from synthetic and mixed fibres. They can be round or flat and range in size from 000 to 24, with 5-cm (2-in) flat brushes for laying large washes. You only need three or four round brushes to begin: a no. 5 for fine detail, a no. 6 and no. 10 for washes, and a no. 16 for large washes.

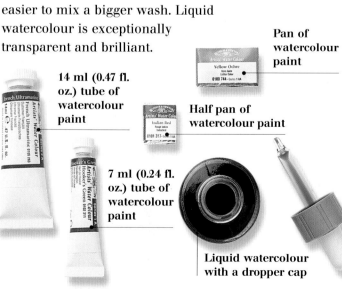

14 ml (0.47 fl. oz.) tube of watercolour paint

7 ml (0.24 fl. oz.) tube of watercolour paint

Pan of watercolour paint

Half pan of watercolour paint

Liquid watercolour with a dropper cap

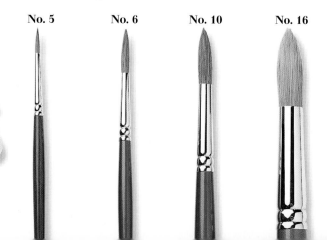

No. 5 No. 6 No. 10 No. 16

Palettes

Watercolour and gouache (see p. 17) are applied as washes, not directly from the tube or pan. Washes are mixed on a palette or in the lid of your paintbox. Palettes vary in shape, size and design and can be made from ceramic, metal or plastic. They are usually white so that you can assess the wash colour. Some, such as the studio palette below, have large recesses to allow you to mix generous quantities of wash.

Folding palettes are ideal for working on location. Tube colours can be squeezed on to the palette before you go out of doors. Any unused paint dries on the palette and can be wetted at the next painting session.

Studio palette
This ceramic tile has slanted wells for mixing colors and round wells for dabbing pure tube color or small washes.

Field palette
This metal palette provides a large surface for mixing.

Field box

A field box is light and portable. It contains 12 to 18 half pans of paint. Washes can be mixed in the open lid. Many field boxes have an additional mixing surface, storage for a retractable brush, a sponge and an integral water container.

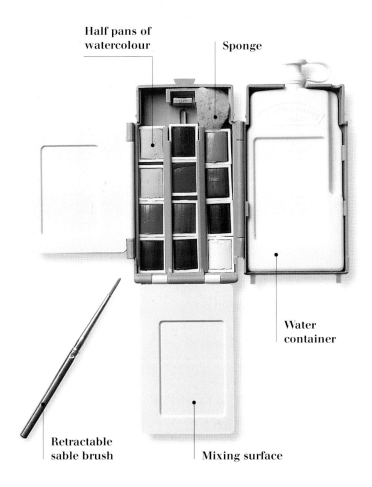

Half pans of watercolour

Sponge

Water container

Retractable sable brush

Mixing surface

Laying a wash

A 'wash' is a solution of paint and water. The term also describes a film of watercolour paint on a surface. For a flat wash a single colour is applied so that it dries with little variation in tone. This technique teaches you how to control the paint and will give you confidence to experiment with more varied washes. You will need to stretch all HP papers and paper up to 300 gsm (140 lb) in weight before laying a wash (see p. 16).

1 Squeeze a blob of tube paint into the palette; mix with water. Test the intensity of the wash on a piece of scrap paper, adding more water or paint as necessary.

2 Make sure you have plenty of wash. Load the brush with paint, tilt the board so that it is at a slight angle, and lay the first stroke across the top of the paper.

3 Work quickly backwards and forwards as shown, picking up fluid paint that gathers at the base of the previous stroke. Keep the brush loaded.

4 Lay the board flat and allow the wash to dry naturally. Don't worry if it looks uneven when wet, as the tone evens out and becomes lighter as it dries.

Papers

Watercolour paper is treated during the manufacturing process to make it less absorbent (sizing). This allows the paint to stay on the paper surface long enough to be worked by the artist.

There are three types of paper surface: hot-pressed (HP), which is smooth; cold-pressed (CP) or NOT, which is moderately textured; and rough, a cold-pressed paper with a pitted surface. Different paper textures affect the final appearance of the painting (see below).

Watercolour papers are available in different weights from light (190 gsm/90 lb) through to heavy (640 gsm/300 lb).

Paper texture

Different paper surfaces result in varied paint effects.

Hot-pressed
Has a smooth surface that results in a continuous flat line.

Cold-pressed (NOT)
The slight texture causes the line to break across the surface.

Rough
Paint gathers only in the recesses of the heavily textured surface.

Stretching paper

Many watercolour techniques involve a lot of water. Paper stretches when it is wet and shrinks as it dries. Unfortunately it doesn't dry flat, but buckles and wrinkles. To avoid this, all HP papers, and papers up to 300 gsm (140 lb) in weight, should be stretched before use. You will need a roll of gummed paper tape, scissors, a board, a sheet of paper, a tray of water and a sponge.

1 *Cut the paper to size and lay it on a wooden board that will not warp. Leave a margin for the tape strip.*

2 *Cut four lengths of tape, one for each side of the paper. The strips should be a little longer than the paper.*

3 *Lay the paper in a tray of clean water. Make sure that it is evenly wet but not soaked. Lift it out and drain off excess water.*

4 *Dip a clean sponge in some water and moisten the adhesive side of the tape strip.*

5 *Tape the paper to the board, starting with the long side. Make sure the tape strip is attached to both paper and board.*

6 *Lay the board flat and allow to dry, ideally overnight. Any wrinkles will flatten out as the paper dries.*

Sheets, pads and blocks

Watercolour paper is available as loose sheets, pads or blocks, and laminated boards. The most common sheet size is 760 × 560 mm (30 × 22 in), which can be cut down if necessary. Watercolour paper is usually white, though tinted papers can be used in place of a pale flat wash.

Lightly tinted watercolour paper

Small pad

Watercolour block

Gouache

Gouache, also called 'body colour' or 'poster colour', is an opaque form of watercolour. It is available in tubes and jars. Gouache and watercolour share many of the same techniques. Gouache can be laid as flat, gradated or variegated washes, similar to watercolour. It can also be applied as semi-transparent scumbles (see p. 141) or straight from the tube with a brush or a knife for impasto effects (see p. 18). Its particular appeal is its intensity of colour.

Gouache is often used in mixed-media techniques. It is opaque, allowing you to overpaint a dark colour with a light one – completely obliterating it if necessary – so that you work from dark to light. This also means that the technique works well on dark paper. In this way you can add any highlights at the end of a project, or overpaint and correct any mistakes.

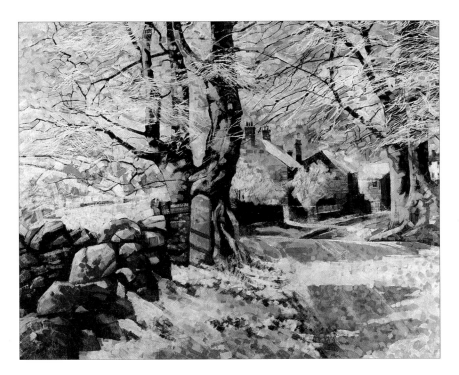

The qualities of gouache
Pure gouache creates colours that are strong and defined with a chalky bloom. Here, artist Bill Taylor used a stippling technique to convey contrasts of light and dark. He exploited the opaque quality of gouache to apply light colour over a dark background, on the tree trunk and the snow in the foreground, for example (see detail).

Dark to light
Applying light paint over a dark background to build highlights.

Gouache paints
Gouache is available in jars of 'poster paint' and in tubes. The colours are strongly pigmented, giving the paint an intensity that is characteristic of gouache.

Jar of poster paint

14 ml (0.47 fl. oz.) tube of gouache paint

Painting on dark paper
Due to its covering power, gouache can be used on dark tinted paper. Choose a medium tone that relates to your subject or a colour that provides a complementary contrast or a temperature contrast. If you plan to lay a wash, stretch the paper first (see p. 16).

Mid-blue **Dark blue** **Forest green**

Oil paints

OIL PAINT IS *favoured by artists for its richness, intensity and versatility. You can use it on location for small, quick sketches, or in the studio for more considered, planned works developed over days, months or years.*

The range of techniques and approaches available to the oil painter is almost unlimited. When used in a traditional way, building up careful layers of glazes or scumbles (see p. 141), oil paint produces a smooth, jewel-like surface in which the mark of the brush is virtually absent. This is a long process, suited to the studio.

Oil paint can also be applied thickly (impasto) for expressive marks, retaining the mark of the brush, knife, or even your fingers. This approach can be used in the studio or for landscapes painted 'alla prima' on location.

Always work 'fat over lean'. 'Fat' describes paint straight from the tube, or with an oil medium added, that is flexible when dry. Lean, or 'thin', paint has little or no oil and tends to crack if applied over a 'fat' layer. To thin oil paint add a diluent or thinner (see opposite).

As oil paint dries slowly it is very forgiving, allowing you to correct and work into the paint surface.

Paints

Oil paint is sold in tubes from 21 ml (0.73 fl. oz.) to 120 ml (4 fl. oz.) in artists' and students' colours. Tins of paint are available for large-scale work. Paint sticks are useful for introducing line and texture. Alkyd paints are fast-drying oils that can be used alone or mixed with ordinary oil paints.

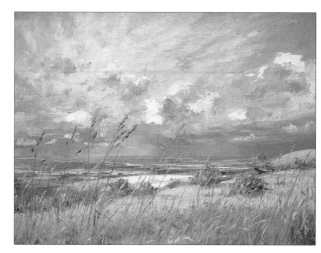

Impasto
The paint is applied thickly to create a textured surface.

The qualities of oil paint
Oil paint allows you to use a range of techniques to achieve different effects. Here, Brian Bennett started by working broadly, scumbling colour over the entire painting. Later he applied wet paint into wet, smearing it to create subtly blended effects in the sky. The paint is applied more thickly in the foreground where the impastoed marks capture the texture of the grasses and shrubs (see detail).

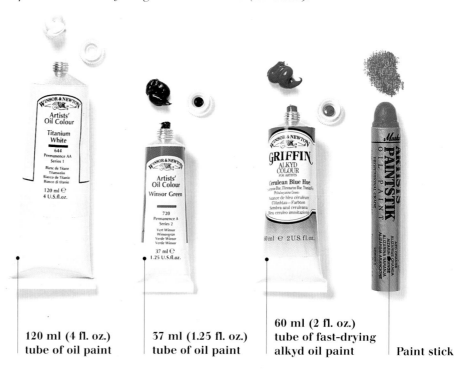

120 ml (4 fl. oz.)
tube of oil paint

37 ml (1.25 fl. oz.)
tube of oil paint

60 ml (2 fl. oz.)
tube of fast-drying
alkyd oil paint

Paint stick

Diluents (thinners)

A diluent is a solvent added to oil paint to thin it so that it can be mixed and is easy to apply.

Turpentine is the traditional thinner for oil paint. Use rectified or double-distilled turpentine and store it in sealed metal cans or dark glass bottles, as it thickens and discolours when exposed to light. Other thinners include white spirit, which has a weaker odour than turpentine and dries more quickly. It is ideal for cleaning brushes and palettes. Low-odour thinners are modern alternatives to turpentine. They do not deteriorate and are less flammable.

Use more thinner in the first stages of your work and add more oil (see below) in the later stages.

NOTE
When using solvents, especially turpentine, always work in a well-ventilated room and follow the manufacturer's instructions.

Thinning and mixing paint

To thin paint for techniques such as scumbling, dip your brush in the diluent, then in the paint, and blend in the palette centre. Add more paint or thinner to adjust the consistency.

Mediums and additives

These products can be added to oil paint. They affect the paint's consistency and texture, how it holds the mark of the brush and the speed at which it dries. The simplest medium is a mixture of linseed oil and turpentine.

Medium/Additive	Description	Use
Bleached linseed	Linseed oil is the most popular drying oil used with oil paint. This pale version dries slightly faster than refined linseed oil.	Particularly useful with pale colours, such as white, which might be muddied by using darker oils.
Cold-pressed linseed	The best-quality linseed oil. It is extracted from the first pressing of the flax seeds without the use of heat.	Used to produce a paint film that is flexible and less likely to crack. Also used to bind pigments to make paint.
Thickened linseed oil	This slightly thicker version of bleached oil is sometimes known as 'fat oil'. It has a honey-like consistency.	Used to improve the flow and handling of oil paint. It is transparent and fast drying, producing an enamel-like, gloss finish.
Poppy oil	This is a common oil medium. It is a pale, slow-drying oil with a buttery consistency, derived from white opium poppy seeds.	Used as a binding and painting medium for light-coloured pigments. Used for impasto as it holds the mark of the brush.
Liquin	Alkyd mediums are quick-drying and suit both oil paint and alkyd paint. Liquin is a fluid medium available in a bottle.	It improves the flow and transparency of paint and is used for thinning paint, glazing and creating a glossy finish.
Oleopasto	A gel-like, quick-drying alkyd impasto medium. Available in tubes.	Good for knife-painting and other impasto techniques. It dries to a matt sheen.
Wingel	A honey-coloured, quick-drying alkyd medium with a gel-like consistency. When manipulated with the knife it becomes a free-flowing liquid.	Mix with paint and leave for a short while before use for moderate impasto effects. If worked with the knife it can create smooth brushwork and transparent glazes.
Varnish	Varnishes are made from resin dissolved in a spirit, such as turpentine or an oil.	Sometimes applied to a finished painting to give a glossy, protective film. Traditionally they were added to the painting medium to enhance the brilliance of the colour.

Brushes

There are three types of brush available: natural bristle, natural hair and a range of synthetic fibres. The most popular is hog hair, made from pig's bristles. Brushes for oil painting have long handles so that you can stand back from the canvas. Start with two or three brushes, such as a no. 5 flat, a no. 8 round and a no. 10 filbert hog hair or its synthetic equivalent.

Always clean your brushes after use. Wipe off surplus paint on a rag, rinse the brush in white spirit, then wipe again. Wash the brush with soap and water, working the bristles in your palm to clean them right up to the ferrule. Rinse the brush in water, dry it on a rag and store bristle-end up in a jar.

No. 10 filbert, hog hair

No. 8 round, hog hair

No. 5 flat, hog hair

Palettes and containers

Palettes are used for laying out paints and mixing colours. Traditionally, an oil palette is made of wood (usually mahogany), and is kidney-shaped with a thumbhole so you can support it on one arm as you stand before the canvas.

Choose a large palette: your mixes may become contaminated and muddy on a small palette. A white plastic palette makes a good mixing surface. Tear-off disposable paper palettes are a clean and convenient alternative.

Metal 'dippers' are designed to hold the diluent and medium. They clip on to the edge of the palette so that the mediums are convenient for mixing. Dippers with lids are ideal for working on location.

Knives

Two types of knife are used by oil painters. Palette knives, which have broad, straight, flexible steel blades and wooden handles, are used for mixing paint, cleaning palettes and scraping paint off the canvas. Painting knives have offset handles and flexible steel blades and are available in a range of shapes. They are used for applying paint to the painting surface.

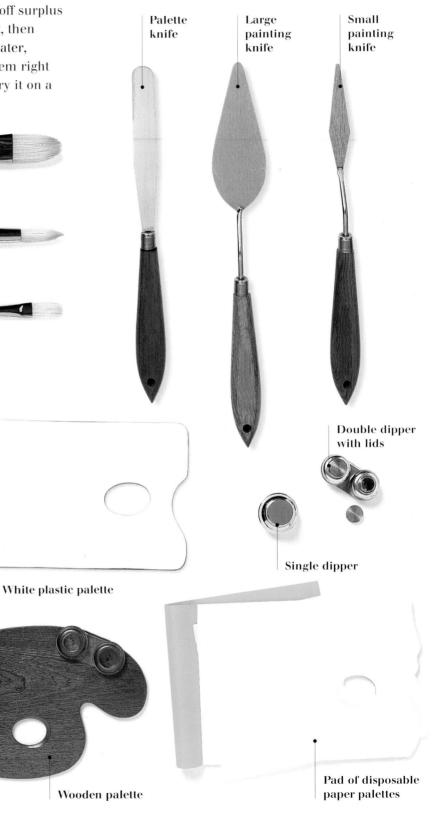

Palette knife

Large painting knife

Small painting knife

Double dipper with lids

Single dipper

White plastic palette

Wooden palette

Pad of disposable paper palettes

Painting surfaces

Surfaces must have sufficient 'tooth', or texture, to hold the paint. Canvas can be bought on the roll, primed or unprimed, in a choice of fabrics, weights, widths, weaves and prices. Linen is the best and most expensive canvas; it is strong and hard-wearing, and does not stretch or shrink. Cotton duck is less expensive and very popular; it is tough and densely woven but can stretch and shrink.

A range of ready-made surfaces can be bought in standard sizes. These include stretched and primed canvases, oilboards and canvas boards. Oil sketching papers are inexpensive embossed papers sold as boards.

You can also use plywood, hardboard, card and paper, but they will need to be sized and possibly primed (see right).

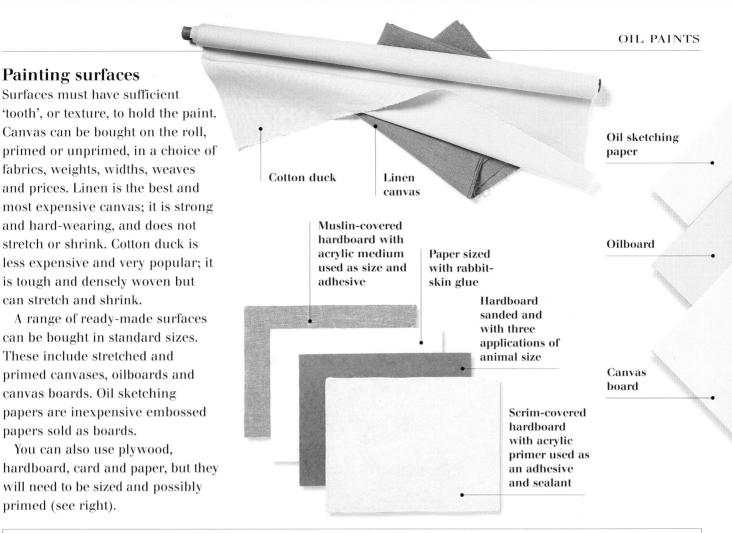

Cotton duck

Linen canvas

Oil sketching paper

Oilboard

Canvas board

Muslin-covered hardboard with acrylic medium used as size and adhesive

Paper sized with rabbit-skin glue

Hardboard sanded and with three applications of animal size

Scrim-covered hardboard with acrylic primer used as an adhesive and sealant

Preparing canvas

Canvas is absorbent and must be sealed with size to separate the paint from the fabric. You can paint directly on to the sized canvas or apply a white ground (primer) first to create a workable surface. An oil primer may take several months to dry; an acrylic primer will dry more quickly.

Stretching canvas

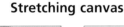

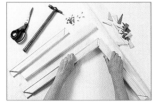

1 Fit together the four stretcher pieces and tap the corners gently with the hammer for a firm fit.

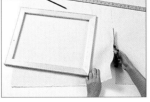

2 Lay stretcher edges parallel to the canvas weave so the canvas is square. Draw a cutting line allowing a 50-mm (2-in) overlap. Cut out.

3 Fold fabric over one stretcher and tack it in the centre as shown. Repeat for all sides, ensuring that the canvas is taut.

4 Continue tacking from centre to corner, finishing with a flat fold. Inset: Tap two wedges in each corner to increase canvas tension.

Sizing and priming canvas

1 Place a tub of size in warm water to melt, then brush into fabric. Inset: Insert card between the canvas and the stretcher to prevent the stretcher bars showing through.

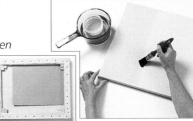

2 When the size is dry, apply the primer. Holding the brush vertically, work a small amount of primer into the weave. Hold the card against the back of the canvas and move it when you start the next section. Allow the canvas to dry.

Acrylic paints

THE OUTSTANDING QUALITIES *of acrylic paint are its versatility and the speed with which it dries. Paintings built up of layers of paint, whether thickly or thinly applied, can be completed in a single sitting.*

Acrylic paint is easy to use and makes an ideal medium for the beginner because you can overpaint and make adjustments to a painting almost instantly. These qualities are also useful when painting the transient effects of light and weather.

Acrylics can be used thickly or thinly, transparently or opaquely, and on almost any surface including paper, canvas, wood and glass. Acrylic paints and mediums are adhesive, a quality that is especially useful for collage.

Brushes

Acrylic paint can be applied with any brush or paint applicator. For wash techniques (see p. 15) use soft fibre brushes; for impasto work (see p. 18) use stiffer bristles. Synthetic brushes offer a range of bristle types and are hard-wearing.

Once acrylic is dry it is insoluble. Rinse brushes as you work and never let paint dry on the brush.

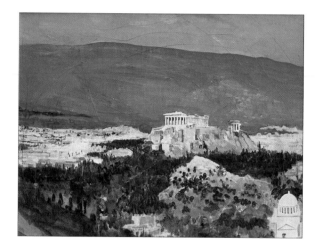

Glazing
A glaze is a thin mixture of paint and medium that modifies the colour underneath to give depth and luminosity.

The qualities of acrylic
With acrylic you can work in a variety of ways. In this study Phil Wildman used collage, pasting strips of paper to the board. Over these he built up layers of scumbles (see p. 141) and glazes (see detail) for the natural features on the hillside. These contrast with the meticulous rendering of the classical monuments.

Paints

Acrylic paint is thinned with water, but is insoluble when dry. Each layer remains discrete and is not lifted by subsequent applications.

Heavy-bodied acrylic paints are designed for impasto. They are paste-like and hold the mark of the brush or knife, but can be thinned for washes. Some acrylic paints are creamy in texture and more fluid. They can be used for wet-into-wet techniques, washes, glazing and staining (see p. 141). Liquid acrylics are transparent and brilliant in colour and resemble ink, but are insoluble when dry and lightfast. They are ideal for line work, washes and airbrushing.

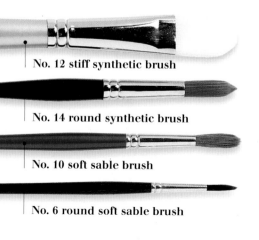

No. 12 stiff synthetic brush

No. 14 round synthetic brush

No. 10 soft sable brush

No. 6 round soft sable brush

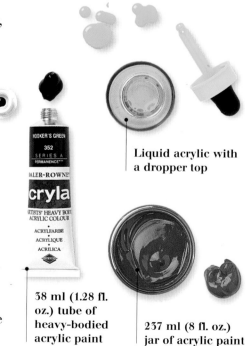

Liquid acrylic with a dropper top

38 ml (1.28 fl. oz.) tube of heavy-bodied acrylic paint

237 ml (8 fl. oz.) jar of acrylic paint

Palettes

Non-absorbent surfaces, such as plastic and glass, are suitable for mixing acrylic paint and mediums. To keep paints workable, use a special acrylic palette with a moisture-retaining lining, or spray your palette with water and cover it with cling film at the end of each session.

If your palette does become encrusted with paint, soak it in hot water until the paint peels off.

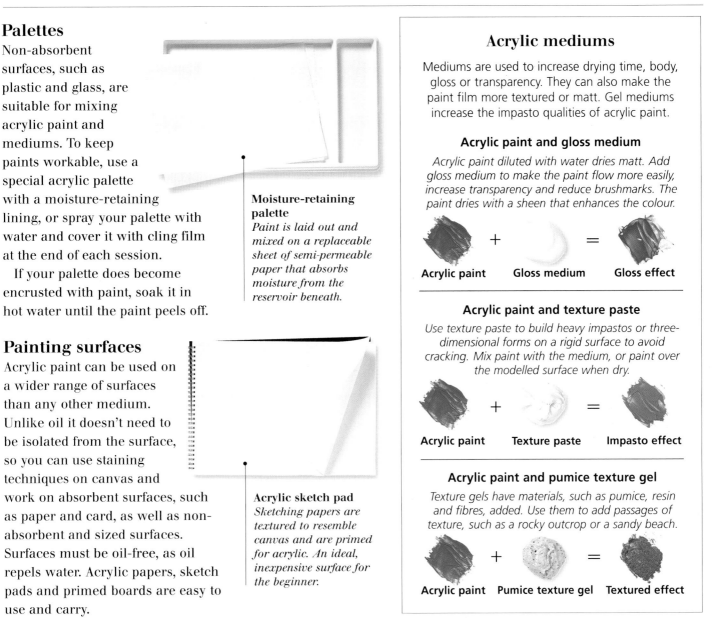

Moisture-retaining palette
Paint is laid out and mixed on a replaceable sheet of semi-permeable paper that absorbs moisture from the reservoir beneath.

Painting surfaces

Acrylic paint can be used on a wider range of surfaces than any other medium. Unlike oil it doesn't need to be isolated from the surface, so you can use staining techniques on canvas and work on absorbent surfaces, such as paper and card, as well as non-absorbent and sized surfaces. Surfaces must be oil-free, as oil repels water. Acrylic papers, sketch pads and primed boards are easy to use and carry.

Acrylic sketch pad
Sketching papers are textured to resemble canvas and are primed for acrylic. An ideal, inexpensive surface for the beginner.

Acrylic mediums

Mediums are used to increase drying time, body, gloss or transparency. They can also make the paint film more textured or matt. Gel mediums increase the impasto qualities of acrylic paint.

Acrylic paint and gloss medium

Acrylic paint diluted with water dries matt. Add gloss medium to make the paint flow more easily, increase transparency and reduce brushmarks. The paint dries with a sheen that enhances the colour.

Acrylic paint + **Gloss medium** = **Gloss effect**

Acrylic paint and texture paste

Use texture paste to build heavy impastos or three-dimensional forms on a rigid surface to avoid cracking. Mix paint with the medium, or paint over the modelled surface when dry.

Acrylic paint + **Texture paste** = **Impasto effect**

Acrylic paint and pumice texture gel

Texture gels have materials, such as pumice, resin and fibres, added. Use them to add passages of texture, such as a rocky outcrop or a sandy beach.

Acrylic paint + **Pumice texture gel** = **Textured effect**

Using acrylic medium to make a fabric-covered surface

Acrylic medium can be used to glue fabric to board to create a textured surface. Fabrics such as muslin and scrim, that are light, inexpensive, and have an obvious weave, are ideal for this purpose. The medium you use to glue the fabric to the board will also seal the surface, resulting in a non-absorbent surface that is suitable for both acrylic and oil paints.

1 *You will need hardboard, muslin, acrylic medium diluted in a little water and a small paintbrush. Cut a piece of muslin 50 mm (2 in) larger than the board.*

2 *Lay the muslin over the smooth side of the board and cover with the medium. Smooth the fabric as you go; keep the weave parallel to the edge of the board.*

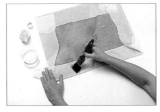
3 *When the muslin is dry, turn over and fold the extra fabric over and paste in place. Brush diluted medium over the entire back of the board to prevent warping.*

4 *When dry, the board is ready to be used; you can paint directly on to the surface. Note how the texture of the muslin resembles fine canvas.*

Easels and equipment

A GOOD EASEL CAN MAKE *painting easier and more enjoyable, allowing you to stand back and review your work. Portable equipment and a method of carrying wet canvases may encourage you to work on location.*

Generally, it is best to keep equipment to a minimum. Think carefully about how and where you intend to use it and the type of media you prefer to use.

An easel is invaluable: it allows you to work standing up, giving you freedom to move away from the canvas to assess your progress. An easel is essential if you work on large canvases that are impractical to hold. Most easels can be adjusted to different heights and can be angled to suit your particular medium. There are many types of easel available. If you use watercolour, acrylic or oil on location, a well-made sketching easel that can also be used in the studio is an economical solution.

Portable easels

If you paint out of doors regularly, you will need an easel that is easy to carry. There are many versions available. Aluminium easels that have telescopic legs are simpler to erect than the wooden versions, but are a little more expensive.

Sketching easels are available in both aluminium and lightweight wood. They can hold canvases or boards of up to 127 cm (50 in), and are compact when folded, making them easy to carry and store.

Seat easels are a compact solution if you prefer to sit down while painting on location. Some sturdier easels, such as the box easel, can also be used in a studio situation.

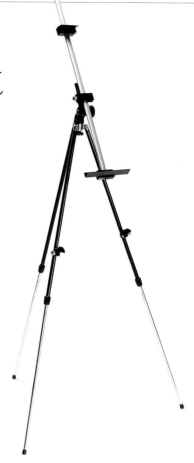

Sketching easel
This aluminium sketching easel has telescopic legs. It can be fixed upright or in a horizontal position to prevent watercolour washes from running.

Seat easel
This light and portable easel offers a range of adjustable working positions, and finished work can be carried on the folded easel.

Box easel
A box easel provides storage space for your materials and folds down to a box with a handle for ease of carrying. The legs can be adjusted for a sitting or standing position.

Studio easels

Studio easels are designed to hold large canvases. They are bigger and more solid and stable than sketching easels. Some can be folded away for storage, but the largest often become permanent fixtures in the studio. Studio easels have either a tripod or an H-shaped base, and some have castors so that they can be moved with ease. The height and angle can be adjusted.

A table easel is ideal if you work on a small scale or if you have limited space at home. It sits on top of a table and can be folded away after use.

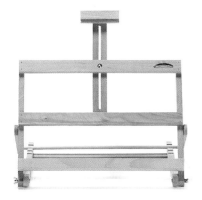

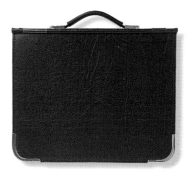

Studio easel

This 'A' frame easel is ideal for large oils or acrylics. It can hold canvases of up to 135 cm (53 in) high and can be tilted forwards and back. It folds flat when not in use.

Table easel

This table easel can be adjusted to a variety of angles or to lie flat; ideal for laying watercolour washes.

Other equipment

If you like to sit when you are drawing or painting away from home, a lightweight folding chair or stool is essential. Choose one that is easy to carry. A compact solution to the problem of carrying all your equipment is a seat combined with a backpack. Use a brush roll to protect your brushes when in transit.

Ordinary pieces of household furniture can be adapted for use in the studio. A trolley can be converted into a palette by laying a piece of glass or perspex on the top shelf. There is storage space for your paints and materials underneath, and you can wheel it round the studio.

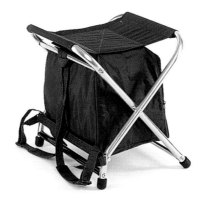

Art backpack

A combined seat and backpack is ideal. The pack holds your drawing and painting kit; the seat folds away.

Brush roll

A fabric brush roll protects your brushes and pencils.

Carrying your pictures

Drawings and paintings need protection, but can be awkward to carry and store. If you work on location, it is important to have a safe way to transport your work.

Portfolio

Artists' portfolios, in a range of sizes and styles, are useful for carrying and storing loose drawings, pastels and watercolours.

Canvas pins

To protect the wet surface of an oil painting, place double-ended pins in the four corners of the canvas and place another canvas on top.

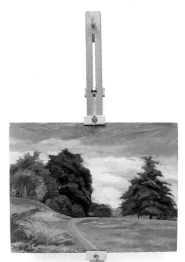

Canvas carrier

A canvas carrier holds two canvases, one on either side. Use it to bring home wet oils or acrylics when you have been working on location.

COLOURS FOR LANDSCAPES

COLOUR WORKS ON MANY levels. In a landscape painting it can be used to describe the actual appearance of things – the green of a tree, for example – but it can also be used to model form, express mood, suggest the luminosity of light and create an illusion of three-dimensional space.

This chapter provides a simple and practical introduction to these ideas and explains how you can utilise them in your work. It defines common terms, introduces the theory behind colour and explains how colours affect one another when placed side by side, overlaid or mixed together. The chapter introduces different palettes of colour and looks at green in detail.

The exercises in this chapter and the projects throughout the book give suggestions for suitable landscape colour mixes.

Understanding colour

GAINING AN UNDERSTANDING *of how colours interact will allow you to use them successfully and confidently in your landscape drawings and paintings to create the illusion of space and form, suggest mood and capture light.*

The colour wheel is a simple device that will help you to understand colour relationships. It allows you to predict how colours will behave in mixes – which mixes will produce clean, pure colours and which will create subtle neutrals.

The appearance of a colour can be modified by adjacent or overlaid colours, and the colour wheel allows you to anticipate the way that colours will affect each other in these situations. You can use it to identify warm and cool colours,

colours that are harmonious and the pairs of colours that create exciting 'complementary' contrasts.

You can use colour to play visual tricks, deliberately choosing complementary or temperature contrasts to create a mood, to lead the eye into a painting or draw attention to a focal point. Use the receding qualities of cool colours and the advancing qualities of warm colours to model form and create a sense of space in the landscape (see p. 55).

Expressive colour

In this vivid oil study, Brenda Holtam used colour both descriptively and expressively. A high-colour key and energetic brushstrokes express her response to the scene.

To express the bright nature of the autumn leaves, the artist exaggerated their colours.

Loose brushstrokes describe the outlines of the bushes and trees.

(see p. 55)

Colour terms

Colour has its own language. It is easier to discuss and learn about a subject if you understand the basic terminology.

Cool colours
Cool colours are blues, violets and greens. They appear to recede when compared to warm colours.

Complementary pairs
Colours that occur opposite each other on the wheel: red and green; blue and orange; yellow and violet.

Harmonious colours
Colours that 'go together' naturally. Colours from adjacent segments of the colour wheel are harmonious; for example, blue and green.

Hue
The general name of a colour that is unmodified by white, black or grey.

Local colour
The actual colour of an object seen close up, such as the green of leaves. Local colour is normally modified by the effects of light and shadow, and by reflections from its surroundings.

Neutrals or coloured greys
Colours that have been muted by adding a touch of black or their complementary. They are darker but still have an identifiable hue.

Shade
A hue that has been darkened by adding black or its complementary.

Tint
A hue that has been lightened by adding white.

Tone or value
The lightness or darkness of a colour judged on a tonal scale (see p. 29).

Warm colours
Warm colours are yellows, reds and oranges. They appear to advance when compared to cool colours.

The basic colour wheel

This basic colour wheel consists of the three primary colours – red, yellow and blue – and the secondary colours – orange, green and violet. The primaries cannot be mixed from other colours. Secondaries are produced when each primary is mixed with its neighbour: red and yellow make orange; yellow and blue make green; red and blue make violet. Opposite colours are described as complementary pairs and have a powerful effect on each other (see p. 34). Each primary is complemented by a secondary – red by green, yellow by violet and blue by orange.

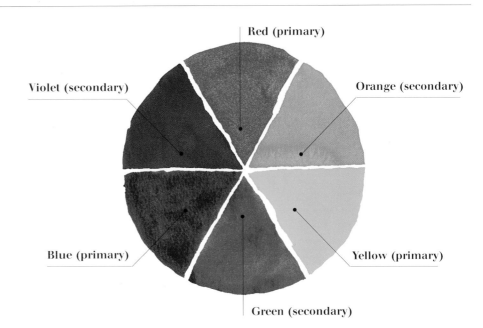

Red (primary)
Orange (secondary)
Violet (secondary)
Yellow (primary)
Blue (primary)
Green (secondary)

The extended wheel

This colour wheel consists of the six primary and secondary colours plus six intermediate colours called tertiaries. To create a tertiary, mix a secondary colour with its adjacent primary colour in equal quantities.

The tertiaries are subtle and complex hues. With their shades and tints they are common in nature – the colours of sea and sky, fruit and flowers. This is reflected in the names used to describe them, such as turquoise, lime, apricot and lavender. They are changed by context; a particular turquoise will look bluer when surrounded by green than when it is surrounded by blue.

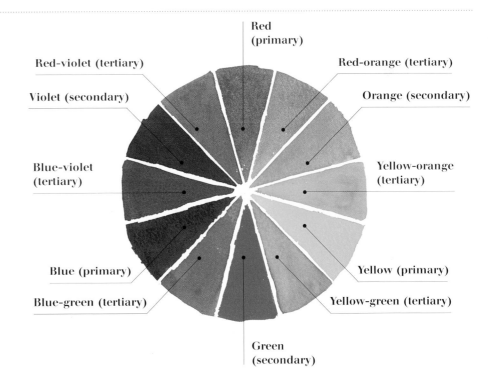

Red (primary)
Red-violet (tertiary)
Red-orange (tertiary)
Violet (secondary)
Orange (secondary)
Blue-violet (tertiary)
Yellow-orange (tertiary)
Blue (primary)
Yellow (primary)
Blue-green (tertiary)
Yellow-green (tertiary)
Green (secondary)

Creating tone

All colours have a tone and can be placed somewhere on a tonal scale between the two extremes of white and black. You can modify a hue to produce different tones: darken it by adding black or its complementary to create a shade, or lighten it with white to create a tint. Practise mixing tones by making a tonal scale like the one below, varying the quantities of black and white to achieve an even gradation.

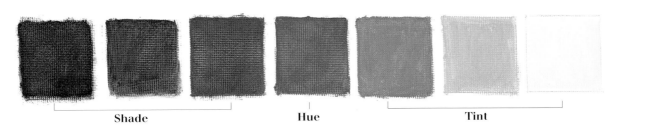

Shade Hue Tint

Mixing paint colour

Paint is not available as pure primary colour. There are many variations: some are warm, some are cool, and all have a bias towards one of the adjacent secondaries. Warm and cool versions of the three primary colours is shown on the wheel below. Note that the primaries on either side of a secondary colour are biased towards the secondary. By mixing these primaries you will create a clean secondary colour.

Experiment with colour mixes based on the colour wheel shown below. To create more muted colours, use different combinations of the primary pairs – for example, a cool red with a cool yellow will produce a dull burnt orange. These muted mixes are not pure secondary colours, but they are useful for producing naturalistic landscape paintings.

Using warm and cool colours

Colour temperature can establish mood – a warm palette suggests heat and excitement, while a cool palette creates a more restrained image. Colour temperature also affects the internal structures of a painting; a warm colour appears to advance, it draws the eye and has more impact relative to its size than an equivalent area of a cool colour. Cool colours are recessive and less visually demanding than warm colours. In this study, Bill Taylor played warm colours against cool to create an image with a vibrant quality.

The pale and cool colours of the hills in the distance make them recede.

Strokes of warm and cool colours intermingle on the hillside to produce a vibrant light.

Warm oranges and reds make this area advance.

The cool tone of the blue shadows contrasts with the warm rocks.

Mixing colour wheel

The secondaries on this colour wheel are clean colours, mixed from two primaries with a bias towards the colour of the secondary. These secondary colours can be used as pure colours in further colour mixes.

Muted mixes

The mixes below are examples of the muted secondary colours that can be mixed from different combinations on the mixing colour wheel.

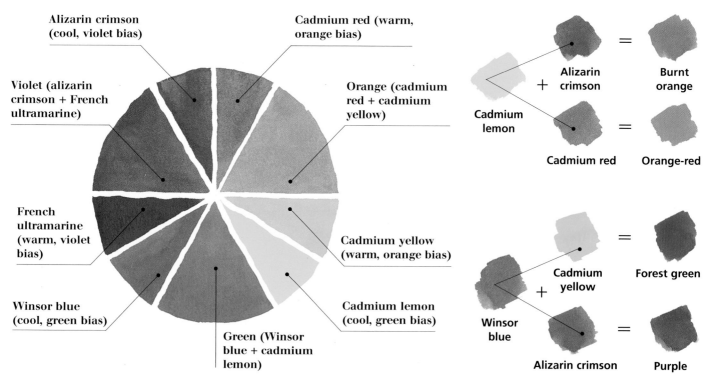

Alizarin crimson (cool, violet bias)

Cadmium red (warm, orange bias)

Violet (alizarin crimson + French ultramarine)

Orange (cadmium red + cadmium yellow)

French ultramarine (warm, violet bias)

Cadmium yellow (warm, orange bias)

Winsor blue (cool, green bias)

Cadmium lemon (cool, green bias)

Green (Winsor blue + cadmium lemon)

Cadmium lemon + Alizarin crimson = Burnt orange

Cadmium red = Orange-red

Cadmium yellow = Forest green

Winsor blue + Alizarin crimson = Purple

Broken colour

If dots of pure colour are placed side by side on a painting surface and viewed from a distance, they merge in the eye to create another colour – a process known as optical colour mixing. These intermediary colours are more luminous than those obtainable from pigment mixed on the palette. Broken colour techniques are particularly suitable for conveying light.

In oil or acrylic, paint can be applied as dabs, dashes or dots that coalesce in the eye of the viewer. You can also scumble (see p. 141) paint over a coloured ground or an existing paint layer.

Other techniques, such as hatching, cross-hatching or stippling (see p. 141), are particularly suited to dry coloured media such as coloured pencil, pastel or pen and ink.

Creating light

In this pastel study, Godfrey Tonks applied warm and cool colours as dabs and dashes over a red ground. Because these touches of colour do not blend completely in the eye, the image appears to be suffused with light and shimmering with heat. The red ground provides a sense of harmony across the picture.

The Impressionists

The Impressionists were a loose and changing association of artists who exhibited together between 1874 and 1886. Their work was different in subject, technique and intention from other painters working at the time. The Impressionists painted directly from nature, often working alla prima (see p. 114). They applied recent discoveries about the effects of juxtaposed colour, laying patches of fresh unmixed paint on to a white ground to capture fleeting 'impressions' of light and atmosphere. They avoided outline, used little black and tinted their shadows with reflected light and complementary colour.

Claude Monet, 'Impression: Sunrise, Le Havre' (1872).
More than any other artist, Claude Monet (1840–1926) typifies the techniques and intentions of Impressionism. He devoted himself to depicting the landscape, working on his canvases in the open air so as to capture the immediate effect of the natural scene. This painting was exhibited in the first Impressionist exhibition of 1874 and gave its name to the movement.

Sketchy brushstrokes capture the immediacy of the experience and the artist's sense of exhilaration.

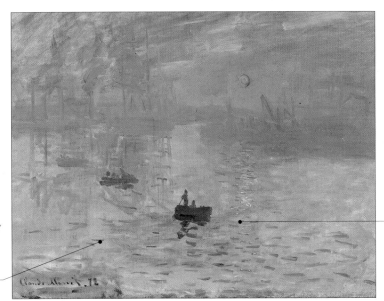

Dabs of complementary orange add a touch of bright reflected light.

Practice exercise: Using a warm palette

Subtle differences in temperature are important when you are mixing colours (see p. 30), using colour to suggest form and space, or trying to create a particular mood in a painting. To capture the heat and brightness of this Egyptian landscape effectively, you must favour the warmer colours in your palette. Compare the finished picture with an alternative painted using a cool palette (see box on p. 33).

You will need:
• Canvas board, 330 x 255 mm (13 x 10 in)
• Oil paints:
 Ivory black
 Titanium white
 French ultramarine
 Cerulean blue
 Sap green
 Yellow ochre
 Raw umber
 Cadmium yellow
 Alizarin crimson
 Cadmium red
• Brushes:
 6-mm (¼-in) flat brush
 3-mm (⅛-in) flat brush
• 2B pencil

1 *Draw the scene using a 2B pencil. The image is bold and crisp, comprised of areas of flat colour. Keep the pencil outlines emphatic and clean, and do not apply any shading.*

2 *With a 6-mm (¼-in) flat brush, paint the fronds of the palm trees using sap green darkened and warmed with a touch of cadmium red. Mix raw umber, yellow ochre, ivory black and a little titanium white for the brown tree trunks. For the dark shadows within the window apertures, use a mix of raw umber, ivory black and cadmium red.*

3 *Cerulean blue and titanium white are inherently cool colours – in Mix A (below) they have been warmed with a touch of French ultramarine, a warm blue. Apply the mix with the 6-mm (¼-in) flat brush, changing direction to achieve even coverage. Add more French ultramarine to Mix A to create a warmer, deeper blue for the façades and the windows.*

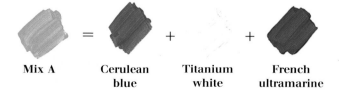

| Mix A | = | Cerulean blue | + | Titanium white | + | French ultramarine |

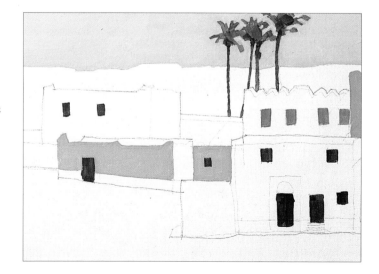

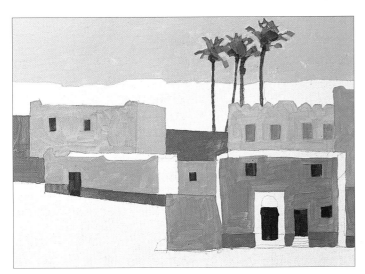

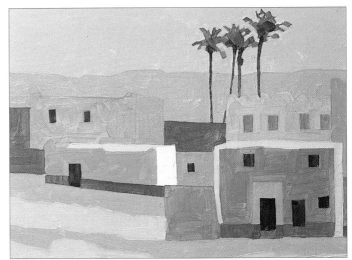

4 *Mix B (below) gives a golden earth colour for the façades of the lighter buildings. This is the base colour for the buildings and can be modified for different buildings and for later layers. Add raw umber and cadmium red to the mix for the darker façades in the foreground. Add more cadmium red for the red skirting along the base of the building on the left.*

5 *Use Mix C (below) for the sandy hills shimmering in the background. Add yellow ochre and white to Mix B to create the lighter shade for the foreground; use a touch of ivory black for the darker tones. To enrich the façades on the left, mix yellow ochre, cadmium red and alizarin crimson. Darken this mix with a touch of ivory black for the crisp shadows.*

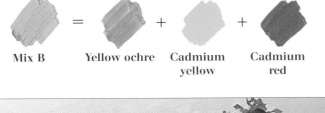

Mix B = Yellow ochre + Cadmium yellow + Cadmium red

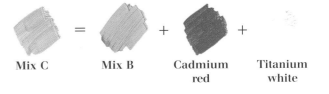

Mix C = Mix B + Cadmium red + Titanium white

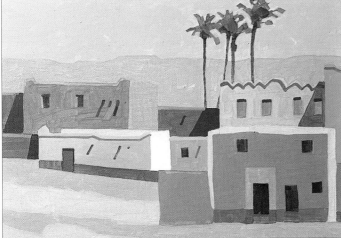

6 *Complete the image by painting a dark shadow under the roof line of the building on the extreme right – use cerulean blue, French ultramarine, yellow ochre and titanium white applied with a 3-mm (⅛-in) flat brush. Use the shadow mix from Step 5 for the shadow under the undulating roof.*

Using a cool palette

In this cooler version of the image, the artist used the cool primaries – cadmium lemon, cerulean blue and alizarin crimson – and added a lot of white to his mixes. By favouring a cool palette the artist gave the scene a crisp and chilly feeling, with a pleasing sense of space and airiness.

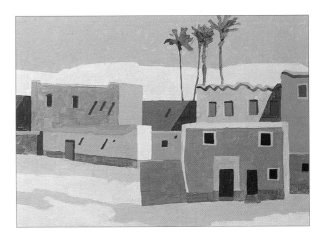

The sky was mixed from cool cerulean blue and white to give it a subtle coolness compared to that mixed with warm French ultramarine.

Exploiting complementary pairs of colours

Complementary pairs are the colours that appear opposite on the colour wheel: red is complemented by green; yellow by violet; blue by orange. Every colour generates its complementary in the form of an after-image (see below) and this explains why colours are modified by adjacent colours.

When complementary colours are placed alongside each other – for example, a red alongside green – both colours look brighter and more intense. This effect is very useful to landscape painters; you can introduce touches of red into passages of green foliage or grass to make the greens more intense and vibrant. Complementaries are also found, together with reflected colours, in shadows.

Complementary red and green

The artist, Helena Greene, added zest to an otherwise austere composition by exploiting contrasts of warm and cool, and by laying a complementary red under the brushy greens on the hillside.

Red showing through scumbled green gives this area a bright and sparkling luminosity.

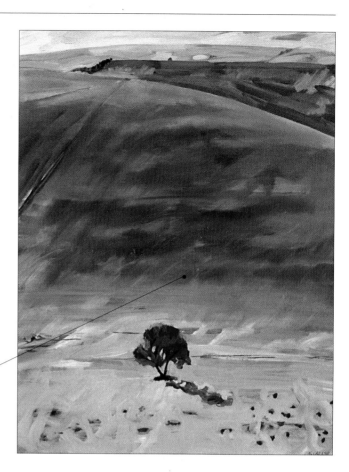

Creating the complementary 'after-image'

Every colour generates its complementary as a coloured halo or 'after-image'. To test this for yourself, cover everything on these pages with white paper, leaving only the green square below. Stare fixedly at the square for about 30 seconds – try not to blink – and then transfer your gaze to a white piece of paper. Almost immediately you will see a film of red light.

Mixing complementaries

When complementaries are mixed together, they neutralise each other and produce a range of coloured greys or neutrals. Use a tiny touch of a complementary to make delicate tonal adjustments; for example, to grey a sky that is too blue.

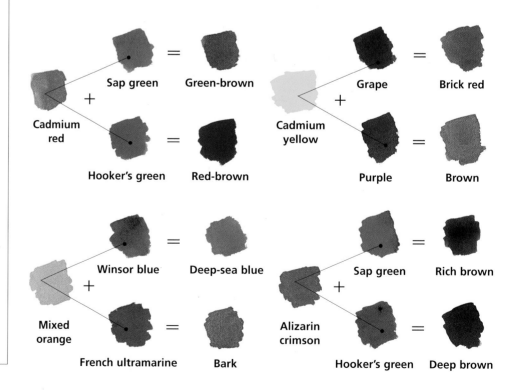

Cadmium red + Sap green = Green-brown
Cadmium red + Hooker's green = Red-brown

Cadmium yellow + Grape = Brick red
Cadmium yellow + Purple = Brown

Mixed orange + Winsor blue = Deep-sea blue
Mixed orange + French ultramarine = Bark

Alizarin crimson + Sap green = Rich brown
Alizarin crimson + Hooker's green = Deep brown

Neutrals

An important range of colours for the landscape painter is that of neutrals, or coloured greys. Neutrals are colours that have been greyed, muted, dulled or dirtied, but which still have an identifiable hue. This category of colours provides an almost unlimited range of subtle shades, from cool, pearly greys and lilacs, seen in overcast skies and distant hills, to the warm earth colours of soil, sand and rock.

You can neutralise a colour by adding black or grey, but the most satisfactory results are achieved by adding a touch of the colour's complementary (see p. 29). Some colours, such as the earth colours (below), are naturally neutralised.

Neutral colours have many uses. They lend themselves to depictions of misty or rainswept landscapes, and can be seen in overcast skies. Because they provide a useful foil for other colours, many painters use a primarily neutral palette with touches of brighter colour.

Pearly greys

In this study of wintry weather, Trevor Chamberlain used a restrained and carefully managed palette of pearly neutrals to create an image that is subtle and atmospheric. Note the way warm neutrals are played against cool greys.

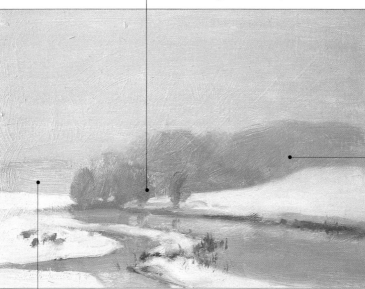

These trees are slightly warmer in tone, so they come forward and occupy the middle ground.

A muted brown with a purple bias suggests a mist-shrouded woodland.

A gentle, muted blue-green on the horizon takes its place behind the warmer neutral of the row of trees.

Earth colours

These naturally occurring pigments are subtle, slightly muted colours that are close to the actual colours in the landscape. Terre verte is a transparent, greyed green that is often used in underdrawings or monochrome paintings. Vandyke brown is a rich brown. Yellow ochre is a semi-opaque, golden-yellow pigment useful for summer cornfields, autumn foliage and in mixes. Venetian red and Indian red are subtly neutralised reds, the colour of brick and terracotta. They create delicate pinks when mixed with white. Raw umber, a brown with a greenish undertone, and burnt umber, a rich ginger-brown, are useful for glazing (see p. 22). Raw sienna is a golden yellow, ideal for staining a canvas to give a warm ground. It is good in mixes and useful for glazing. Burnt sienna is a neutralised red-orange, the colour of autumn foliage and sunsets.

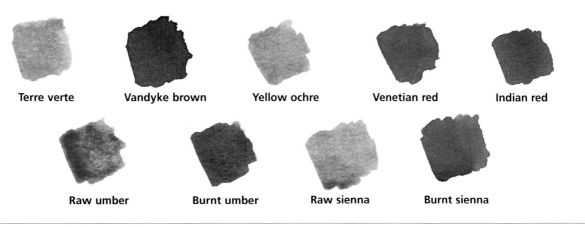

| Terre verte | Vandyke brown | Yellow ochre | Venetian red | Indian red |

| Raw umber | Burnt umber | Raw sienna | Burnt sienna |

Practice exercise: Using neutral mixes

Colours in the landscape are modified by the effects of light, shade, weather and the atmosphere. Your paintings will look more realistic if you use naturally muted colours or neutralise the brighter colours in your palette by mixing, as the artist has done in this exercise, using colours from the starter palette (see p. 38). Compare the finished picture with a version painted in brighter, purer colours (see box on p. 37).

see p. 38
see box on p. 37

You will need:
- Canvas board, 330 x 255 mm (13 x 10 in)
- Oil paints:
 Titanium white
 French ultramarine
 Cerulean blue
 Sap green
 Yellow ochre
 Raw umber
 Lemon yellow
 Cadmium yellow
 Alizarin crimson
 Cadmium red
 Ivory black
- Brushes:
 6-mm (¼-in) flat brush
 3-mm (⅛-in) flat brush
- 2B pencil

1 *Establish the main outlines of the image using a 2B pencil. Indicate the drifts of flowers and clumps of foliage in the foreground – these will be useful later. Keep the drawing simple with clean lines.*

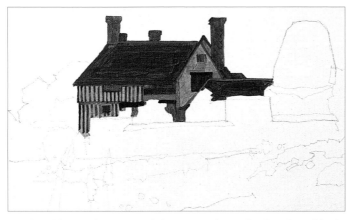

2 *Use Mix A (below) and the 6-mm (¼-in) flat brush to block in the roof, chimneys and timber. Mix yellow ochre, raw umber and titanium white for the sandy colour of the walls. Add cadmium red for the warm terracotta on the end wall.*

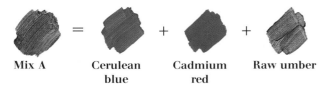

| Mix A | = | Cerulean blue | + | Cadmium red | + | Raw umber |

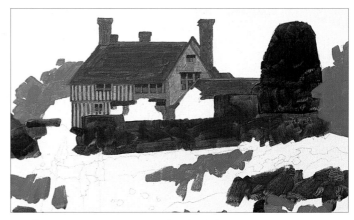

3 *Create a range of greens for the foliage from Mix B (below). This is a mix of sap green muted by a touch of complementary red. Use this colour for the yew hedges and topiary. Add white to Mix B for the trees round the house.*

| Mix B | = | Sap green | + | Alizarin crimson |

4 *Continue to develop the range of greens by adding colour to your existing mixes. Scumble (see p. 141) Mix C (below) on loosely, adapting the brushmarks to follow the forms of the clumps of foliage in the foreground.*

see p. 141

| Mix C | = | Mix B | + | Titanium white | + | Yellow ochre |

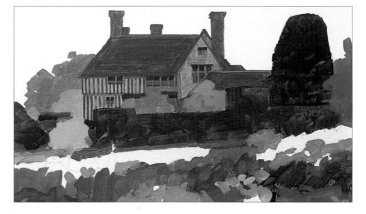

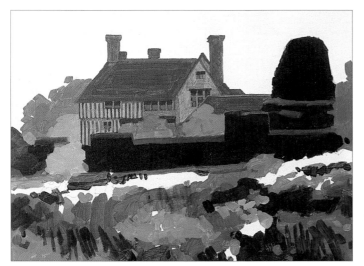

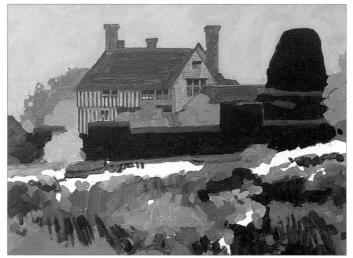

5 *Start to tighten up the rendering of the plantings round the house, so that this area becomes less impressionistic. To give solidity and form to the clipped yew hedges, mix a dense, black-green from French ultramarine, sap green and black. Continue to develop the foreground, using the range of mixed greens on your palette.*

6 *Lay in the sky with Mix D (below). This is a blue neutralised with orange (mixed from cadmium red and cadmium yellow), which warms and softens the sky. Apply the colour loosely to build up a flat, unmodulated layer of colour. Use the 3-mm (⅛-in) flat brush to dot touches of the sky colour into the windows to make them appear more reflective.*

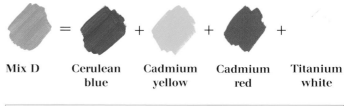

| Mix D | | Cerulean blue | | Cadmium yellow | | Cadmium red | | Titanium white |

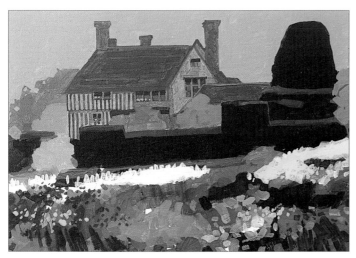

7 *Complete the painting by adding the beds of flowers. Their local colour (see p. 28) is modified, or neutralised, by the effects of shade, reflected light and distance. For the bank of yellow flowers use cadmium yellow mixed with lemon yellow. Mix a subtle pink from cadmium yellow, alizarin crimson and titanium white. Use Mix E (below) to create the violets. To soften the colour further, add a touch of cadmium yellow.*

| Mix E | | Alizarin crimson | | French ultramarine | Titanium white |

Using bright colours

For this version of the subject the artist used many of the colours straight from the tube, with very little mixing. The range of greens is more limited and the flower colours are less subtle. The image is bolder and simpler, with patches of bright colour and a strong, intense sky.

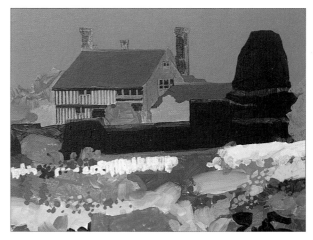

The intense colour of the sky is almost pure French ultramarine. The colour of the roof, mixed from black and white, is flat and uninteresting and looks unnatural.

Selecting a colour palette

The term 'palette' describes the selection of colours used for a painting as well as the surface on which colours are mixed.

Most painters evolve a personal palette of colours by trial and error. From time to time you will find that a certain subject demands particular colours. For example, cerulean blue is ideal for the intense blue of the sea and sky in hot regions. Naples yellow is a neutralised, chalky yellow that is perfect for depicting sun-baked earth. Payne's grey and Davy's grey are useful coloured greys that can be used as a base for shadows and for neutralising other colours.

Laying out a palette

To avoid confusion, you should always lay out your palette of paints in the same order, as dark colours look much the same when undiluted. The usual practice is to lay the colours warm to cool, with black and white together at one end (see box, right) or at either end.

Suggested starter palette

This suggested starter palette is based on the pairs of warm and cool primaries used on the 'Mixing colour wheel', (see p. 30), together with some useful proprietary greens (see p. 40) and a selection of earth colours. This selection is intended as a starting point only. If you want to use fewer colours, you could limit yourself to the primary pairs plus black and white, with possibly one green; or you could make do with only one of each of the primaries and add other colours later.

Palette for a sun-drenched view

This watercolour study was made on location. The artist, Francis Bowyer, worked quickly on grey paper, using a simple palette of primary and secondary colours, with titanium white for body colour. The paint was flooded on wet into wet (see p. 14) to create ghostly outlines, then strokes of opaque colour were laid on top to create a broken colour effect (see p. 31) that captures the luminosity of the sun-drenched bay.

Color palette:

| Cadmium red | Alizarin crimson | Cadmium yellow | Sap green | Viridian | French ultramarine | Titanium white |

A limited palette

Working with a restricted palette has many advantages. It forces you to be inventive and to experiment with mixes, so that you become familiar with the characteristics of each colour and the way they respond in different mixes. This in-depth knowledge will give you control of your palette.

An image painted from a limited palette will have an inherent harmony, because inevitably certain colours will recur across the canvas. Mixes that contain the same parent colour have a familial resemblance and this, too, imposes a sense of coherence. It is more difficult to control an extended palette of different colours.

A limited palette has some disadvantages. If you use the same colours all the time, your work may become predictable. You can counteract this by introducing a new colour occasionally. Also, it may be difficult to create special colours such as the fresh, clean hues needed for flowers.

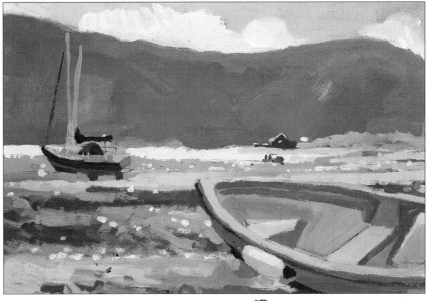

Using a limited palette

The artist, Alastair Adams, uses a restricted palette of colours loosely based on the warm and cool versions of the primaries (see p. 29), supplemented with specific colours when required. In this moody acrylic sketch, the range of subtle greys and coloured neutrals is mixed from the complementary pairs (see p. 34), with touches of colour added to move the mix in one direction or another.

Cadmium red

Napthol crimson

Cadmium yellow medium

Lemon yellow

Phthalo blue, green shade

Phthalo blue, red shade

Titanium white

Palette for flowers

The jewel-bright colours of flowers are difficult to match in paint, especially purple, lilac and violet. For this study of an iris field, Timothy Easton expanded his palette with a range of transparent scarlets and crimson that mix with blue to give clean, fresh violet shades. He also used a proprietary violet and a bright, golden yellow called Indian yellow.

Special palette:

Scarlet lake	Scarlet vermilion	Geranium lake
Permanent magenta	Alizarin violet	Indian yellow

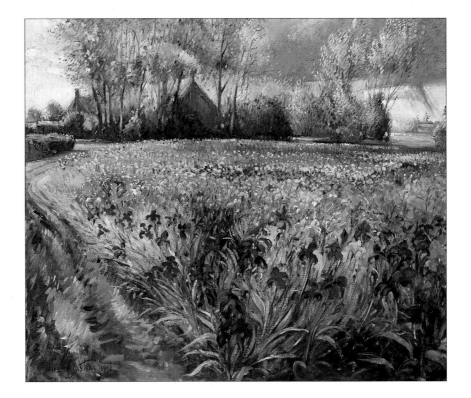

Greens for landscapes

G REEN IS THE *most important and varied colour in the landscape painter's palette. Ready-made 'paintbox' greens are easy to use, and by mixing them with other colours you can produce a wide range of hues.*

There are two stages to mastering green in the landscape. First, train your eye to detect the subtle differences between one green and another, and between the same green seen at different times of day or in different light conditions. Always try to work directly from nature whenever you can, as photographs tend to interpret, simplify and freeze colour.

The second stage is to match what you see in paint. The various ways of producing a range of greens are explained here (see also 'Mixing paint colour', p. 30). It is worth noting that you rarely need a bright apple green in a landscape. Most of the greens you see in nature are slightly muted, their inherent colour tempered by shadows, haze and dust and reflected light.

Modifying greens

You can extend your palette by modifying proprietary greens – brightening them by adding lemon yellow, for example, or neutralising them by adding a touch of their complementary, or creating a tint by adding white (see p. 29).

Experiment by mixing the greens in your paintbox with other colours, varying the proportions to see how many different shades you can produce. Always keep a note of any mixes that work well so that you can be sure of recreating them.

Modifying viridian green

Viridian is a strong paintbox green. Its clarity and intensity make it a good colour for mixing. Here it was mixed with a selection of colours from the suggested starter palette (see p. 38), producing a range of shades.

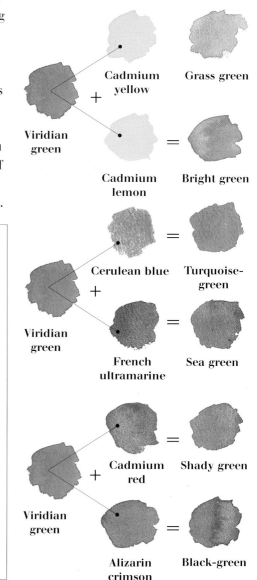

Viridian green + Cadmium yellow = Grass green

Viridian green + Cadmium lemon = Bright green

Viridian green + Cerulean blue = Turquoise-green

Viridian green + French ultramarine = Sea green

Viridian green + Cadmium red = Shady green

Viridian green + Alizarin crimson = Black-green

Paintbox greens

Select one or two commercial or 'paintbox' greens for your palette. The paintbox greens shown below are very different in character. Sap green, a bright, transparent, grass green, is used in different mixes in the project on pp. 42–45. Terre verte, a delicate grey-green, is useful for creating aerial perspective effects. Hooker's green dark, an intense holly green, is useful on its own and in mixes. Viridian is a brilliant, transparent and rather strident colour. Oxide of chromium is muted and very opaque. The exact hue of a green will vary in different media.

| Sap green | Terre verte | Hooker's green dark | Viridian | Oxide of chromium |

Mixing greens

A range of greens can be mixed from the primaries yellow and blue. Different hues of primary colours, and varying proportions of paint, produce very different greens. Experiment with different mixes, adjusting the proportions of each colour so that you produce a graduated scale for each pair.

Colour mixing is full of surprises. Black may seem an unusual choice when looking for a mossy green, but mixing black and yellow produces some useful muted greens for the landscape. Experiment with blacks, greys and yellows: some mixes give green shades, others give rich browns. But treat black with respect as too much can dull a painting.

Green landscape from a limited palette

The greens in this oil painting by Richard Tratt were derived from a limited palette: viridian, burnt sienna and lemon yellow. The resulting mixes have an inherent harmony. The artist observed the different greens created by distance and light, and conveyed these effects through warm and cool mixes.

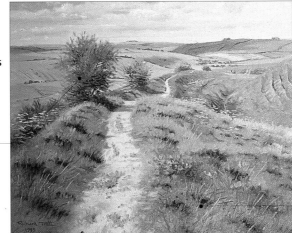

The mixes used to suggest light and shade in this bush were all derived from the limited palette.

Warm and cool greens used close together advance and recede, creating a lively foreground.

Greens from a cool yellow

Lemon yellow is cool. When mixed with a cool blue, such as cerulean (top row), it results in bright greens. French ultramarine (second row) is a relatively warm blue, and when combined with lemon yellow it produces a muted range of shades.

Greens from a warm yellow

Cadmium yellow has a more orange cast compared to lemon yellow and is warmer. Mixed with cool cerulean and warm ultramarine, the results are subtle and muted, and have a warmer feel.

Greens from black

A cool black, such as blue-black, can be mixed with a cool yellow, such as lemon yellow, or with cadmium yellow, to give a range of sages and khaki greens. The cadmium yellow mix is slightly warmer.

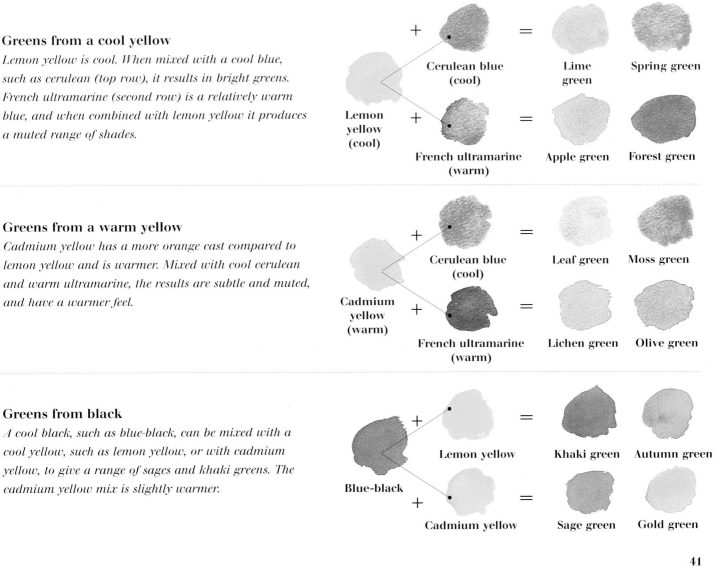

Lemon yellow (cool) + Cerulean blue (cool) = Lime green / Spring green

Lemon yellow (cool) + French ultramarine (warm) = Apple green / Forest green

Cadmium yellow (warm) + Cerulean blue (cool) = Leaf green / Moss green

Cadmium yellow (warm) + French ultramarine (warm) = Lichen green / Olive green

Blue-black + Lemon yellow = Khaki green / Autumn green

Blue-black + Cadmium yellow = Sage green / Gold green

Using greens

BY SIMPLIFYING FORM *and enhancing colour, a relatively simple scene is transformed into a tapestry of subtle greens. Here, Ian Sidaway explores the colours that can be created from a palette that includes paintbox greens.*

In this late-summer landscape, a range of greens is used to describe the vegetation. By exploiting contrasts of temperature and tone, the different greens are used to model form, create an illusion of space on a flat surface and describe the pattern of light and long shadows created by the bright but cool sun. Two ready-made colours – emerald green and sap green – were used as a base to produce all the greens required for the project.

Light emerald green is a sharp, cool and unnatural green. It is opaque, but can be thinned for washes and glazes. In this project it is mixed to produce a range of colours, from bright lime green to a subtle khaki.

Sap green is warm and natural, the colour of sunlit grass. It is transparent and therefore ideal for glazing other colours (see p. 22). It is also a useful mixing colour: mix it with white or lemon yellow to produce 'spring' greens.

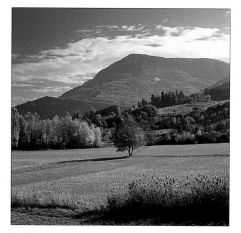

A vista of greens
Bright sunlight slanting across the scene creates a patchwork of light and dark greens. The plain green foreground and patterned middle distance are seen against the brooding presence of the mountain. These three distinct bands provide the structure of the composition.

You will need:
- Stretched canvas or canvas board, 635 × 760 mm (25 × 30 in)
- Thin stick of charcoal
- Aerosol fixative spray
- Acrylic paints
 Emerald green light
 Sap green permanent
 Prussian blue
 Phthalo blue
 Payne's grey
 Raw umber
 Yellow oxide
 Cadmium orange
 Cadmium yellow medium
 Titanium white
- Two jars of water, one for mixing and one for cleaning your brushes
- Brushes
 No. 4 bristle flat brush
 No. 10 bristle flat brush
 40-mm (1½-in) flat brush
 3-mm (⅛-in) synthetic brush

Starting to paint
Decide upon your format, then complete the underdrawing. Block in the main areas of colour, working across the entire picture surface.

1 *Sketch in the main elements with charcoal. Include shadows, cast here by the single tree in the foreground; these lead the eye into the painting. Spray with aerosol fixative to protect the paint from charcoal dust. Inset: Mix a muted blue-green from sap green, raw umber, Prussian blue and white, and dilute with water. Block in the mountain with a no. 10 brush.*

2 *Paint the trees and fields in the middle distance using Mix A (below) for the darkest green. Add cadmium orange for a range of muted khaki greens. Using a no. 4 brush, scrub cadmium yellow thinned with water on to the sunny side of the foreground tree and the poplars on the left. Inset: Using the no. 10 brush, wash in the sky with a mix of phthalocyanine blue and white. Leave some canvas showing to represent clouds.*

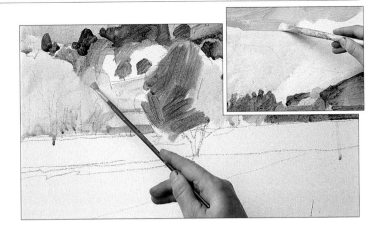

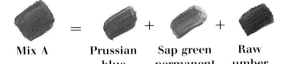

Mix A = **Prussian blue** + **Sap green permanent** + **Raw umber**

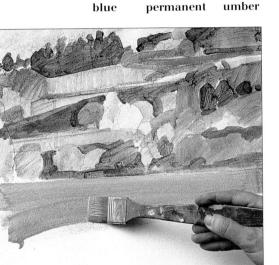

3 *Mix emerald green, cadmium yellow and sap green for the bright grass green of the foreground and apply with broad horizontal strokes, using a 40-mm (1½-in) brush. When the paint is dry apply another layer of the same mix, varying the direction of the strokes to create the texture of the grass.*

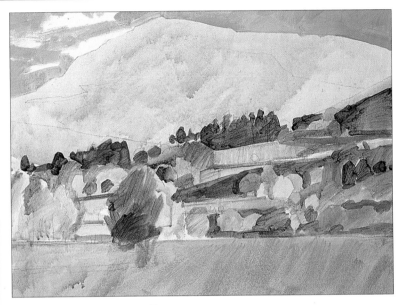

Progress report
All the basic elements of the composition are now established. Step back a few paces from the painting and view it through half-closed eyes to assess the colour, tone and spatial relationships.

Developing the picture

The next stage is to add emphasis by building up colour and texture, and enhancing contrasts of light and dark. Changes in one area will affect adjacent areas; try to keep the whole painting progressing at the same rate.

4 *Using a no.4 brush, lay in the shadows of the mountain peak using a variation of Mix A (see Step 2) with extra Prussian blue and a touch of white. Inset: Where the sun catches the top of the lower hill it creates a rim of light. Recreate this by darkening the hill using the mountain shadow mix, but with more Prussian blue. Leave a strip of the under-painting to represent the sliver of light.*

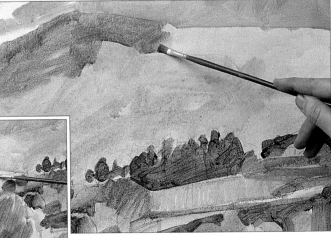

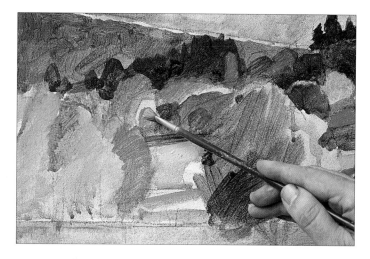

5 *Begin to rework the middle distance, defining and refining the shapes and intensifying the existing colours. Use a dark green mixed from Prussian blue, Payne's grey and a touch of raw umber to 'draw' the silhouettes of the conifers at the back of the wooded area. Introduce Mix B (below), which gives a range of warm brown-greens.*

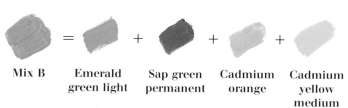

| Mix B | Emerald green light | Sap green permanent | Cadmium orange | Cadmium yellow medium |

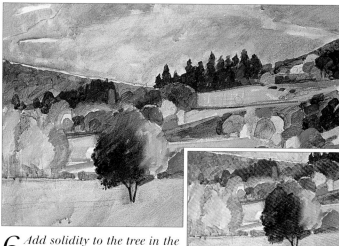

6 *Add solidity to the tree in the foreground by scumbling (see p. 141) a dark green on the shadowed side and a warm yellow-green, such as Mix B (see Step 5) with more sap green and cadmium yellow and orange, on the opposite side. Inset: Using the dark green and a no. 4 brush, lay in the shadow to the edge of the painting. This leads the eye in and confirms the direction and intensity of the sunlight and the horizontal plane of the field in the foreground.*

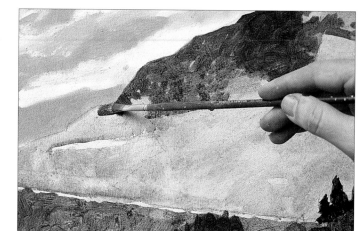

7 *With a no. 4 brush and a dilute mix of Mix C (below), add the shadows on the mountain. Use a scrubbing motion to create texture. Add more sap green and yellow oxide to Mix C, and scumble this on to the lower slopes.*

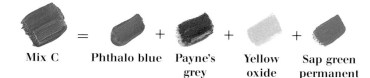

| Mix C | Phthalo blue | Payne's grey | Yellow oxide | Sap green permanent |

Finishing touches

A few carefully chosen details can pull a painting together. For example, the small trees along the field boundaries and footpaths give a sense of scale. But don't overwork the painting as it may lose its spontaneity.

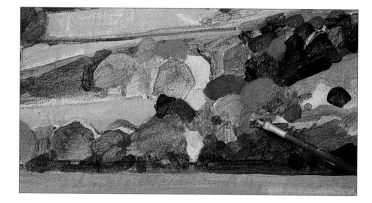

8 *The middle distance is the focus of the painting. Work across the entire area using your range of greens and Mix D (below), crisping up shapes, adding dark tones and introducing light areas. By adding dark shadows under the clump of trees on the left, you suggest the density of foliage above. Use Mix D with a little white for the wedge-shaped field on the extreme right of the picture, which is in shadow.*

| Mix D | Prussian blue | Sap green permanent |

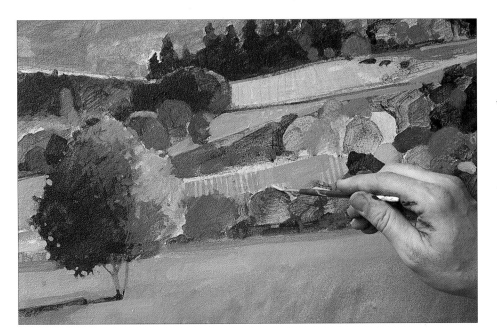

9 *Using a pale green mix from sap green and yellow oxide with plenty of white, lay a band of dilute colour across the top of the field in the foreground. Visually, this helps to push back the far side of the field beyond the tree. The ribbed pattern of the mown meadows, clearly visible because of the angle of the sun, is a detail that is worth including. Use the 3-mm (⅛-in) synthetic brush and a mix of sap green, titanium white and a touch of cadmium orange to paint the parallel stripes. In reality this particular pattern occurred in only one field, but the artist 'borrowed' it to use in this area.*

The Finished Painting

Although the finished painting is predominantly green, the impression is of colour and light. The mosaic of greens is loosely based on the observed scene: by simplifying forms, looking for patterns and playing with colour the artist created an image that captures the spirit of the subject, has a feeling of space and distance, and is aesthetically pleasing. Alternating warm and cool greens creates the illusion of depth, so that the eye is led into and out of the wooded area. Bits of accidental colour may travel from one area to another; these enliven the paint surface and bring the composition together.

On the mountain scumbled layers of colour and vigorous brushwork add interest without being laboured.

This dark green adds emphasis and contrast. It creates a pattern that zigzags across the image.

Several shades of green were used to render the canopy of the tree.

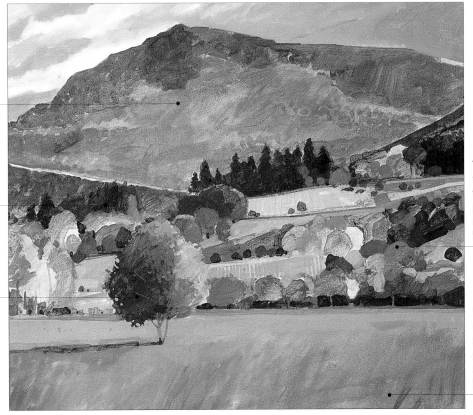

This khaki green was also used on the left of the picture, providing a visual link across the paint surface.

The bright green underpainting shines through, capturing the effect of grass in sunlight.

45

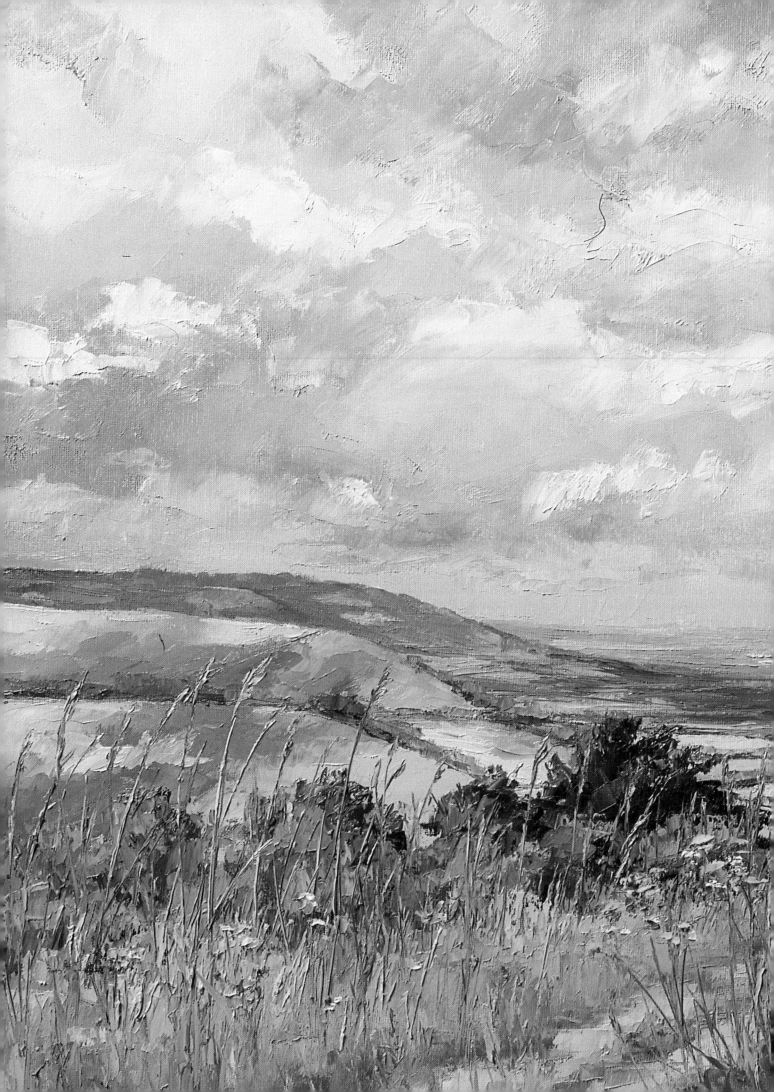

COMPOSING
LANDSCAPES

COMPOSITION IS PROBABLY the most important aspect of making a successful landscape painting. Pleasing compositions are rarely 'found', they have to be designed, so simply copying what you see won't necessarily result in a well-composed picture. A good composition hangs together, has an internal harmony and logic, and grabs and holds the viewer's attention. To create a composition that works and is uniquely your own, you have to select, edit, shift and emphasise the various components of the landscape.

This chapter shows you how to select a suitable format, organise the picture area and create a focus. It also introduces the principles of linear and aerial perspective, and explains how to use them to create a sense of depth and space in your landscape drawings and paintings.

Designing the landscape

A PLEASING LANDSCAPE DRAWING *or painting is the product of a series of aesthetic judgements. Identifying and analysing the components of a scene will help you to make those decisions and produce satisfying landscape pictures.*

The building blocks from which a picture is constructed include shape, tone, colour, light, rhythm, line, texture, perspective and space. In the composition process you organise these components in order to create an image that holds the viewer's interest and makes a convincing whole. These concepts are illustrated in the practical projects throughout the book.

Start by finding a theme for your landscape study – the pattern of shadows on a sunny day, for example, or the jigsaw shapes of rooftops seen from a window. If you constantly remind yourself of that initial inspiration, your work will have coherence and focus.

Next, look for contrasts, patterns and similarities and see how these can be used most effectively in the picture. For example, the striped pattern of a ploughed field could be contrasted with the billowing shapes of clouds. Explore your ideas in a series of small thumbnail sketches (see p. 104).

Choosing a format

Format affects the dynamics and mood of the composition. There are three traditional formats: landscape, portrait and square.

The landscape, or horizontal, format has a wide base that allows the eye to sweep from side to side and suggests stability and calm. It is ideal for panoramic vistas.

The narrow base of the portrait, or vertical, format forces the eye up through the picture, creating a more dynamic mood. It can be used to focus on a single vertical feature.

A square format is the most contained and stable of all. The eye tends to move round the picture in a circular motion, which focuses attention on the centre. It is ideal for intimate subjects.

To check which format works best, place a pair of adjustable L-shaped masks over sketches or use a viewfinder (see p. 104).

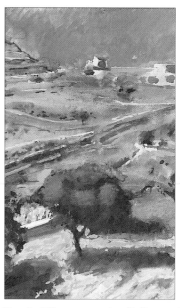

Exploiting a portrait format
In this tightly cropped picture by Francis Bowyer, the eye is drawn upwards through the confined space towards the narrow sliver of sky.

The effect of different formats
These illustrations show three possible treatments of the same subject. You can find different solutions by varying the crop or the location of the horizon.

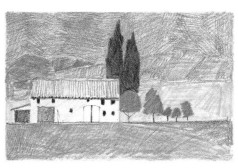

Landscape format
A wide format feels 'natural' because it matches our field of vision. Here, it allows you to include a large expanse of land and sky, creating an open vista and a restful mood.

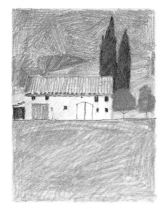

Portrait format
Here, a high horizon creates a deep, empty foreground that draws the eye and contrasts with the top of the picture.

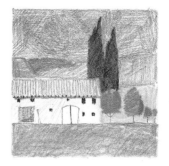

Square format
Here, the square format is used to crop into the centre of the subject, creating a compact image. The picture space is flattened, which emphasises the pattern of buildings, sky, trees and foreground.

Organising the picture

A successful composition depends on how the different elements work together. Plan your composition carefully; start with the location of the horizon line (see right), then decide on the position of your centre of interest, or focal point (see p. 51). Arrange the components to direct the eye round the picture: don't forget to include some empty space. Consider the geometry within the painting – bear in mind that symmetrical compositions tend to look dull and unnatural.

An easy way to organise the picture area is to divide it into an imaginary grid based on thirds (see below). Key elements, such as a tree or the horizon, can be laid along vertical and horizontal divisions. Locate important focal points at the intersections.

The horizon line

The horizon provides a natural and dominant division in a landscape painting. Its location within the picture area is one of the most important decisions you have to make when composing your landscape painting or drawing, as it determines the balance of sky to land and the feel of the composition. Avoid placing the horizon half-way up the picture as this looks unsatisfactory.

High horizon
In this composition the horizon is high. There is little sky, so the picture has an enclosed feeling. A large foreground permits you to create textural interest and gives you space for compositional devices such as this sweeping lane, which leads the eye into the picture space.

Low horizon
In this version of the image the horizon is low, so that most of the picture area is devoted to sky. The image has a spacious, airy feeling, though there is little sense of recession from foreground to background. The clouds become an important element in the composition.

Dividing on the thirds

To help you to organise your picture, divide it into thirds, vertically and horizontally. The one-third grid is very flexible – once you have selected the elements of the landscape you can place them on the grid to achieve a satisfying composition (see the examples below). Don't stick rigidly to the grid – it is merely a guide to help you impose an order on your picture. In successful compositions the viewer is not aware of the underlying structures.

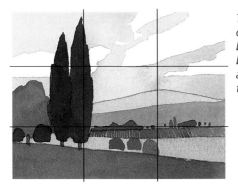

The tallest tree, one of the field boundaries and the base of the cloud all fall on the one-third grid.

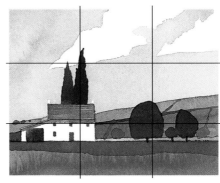

A tree falls on each vertical line, while the eaves of the house fall close to one of the horizontal lines.

The large deciduous tree falls on a vertical third, while the bases of the line of trees almost fall on a horizontal.

Both trees fall on the vertical thirds. To avoid symmetry one tree is smaller than the other. You can rearrange elements in the landscape to make them fall on your compositional grid.

Cropping

One of the decisions that you have to make is how much of the landscape to include in your picture. You can show the same view as a distant panorama or in close-up, or you can create a deep picture space that recedes from foreground through to a distant background. Each treatment has an entirely different mood.

You can crop your pictures to introduce a sense of distance. For example, if a tree is cropped by the top and bottom edges of the picture it will appear near to the viewer. If it is left uncropped it will appear to be further away.

On location you can use a viewfinder (see p. 104) to crop in to different views. In the studio place a pair of rigid card 'Ls' over sketches and photographs to see which part of the image you want to include. Sometimes a small area makes a better picture than the entire original view.

Cropping for effect

In this verdant landscape, Richard Tratt used a low viewpoint, a square format and a tight crop to create an image that is compact, quiet and intimate. The low viewpoint and close focus allow the wildflowers in the foreground to be seen in detail.

The cropped edges of these bushes enhance the enclosed feeling.

By minimising contrasts of tone and colour in the distance, the artist created a sense of the space beyond the foreground.

The grasses and flowers seen in the foreground are rendered in detail.

Composition in practise

Every aspect of this serene and simple image was carefully considered by the artist, Peter Folkes. An invisible grid provides a complex internal geometry that underpins the composition. The textured slabs of woodland fit into the pale blocks of the fields, creating an integrated and balanced pattern. This counterpointing of abstract and figurative results in an image that is ordered and full of dynamic tension.

A high horizon flattens the picture space and gives the image an enclosed feeling.

Simplifying shapes and textures focuses attention on the interlocking pattern of fields, trees and buildings.

The building is a key focal point, located at the intersection of the horizontal line of the field and the vertical line of the hedge.

The warm red of these buildings stands out, creating a colour focus.

Finding a focus

A painting needs at least one focal point; without a focus the eye wanders over the picture surface. There are many ways of directing the eye to the focal point or points. They can be placed on naturally prominent locations – near the centre of the picture or on the grid intersections, for example. A bright or contrasting colour, or a change of tone, can be used to highlight a focal point, and repeated colours or shapes can be used to draw the eye. You can also use the internal geometry of the composition: the orientation of a shadow or the diagonal of a path can be used to lead the eye round the picture.

Providing a way in

To guide the viewer into the image, use elements that break the edge of the picture – especially at the base. Rivers and paths are obvious devices, but any diagonal will do. We tend to 'read' pictures from left to right. A diagonal that comes in from the left takes the eye in, while a diagonal that comes in from the right tends to lead the eye out.

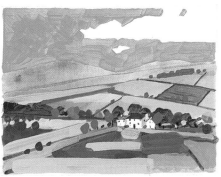

A single focus
To ensure that the eye returns to the white buildings, they are placed at the intersection of the thirds (see p. 49). The bright white contrasts with the dark tones of the surrounding landscape.

Three focal points
The strong, dark vertical of the tree in the foreground is echoed by the trees in the middle distance. They both frame and direct the gaze to the mountain peak in the background.

Lead-in from the left
The strong left-to-right diagonal of the road draws the eye up into the picture to meet the slope of the tree line. It then zigzags up to the peak and down to where the trees turn the gaze back.

Lead-in from the right
The fallen tree leads the eye from the bottom of the picture up to the trees that frame the distant peak. Note the way that the log leads the eye both into and out of the picture area.

Composing with diagonals
This vigorous watercolour study by Caroline Bailey pivots round the blocks of the white buildings at the head of the canal. The diagonals of rooflines, windows and the sides of the canal radiate from this focal point. Patches of brilliant white converge on the same point. The verticals of the windows, posts and the white bell tower provide stability.

The white bell tower stabilises and anchors the composition.

The windows provide vertical elements within the picture.

The eye is inevitably drawn to this focal point on which all the diagonals converge.

Linear perspective

Y OU CAN USE THE BASIC *principles of linear perspective to create an illusion of three-dimensional space and recession on the flat, two-dimensional surface of your sketch pad or canvas.*

To convey linear perspective you need to look carefully, draw what you see, and remember two simple guidelines: parallel lines appear to converge on the horizon and objects appear smaller in the distance. Establish the horizon line before you start to draw; this corresponds with your eye level.

Converging lines
Perspective makes parallel lines, such as avenues of trees, railway tracks and roads, look closer together in the distance so that they appear to converge at a point on the horizon – the vanishing point.

Bear in mind that perspective lines above the horizon line slant down and those below the horizon line slant up.

Changing size and shape
Perspective makes objects appear smaller the further away they are. It also distorts shapes and angles so that the façade of a house seen in perspective no longer looks like a rectangle, and circles, such as bales of hay, appear as ellipses.

Drawing by observation
To transfer the angles and slopes of perspective lines correctly, hold a pencil directly in front of you and lay it along the slope of the line. Carefully transfer that slope to the drawing. A cardboard angle frame can also be used (see p. 105).

The trees are, in reality, the same height. The second tree is drawn smaller than the first to indicate that it is further away.

The verge, which is below your eye level, slants up towards the vanishing point on the horizon.

The façade of the building is parallel to the picture plane. The rules of perspective do not apply; the angles remain as right angles.

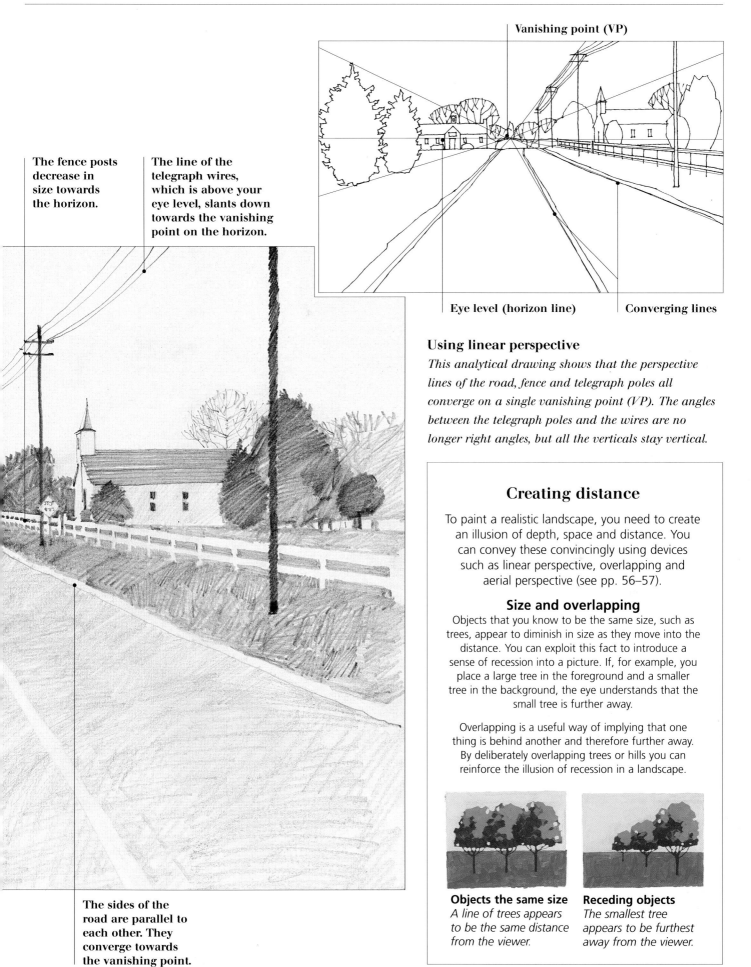

Vanishing point (VP)

The fence posts decrease in size towards the horizon.

The line of the telegraph wires, which is above your eye level, slants down towards the vanishing point on the horizon.

Eye level (horizon line)

Converging lines

The sides of the road are parallel to each other. They converge towards the vanishing point.

Using linear perspective

This analytical drawing shows that the perspective lines of the road, fence and telegraph poles all converge on a single vanishing point (VP). The angles between the telegraph poles and the wires are no longer right angles, but all the verticals stay vertical.

Creating distance

To paint a realistic landscape, you need to create an illusion of depth, space and distance. You can convey these convincingly using devices such as linear perspective, overlapping and aerial perspective (see pp. 56–57).

Size and overlapping

Objects that you know to be the same size, such as trees, appear to diminish in size as they move into the distance. You can exploit this fact to introduce a sense of recession into a picture. If, for example, you place a large tree in the foreground and a smaller tree in the background, the eye understands that the small tree is further away.

Overlapping is a useful way of implying that one thing is behind another and therefore further away. By deliberately overlapping trees or hills you can reinforce the illusion of recession in a landscape.

Objects the same size
A line of trees appears to be the same distance from the viewer.

Receding objects
The smallest tree appears to be furthest away from the viewer.

Aerial perspective

AERIAL PERSPECTIVE *is conveyed through contrasts of tone, texture and colour temperature. It is useful in naturalistic landscape paintings, especially for views with broad vistas, to create an illusion of space and recession.*

Parts of a landscape that are far away, such as distant hills, often appear bluer and less distinct than those close to you. This effect is known as aerial, or 'atmospheric', perspective. By observing the differences between near and far objects and recreating these in your landscape drawings and paintings, you can create a sense of space and distance.

These two pages show three ways of conveying aerial perspective in drawing and painting. The relative size of objects also give us important clues about spatial relationships (see 'Creating distance', p. 53).

Contrasts of colour temperature
Distant objects tend to look 'cooler' and bluer than those close to you. Foreground objects appear warmer.

Contrasts of tone
An object that is close to you in the landscape is composed of areas of light and dark tone. With distant objects the contrasts between these areas are softened and the overall tone is lighter and more uniform.

Contrasts of texture
As objects become more distant we can discern less detail and texture. This is partly due to the limitations of eyesight, but is also compounded by the effect of the intervening veil of atmosphere.

Compare these warm greens with those in the background.

Background greens are much cooler, bluer and paler.

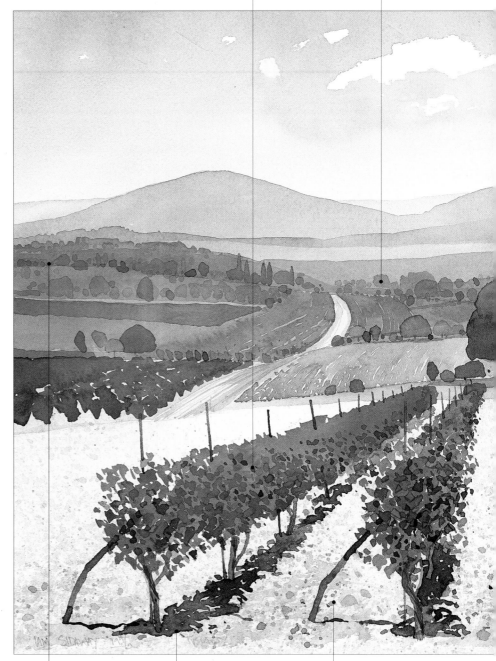

Blurring details of trees and hedges makes them appear far away.

The contrast between the dark shadows and the areas in full sun brings this area forwards.

Spattered texture suggests the gravelly soil. It is applied only in the front of the image.

The tile roof is painted in a muted terracotta red. A more intense red would be distracting and bring it too far forwards.

Blue hills in the distance and the sky appear paler as they recede towards the horizon.

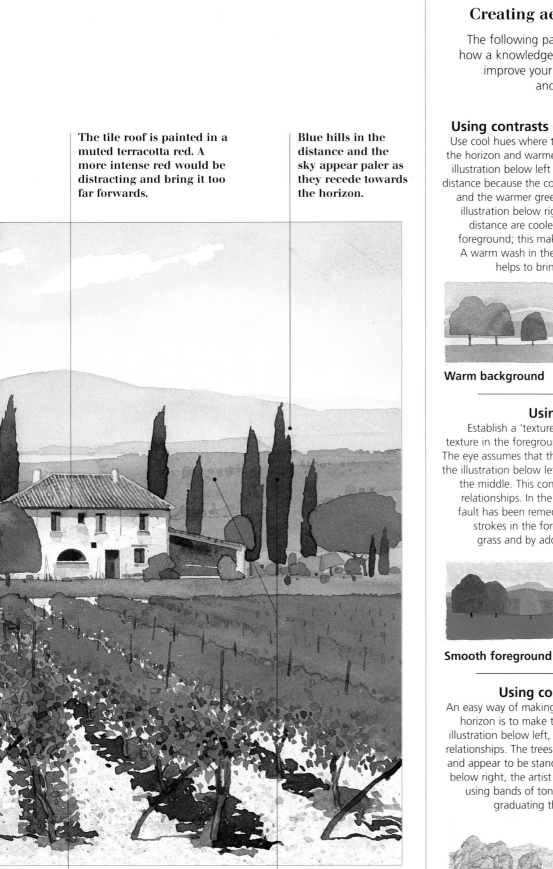

Touches of complementary red in the foliage of the vines in the foreground add warmth to this area and make it jump forwards.

Trees in the foreground are dark in tone, while those in the distance are much paler.

Creating aerial perspective

The following pairs of illustrations show how a knowledge of aerial perspective can improve your landscape drawings and paintings.

Using contrasts of colour temperature

Use cool hues where the landscape recedes towards the horizon and warmer tones in the foreground. The illustration below left fails to give any impression of distance because the coolest green is in the foreground and the warmer greens are in the distance. In the illustration below right, however, the hills in the distance are cooler, bluer and paler than the foreground; this makes them seem further away. A warm wash in the immediate foreground also helps to bring the area forwards.

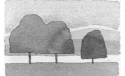
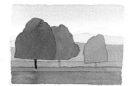

Warm background **Cool background**

Using texture

Establish a 'texture gradient' by having more texture in the foreground and less in the background. The eye assumes that the textured areas are in front. In the illustration below left, the main area of texture is in the middle. This contradicts the intended spatial relationships. In the illustration below right, the fault has been remedied by using vigorous brush strokes in the foreground to suggest thick grass and by adding foliage to the trees.

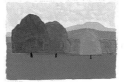

Smooth foreground **Textured foreground**

Using contrasts of tone

An easy way of making a painting recede towards the horizon is to make the distant parts paler. In the illustration below left, it is difficult to read the spatial relationships. The trees are all drawn in the same tone and appear to be standing in a row. In the illustration below right, the artist created a sense of distance by using bands of tone from dark to light and by graduating the tones of the trees.

No tonal contrast **Tonal contrast**

Space in the landscape

FLAT OR ROLLING *terrain, such as prairie or marshland, offers few obvious clues to recession. To capture the unique character of these wide, open spaces you need to exploit all the devices of linear and aerial perspective.*

If you stand on a high point, such as a hill, and look across a gently undulating landscape you can see over great distances, and the horizon appears far away. With no mountains, trees or architectural features obstructing the view, the sky becomes a large and important part of the scene. Such landscapes engender a pleasing sense of space and freedom. By exploiting the tricks of linear and aerial perspective, you can paint pictures that express these qualities.

Try to think of the landscape as a series of overlapping planes – most landscapes naturally fall into foreground, middle distance and distant bands. In the nearest plane, objects appear large and contrasts of tone and texture are at their maximum intensity. Colours are warmest and local colours are seen at their maximum saturation. As the planes recede into the distance, objects become smaller, contrasts of tone and texture become less obvious and colours become cooler and more muted. These contrasts may be subtle but by looking for, and even exaggerating, them you can create a sense of space even when there are few visual clues. If your painting appears too flat, you can add a screen of plants and foliage in the foreground.

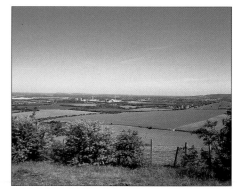

A panoramic view
In this wide-ranging view the landscape falls naturally into three horizontal bands – the bushes in the foreground, the fields in the middle distance and the distant rolling hills. By emphasising these overlapping planes you can enhance the sense of recession. The sky is a feature of panoramic landscapes. In this project the artist chose to add a cloudscape to the composition, developing the landscape around it.

You will need:
- Medium grain, primed canvas board, 760 x 510 mm (30 x 20 in)
- Oil paints:
 Alizarin crimson
 Flesh tint
 Cadmium yellow
 Lemon yellow
 Naples yellow
 Winsor green
 Indigo
 French ultramarine
 Titanium white
- No. 5 bristle brush
- Selection of painting knives

Getting started
Select those elements of the landscape that will make a pleasing composition. This may involve looking round you to find features that will enhance the composition, ignoring any that you find distracting. Here, Brian Bennett 'borrowed' a path hidden from view, and exaggerated the small tree on the right and the gentle hill on the distant plane to balance the image.

The hedge and grasses were included to define the foreground plane and provide textural interest.

By increasing the slope of this hill the artist framed the distant vista.

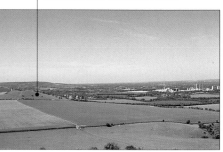

The path alongside the hedge provides a diagonal lead-in.

Making this tree bigger provided a necessary vertical emphasis.

Starting to paint

Locate the horizon approximately one-third of the way up the picture area and indicate the limits of the foreground and middle distance. By establishing these overlapping planes at an early stage you build in a sense of structure and recession.

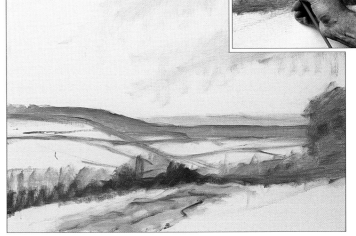

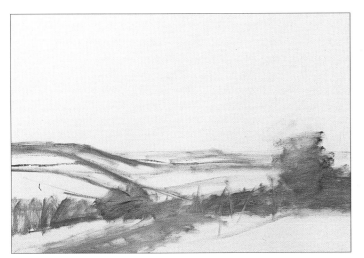

1 *Mix a cool, pale grey from titanium white and indigo. Load a no. 5 bristle brush and roughly draw in the horizon and the hill on the left. Add a little cadmium yellow to the pale grey mix for the hedge and the tree.*

2 *Mix French ultramarine with titanium white and scumble (see p. 141) colour loosely into the sky area with the no. 5 bristle brush. Add a little titanium white to indigo and scumble a darker tone along the base of the hedge. Inset: Twist and turn the no. 5 bristle brush to scrub this mix over the tree.*

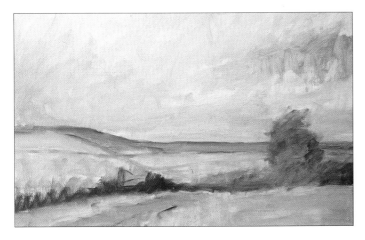

3 *Use a warm, neutral mix of Mix A (below) to scumble colour into the sky, making it darker and denser on the left. Add cadmium yellow and more titanium white to Mix A and apply this thinly over the foreground and middle distance. The warm 'advancing' yellow in the foreground contrasts with the 'receding' blue in the background.*

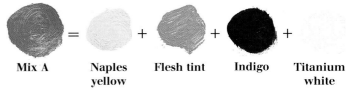

Mix A = **Naples yellow** + **Flesh tint** + **Indigo** + **Titanium white**

Developing the painting

All the elements of the composition are now in place. Change to a painting knife and start to develop the picture using paint straight from the tube or mixed with a medium (see p. 19). The sky sets the mood for the painting; here, the artist chose to build up clouds in the sky to add depth and interest.

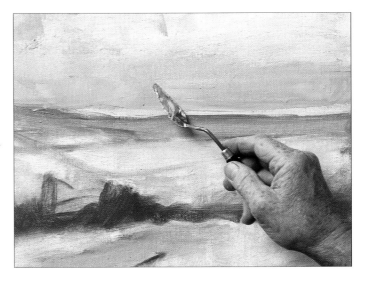

4 *Using a mix of alizarin crimson, French ultramarine and titanium white, use the flat of a painting knife to lightly spread, or skim, colour into the wet paint surface. Apply the colour on the left of the painting and just above the horizon.*

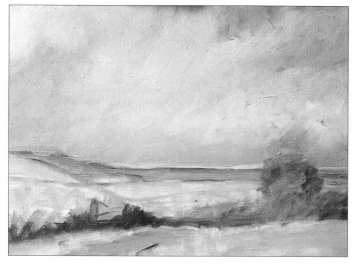

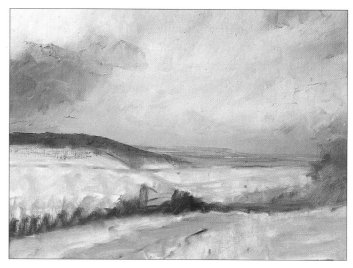

5 Block in the remainder of the image. Mix indigo, titanium white and flesh tint, and apply the mix to the clouds with the knife, working diagonally across the picture. For the blue segments of the sky on the right, mix French ultramarine, indigo and a little Winsor green.

6 Mix a pale blue from French ultramarine and titanium white and lay a swathe of colour for the land along the horizon. This helps to establish the distant transition between the sky and the land. It is important to get this right if the landscape is to recede convincingly.

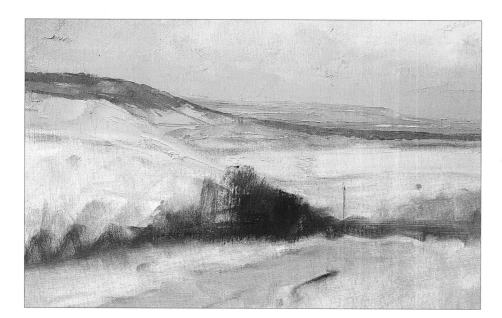

7 Working down the picture, lay in the distant landscape using the side of the knife to apply narrow bands of colour. Use a mix of indigo, flesh tint and titanium white to define the shadow on the hilly outcrop on the left. Block in the bush in the middle foreground with indigo. This dark tone sets a key for the gradation of tones into the distance.

8 Mix indigo and cadmium yellow and apply patches of colour to the hillside on the left of the picture. Vary the mix to achieve shades from pale yellow to moss green. Inset: To describe the sun shining on the landscape, lay in the pale yellow-green of Mix B (below). Use the side of the blade to stroke on slivers of paint.

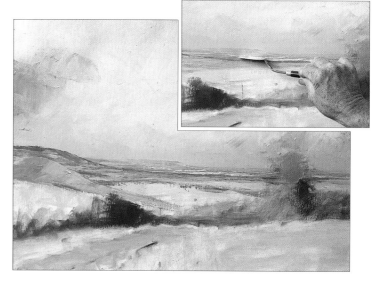

 = +

Mix B Winsor Lemon Titanium
 green yellow white

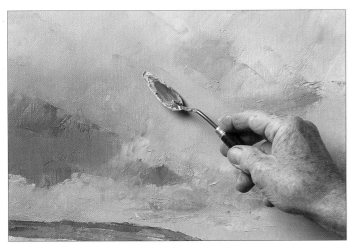

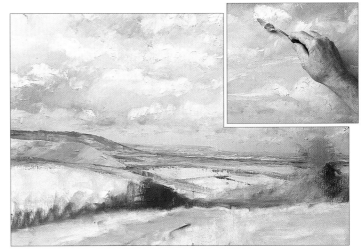

9 *It is important to keep the sky progressing in tandem with the landscape. Stand back and assess the picture. Mix French ultramarine and titanium white with a touch of indigo and develop the sky. Look for the dark areas under the clouds, and lay in swathes of the grey mix. Be bold and apply the colour with a light touch of the painting knife.*

10 *Continue to develop the three-dimensional qualities of the sky by smearing touches of white impasto (see p. 18) on to the upper margins of the clouds, where they catch the light. As you spread the paint across the wet paint on the canvas, the colours blend to create a range of greys. Inset: In some places, skim pure white paint on to the clouds.*

11 *The centre distance is a key focus of the painting. Add more detail here with broad bands of colour. Mix indigo with alizarin crimson and apply it with the side of the knife to suggest patches of woodland. Make the colours bolder than in the distance, as this reinforces the fact that they are nearer the front of the picture plane. Carefully grade the scale of the knife marks to emphasise the way the landscape moves into the background.*

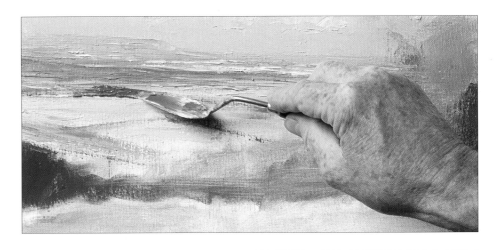

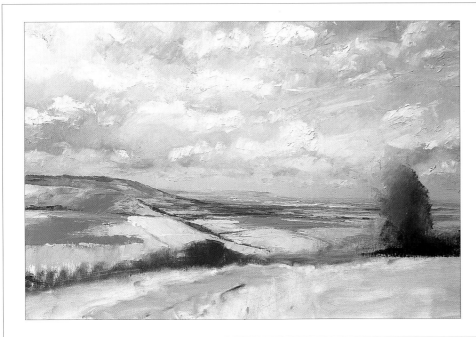

Progress report

The sky, distance and middle distance are now established and work satisfactorily with each other. Gradations of texture and tone help to create a sense of recession in the sky. The sky and land are linked by the muted shadow cast by the clouds, laid in with a mix of cadmium yellow, alizarin crimson, French ultramarine, flesh tint and titanium white applied to the hillside. The foreground is a little flat and needs to be developed to enliven the picture and create a texture gradient (see p. 55).

Finishing touches

By emphasising and even exaggerating the contrasts between size, texture and colour of the vegetation in the foreground and the landscape in the distance, you can create an illusion of three dimensions on the flat surface. The knife is an ideal tool for achieving these effects with oil paint.

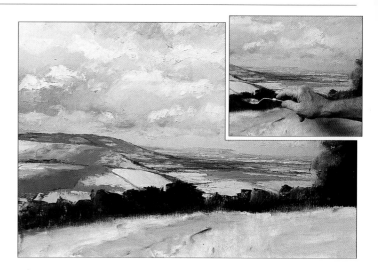

12 *Start to work up the foreground area. The hedge is a key element in the composition of the landscape; block this in with a dark green mixed from indigo and cadmium yellow. Inset: Work broadly and boldly – this paint layer will provide a base for working in the details of foliage.*

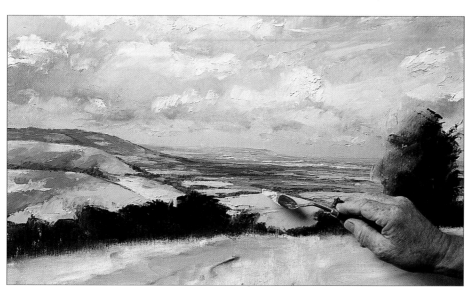

13 *To suggest shafts of sunlight on cornfields, mix Naples yellow with titanium white and lay in some broad bands of thick, creamy paint in the centre of the foreground using the flat of the knife. This patch of light colour draws the eye along the pathway and leads it up and into the picture. Use the paint to create a definite V-shaped gap in the hedge to represent a path cutting through the bushes.*

14 *Using greens mixed from various blends of indigo, lemon yellow and Naples yellow with titanium white and a touch of Winsor green, start to put in details of the small tree and the hedge. Use the side and the tip of the knife for branches and twigs, with the flat of the blade for clumps of foliage. You will find that the painting knife is a responsive and flexible tool.*

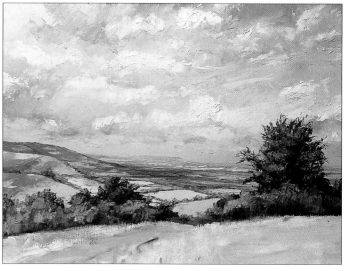

15 *Using variations of the green mixes from Step 14, lay in the entire hedge. Half-close your eyes so that you can simplify and isolate the areas of light and dark tone. Because the light comes from the sky, the areas under the tree branches and the hedge will be in shadow. Use a darker tone along the base of the hedge to give it form and anchor it to the ground plane.*

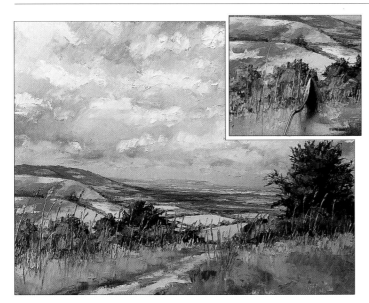

16 *The texture of grass in the foreground is an important component in the creation of a sense of space. Here the artist used warm, muted greens and dirtied yellows to suggest the dry grasses. Inset: With the side of the knife, create grassy shapes using a combination of sgraffito (see p. 141), where the knife cuts into the wet paint, and impasto.*

17 *Using pure cadmium yellow applied with the tip of the knife, touch in details of wildflowers, smearing the paint randomly to suggest that they are being seen through overlying layers of grasses, with crisp touches of paint to lead the eye in and out of the grassy area.*

The Finished Painting

Panoramic views offer a broad canvas against which to observe changes in weather and light and the effects of aerial perspective. To create a sense of space and distance within this open composition, Brian Bennett made the sky brighter overhead and muted towards the horizon and established a texture gradient between the foreground and background. The painting knife was used with delicacy and precision to create a subtly blended surface that suggests the space and airiness of open countryside.

The sky becomes muted towards the horizon, following the rules of aerial perspective.

The hedge defines the foreground plane.

The path leads the eye into the centre of the painting.

The three-dimensional cloud forms enhance the sense of distance.

The dark foliage sets up a tonal gradient into the background.

Grass and wildflowers add textural interest in the foreground.

ELEMENTS OF THE
LANDSCAPE

THIS CHAPTER LOOKS at the five main elements of the landscape: skies and clouds; light and shade; weather; water; and trees. Each topic is reduced to its basic principles and is considered as part of the landscape as a whole. Studying the components will encourage you to look at the landscape with an artist's eye. You will begin to notice the quality of light, the colour in shadows, the shape of trees, reflections and changing cloud forms.

A series of practice exercises accompanies each topic. By working through them, you will see how the basic concepts can be applied in practice and this will give you confidence when you make your own studies and observations. Once you have mastered the individual elements, you will be able to combine them in convincing compositions.

Skies and clouds

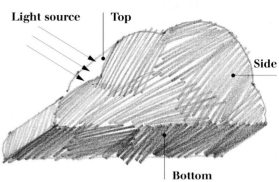

Light source | Top | Side | Bottom

FOR THE ARTIST, *the sky is the most important element in a landscape. It is the source of light and weather, which dictate colour, tone and ultimately the mood of a landscape painting.*

The sky provides the backdrop against which the other elements of the landscape are seen, changing throughout the day. In a painting the sky should enhance the landscape, but not overwhelm it. It must also relate logically to the rest of the painting. For example, if the sky is sunny and cloudless the landscape should be bright with clearly defined shadows. There are many ways to ensure that the sky and the landscape relate; laying a toned ground over the surface (see p. 141), for example, subtly modifies both the sky and the landscape, or you can use touches of sky colour in the landscape.

In a cloudless sky you need to produce subtle gradations of colour and tone. You can do this in watercolour by laying a gradated wash, or in oil by working wet paint into wet paint to create subtle blendings. However, skies of great complexity and depth can be achieved by building up layers of colour using scumbling and glazing techniques (see p. 22). You can even use a rich impasto (see p. 18).

Clouds

Clouds are formed from visible water vapour. Their myriad and constantly changing forms have always fascinated artists. In a

Cloud shape

Clouds are three-dimensional forms, with a top, side and bottom. The top faces the sun and is lighter than the side and bottom, which face away from the sun and are in their own shadow.

painting clouds provide clues to present and coming weather, add interest to the sky and are useful compositional devices (see p. 49). Their insubstantial forms contrast with the more solid elements on the ground. And it is clouds that make the pageant of sunset so endlessly fascinating, reflecting the changing colours of the sky.

Illustrating common cloud forms

It is possible to group clouds into three main types identifiable by their form, colour and height. These characteristics can be illustrated using a variety of techniques.

Cirrus
The highest of the common cloud forms, with delicate tufts and plumes that sometimes appear to converge on the horizon. Include these insubstantial clouds in sunny landscapes. Use subtle painting techniques, such as blending, smearing, scumbling (see p. 141) or drybrushing.

Stratus
The lowest of all the clouds. These have a ragged grey appearance and vary in thickness. Stratus are sometimes associated with rain or light drizzle. Use coloured neutrals (see p. 35) to create passages of subtlety by careful blending and hatching, or working wet into wet in watercolour (see p. 14).

Cumulus
These clouds form conical heaps with broad, flat bases generally in shadow – render these in a dark tone. The tops are often brilliant white – render with solid white highlights or impasto. In watercolour, leave patches of white paper showing through a wash or take out colour with a sponge.

Linking sky and landscape

In this study by David Curtis, the sky occupies the greater .part of the picture space. While the landscape is quite detailed, the sky is broadly and sketchily rendered. The artist used colour to tie the two elements together. A warm neutral ground underlies the two areas and the ochres, pinks and green-blues of the landscape are reflected in the sky, so that sky and land create a satisfying and harmonious whole.

Cerulean blue mixed with white is scumbled over a warm, ochre ground to create a sense of looking through layers of atmosphere.

Clouds are blocked in with thicker paint in a smeared impasto.

A band of a warm neutral tone creates a hazy effect that pushes the horizon into the background.

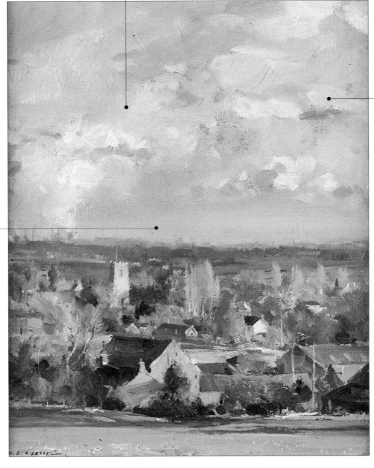

John Constable's cloud studies

The great landscape painter John Constable (1776–1837) declared in a letter written in 1821 that 'The landscape painter who does not make his skies a very material part of his composition neglects to avail himself of one of his greatest aids'. In the years 1821 and 1822 he spent a lot of time 'skying' – making rapid oil sketches on paper, working directly from the subject.

John Constable, 'Study of clouds' (c. 1822).
In this large study, Constable recorded the frothy cumulus clouds that bubble up in blue summer skies. According to the inscription on the back, this study was made on '31st Sep'r 10–11 o'clock morning, looking Eastward, a gentle wind to the East'. Take a tip from Constable's working methods and make a note of the date, time and weather conditions on your sketches – they will be extremely useful when you are trying to reconstruct particular conditions in your own paintings and drawings.

Creating depth and recession in the sky

It is all too easy to make your sky look like a solid blue wall across the back of the painting. You can suggest the luminosity and depth of the sky by building up a series of transparent and semi-transparent layers, by using broken colour techniques (see p. 31), or by creating carefully controlled gradations of colour and tone using wet-into-wet methods or blending.

The devices of aerial perspective (see pp. 54–55) can be exploited to enhance the sense of recession, making the sky paler and cooler as it approaches the horizon, and making it darker and more saturated in colour overhead.

Composing the sky

The most important compositional decision in any landscape painting or drawing is the position of the horizon line. A high horizon with little sky produces a contained and intimate landscape – keep it simple and avoid including complicated cloud shapes. When the horizon is low the sky takes up a large proportion of the picture area, allowing more dramatic effects.

Clouds can be edited and selected to create a sense of recession, to achieve a balanced composition or to lead the eye into and over the picture surface. Make adjustments to those that don't enhance the composition. Try to avoid symmetrical arrangements and vary their size and shape.

Composing with clouds
Here, the mass of clouds on the right of the picture area balances the land mass on the left. Note that the long cloud is cropped by the edge of the picture, implying that the sky continues beyond the picture area.

Creating a spacious sky
The rules of linear and aerial perspective (see pp. 52–55) apply to the sky. If your sky looks flat, you can adjust the tone, texture and colour temperature gradients to create a sense of space.

Gradated and blended tones
The sky tends to become lighter at the horizon. In watercolour this effect is created with a graded wash; in oil it is achieved by blending carefully graded tones.

Scale and recession
By overlapping cloud shapes and making the clouds in the foreground bigger than those in the distance, you can suggest that the clouds are moving away into the distance.

Using clouds to add drama
In David Carr's study of summer clouds, the sweeping, piled-up forms of the clouds and the artist's swirling brushmarks suggest the wind and movement of a blustery day.

Dark tones built up from transparent scumbles and glazes capture the lightness of the cloud forms.

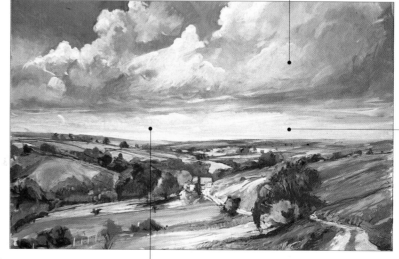

The pale horizon contrasts with the bright blue overhead.

Touches of encrusted impasto capture the brightness of the sunlit clouds, adding texture in the foreground.

The colour of the sky

The sky is brightest and whitest close to the sun, and darkest and bluest at an angle of 90 degrees from the sun. It is generally paler at the horizon and darkest blue immediately overhead. It is at its deepest blue between showers of rain, while, surprisingly, on a beautiful summer's day it is often paler. Check your assumptions about what the sky colour should be – hold up a patch of blue paint or a coloured chalk to help you judge the intensity of colour.

Sunrise, sunset and rainbows provide colourful spectacles. These effects can be recreated with techniques that allow you to describe these subtle and gradual transitions, such as blending and wet into wet techniques.

How sky colour is created

Sunlight is white and travels in invisible waves but it is composed of all the colours of the spectrum: red, orange, yellow, green, blue, indigo, and violet. Each spectrum colour has a different wavelength; red and orange have the longest, while blue and indigo have the shortest.

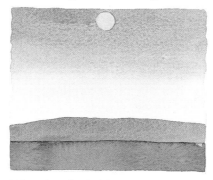 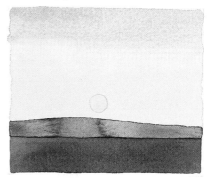

Why the sky is blue
When the sun is high in the sky, light has its shortest journey through the atmosphere and only the shortest light waves (violet, indigo, blue and green) are scattered, creating a blue sky.

Why the sky is red
With the sun low in the sky, light has a longer journey through the atmosphere. The light waves with the longest wavelengths (yellow, orange and red) are scattered in the lower layers of the atmosphere, creating fiery red sunsets.

The sky at sunset

In this dramatic study of the setting sun, Robert Tilling exploited the transparency of watercolour to create a subtly graded sky. He worked in a spontaneous way, laying down variegated and gradated washes, and allowing the pigments to bleed, run, feather and flow.

At sunset the sky is filled with rich, dramatic colours that flow almost imperceptibly into one another.

The bold crisp bulk of the headland was laid on wet on dry. The dark backlit land enhances the brilliance of the sky.

Orange and red washes laid under the sea area capture the sun's reflection.

Practice exercise: Early evening sky

The colour, the pattern of clouds and the quality of the light in the sky at sunset are mesmerising. In this exercise a sunset has been reduced to six simple steps. The drama comes from the contrast between the graphic pattern of the dark, backlit clouds and the transparent bands of purple, green and lemon that stain the sky. Note, in particular, the way a band of dark colour at the bottom of the picture reads as the land and gives the image a sense of space and dimension.

Tip

- Make the cloud forms smaller as they approach the horizon. This helps to create a sense of recession.

You will need:
- Oil sketching paper, 405 x 510 mm (16 x 20 in)
- Oil paints:
 - Phthalo blue
 - Cerulean blue
 - Yellow ochre
 - Chrome yellow
 - Cadmium orange
 - Raw umber
 - Purple madder alizarin
 - Payne's grey
 - Titanium white
- Brushes:
 - No. 4 bristle brush
 - No. 8 bristle brush
 - 25-mm (1-in) flat soft brush
 - 25-mm (1-in) flat bristle brush
- Turpentine
- White spirit

1 *Block in the main areas of the sky using warm and cool versions of Mix A (below). Be bold and work briskly, using a no. 8 bristle brush to create the funnel of dark, backlit clouds. Add phthalo blue to Mix A to 'blue' the sky as it approaches the horizon.*

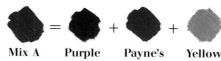

Mix A = Purple madder alizarin + Payne's grey + Yellow ochre

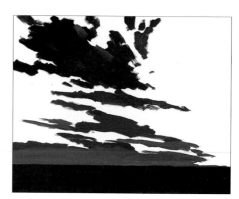

2 *Use a mix of Payne's grey and raw umber to block in the strip of land at the bottom of the picture area – immediately the image begins to make sense as a study of land and sky.*

3 *The setting sun throws an orange rimlight around the clouds. Lay this in with a small no. 4 bristle brush loaded with cadmium orange and skim in streaks of orange along the underside of the most distant clouds (see inset).*

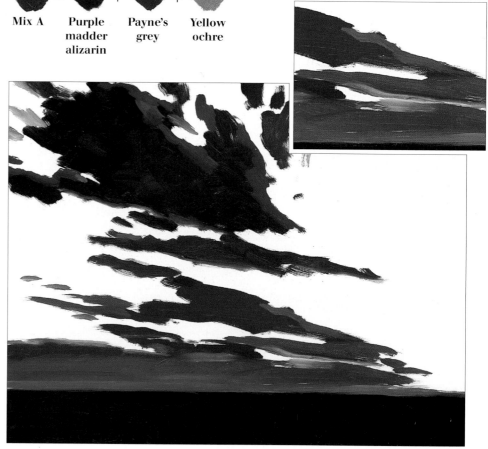

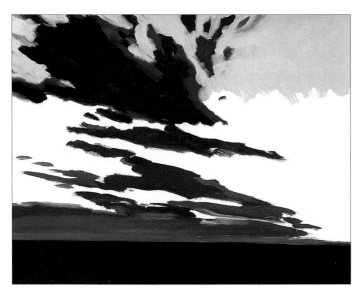

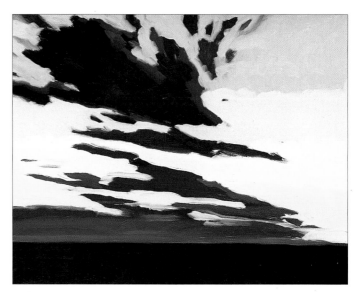

4 *The sky at its zenith is flushed with a pinkish violet. Lay this in with a 25-mm (1-in) flat bristle brush, using Mix B (below). Scrub the colour on, taking it round the dark clouds. Scumble over the dark colour in some areas to soften edges.*

 = + +

Mix B **Purple madder alizarin** **Cerulean blue** **Titanium white**

5 *Below the purple the sky grades from a pale green into a darker lemon at the horizon. Apply these bands of colour loosely so that they delicately tint the canvas, blending them at their margins. Add chrome yellow, and more cerulean blue and titanium white to Mix B (see Step 4) to produce the green. Mix the pale yellow from lots of white with a touch of chrome yellow, and add more yellow for the sharper lemon near the horizon.*

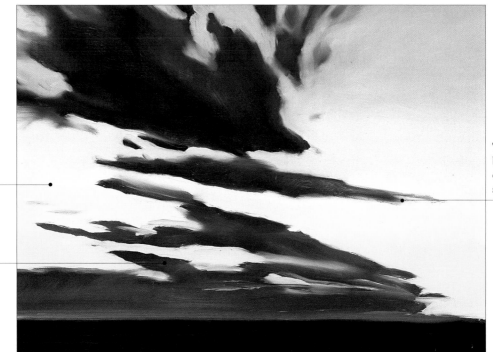

Bands of graded colour show the effect of the setting sun.

Small clouds give a sense of perspective and recession.

Tinted edges of backlit clouds enhance the sense of light.

6 *Clouds are constantly shifting, moving and changing shape. You will create a more convincing effect if you vary the edges; as oil stays 'open' and workable for so long, it is easy to achieve this softening of forms. Use the 25-mm (1-in) flat soft brush to soften and blend the joins between the dark clouds and the sky. Hold the brush loosely and brush it gently back and forth across the top of the paint film.*

A simple band of colour reads as the land.

Practice exercise: Cumulus cloud study

In this exercise watercolour is used to build up a sky of billowing cumulus clouds. The technique is easy if you remember that with watercolour your lightest tone is the white of the surface and darker tones are built up from transparent washes, the lightest ones applied first and the darkest last. Here, the white of the clouds is the paper, while the various greys of their shaded side are created by laying three applications of the same wash, each more intense than the previous one.

You will need:

- Watercolour paper (NOT), 410 gsm (200 lb), 280 x 380 mm (11 x 15 in)
- Watercolour paints:
 Cobalt blue
 Cerulean blue
 Payne's grey
 Yellow ochre
 Sap green
 Sepia
- Brushes:
 No. 12 round brush
 No. 6 round brush
- Tissue paper

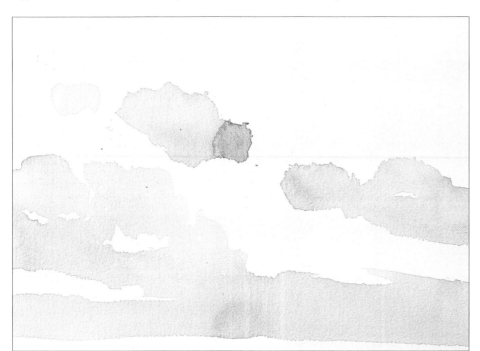

Tip

- To suggest recession and scale when painting clouds, remember to make the clouds in the foreground appear larger than those in the distant sky.

1 *Place the drawing board so that it is slightly tilted. Mix a large amount of Mix A (below), load a no. 12 round brush and roll it across the paper, laying down patches of colour that become the dark underside of cumulus clouds. The wash will run down and accumulate on the bottom edge of each area of wash; allow this to dry naturally to create defined edges.*

Mix A **Payne's grey** **Yellow ochre**

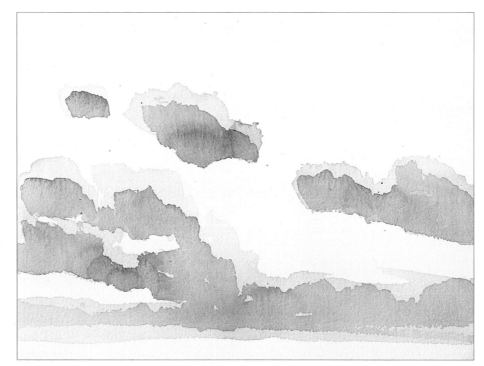

2 *Develop the dark tones on the underside of the clouds by applying another layer of wash. Add more paint to Mix A (see Step 1) to create a more intense wash and apply it with a no. 6 round brush. Allow to dry naturally.*

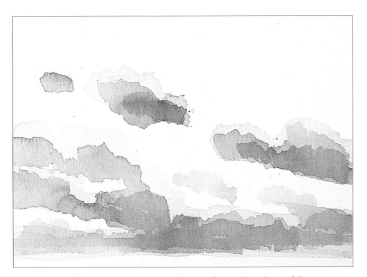

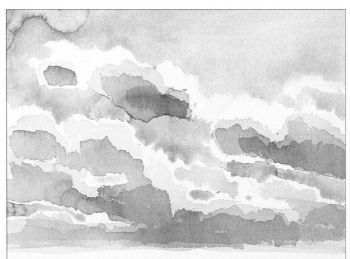

3 *Repeat Step 2, darkening the wash further by adding more Payne's grey and yellow ochre, and rolling the colour on to the dry surface. Allow to dry. A third wash gives the clouds a convincingly three-dimensional form.*

4 *Define the lightest areas by laying in the blue of the sky showing between the clouds – this will 'draw' the outlines of the clouds. Load a no. 12 brush with Mix B (below) and lay a loose wash, pushing the colour over the paper and leaving the white of the paper to stand for the white tops of the clouds. Blot the wet wash with tissue in places to create softer edges.*

Mix B = Cobalt blue + Cerulean blue

The three washes of greys give 'solidity' to the cloud shapes.

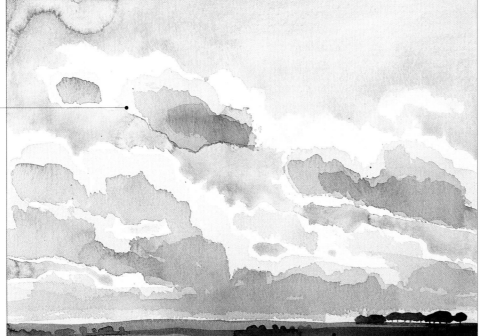

5 *At this stage the painting reads as a convincing rendering of clouds scudding across the sky on a breezy day. Lay in a band of colour mixed from sap green and sepia to stand for the landscape and the illusion will be complete. When the band is dry, add silhouettes of trees, bushes and hedges with a darker version of the wash.*

Cloud shadows on the land were laid on simply as blocks of colour.

71

Weather conditions

FOR THE LANDSCAPE PAINTER *there is no such thing as 'bad weather', because the changes caused by sun, rain, fog, wind and snow provide endless variations of mood. They are also an ever-changing source of inspiration.*

Each type of weather has its own magic. On a misty autumn day the landscape is drained of colour, details become indistinct and tonal contrasts are evened out.

On a crisp winter's day low sun turns trees into skeletal silhouettes and throws long, dark shadows. Snow makes the land much brighter in tone than the sky – a reversal of the usual effect. Painting the same landscape under different conditions produces pictures that are entirely different in colour, composition and mood.

Sketching weather

The effects of the weather on the landscape are often transitory, so you need to work quickly. Choose quick ways to express the character of different weather conditions – smearing soft pencil and charcoal to suggest the blurring effects of rain and mist on the landscape, for example. With watercolour you can work on several studies at once.

Snowy weather

In this oil study Timothy Easton conjured up a chilly winter scene by playing cool colours against warm. On a warm ground of raw sienna mixed with a little sap green, he added trees and leafless vegetation using warm earth colours, such as burnt sienna. The snow was laid in with titanium white mixed with cobalt blue, a range of cool greys and occasional touches of pure white so that the picture shimmers with a cold, pearly light.

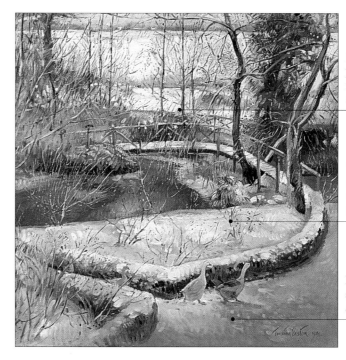

Dabs and dashes of paint create an impression of light sparkling on snow.

Touches of pink and ochre add a vibrant contrast to the cool scene.

Pale blue shadows create a cold feeling.

The effects of weather

Weather can change the appearance of the landscape dramatically. Observe those effects that are peculiar to the particular weather conditions. For example, the visual clues to rainy weather include wet reflective surfaces and dark clouds. Make sketches and annotate them with notes about colour, wind direction and time of day.

Rain
Showers can be localised, with dark clouds and rain in one part of the landscape and blue sky in another.

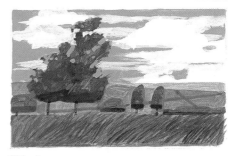

Wind
Wind is seen through its effect on moveable objects, such as trees, foliage and corn or long grass.

Rainy weather

By identifying and focusing on the key aspects of the weather, Peter Folkes captured the effect of squally showers with great economy. The bright, colourful landscape was crisply rendered with drybrushed details, and for the slanting rain the artist used streaked and smeared diagonal washes, applied wet into wet with a large brush.

Wet watercolour dragged down with a large brush suggests heavy, slanting rain.

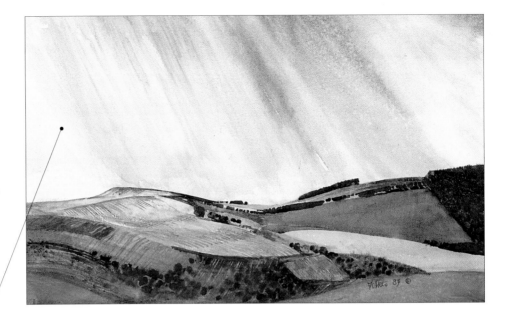

Tiny dots of bright red stand out against the predominant blues.

The white of the paper shines through glazes of colour so that the image appears to be illuminated from within.

Stormy weather

Here, Caroline Bailey exploited the blending, blurring and bleeding qualities of wet watercolour to capture the drama of a tumultuous sea. Touches of crisp, wet-on-dry paint pull the picture into focus, creating an expressive image.

'Accidental' bleeding and blending of wet-into-wet watercolour captures the energy and excitement of a stormy sea.

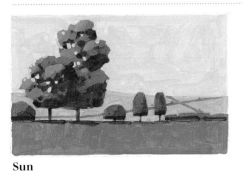

Sun
Sunshine is associated with intense, bright colours and strong contrasts of light and shade in the landscape.

Snow
Snow changes the landscape dramatically, softening contours and masking detail.

Fog and mist
Fog and mist obscure contrasts of colour and tone. Sunlight filtered through mist produces a soft, luminous light.

Practice exercise: Snow scene

Snow transforms the landscape more than any other manifestation of the weather. It masks untidiness, softens edges and casts an unearthly light that can transform a mundane tract of countryside into an inspirational scene. Snowscapes are a popular subject, so it is worth mastering the art of depicting snow in both wet and dry media. If you work through this exercise, and study the project on pp. 128–133, you will find that rendering snow convincingly is easier than you think.

You will need:
- Acrylic paper, 405 x 255 mm (16 x 10 in)
- Acrylic paints:
 Cerulean blue
 Payne's grey
 Cobalt green light
 Raw umber
 Cadmium yellow
 Titanium white
- 2B pencil
- Brushes:
 25-mm (1-in) flat soft brush
 3-mm (⅛-in) flat soft brush
 No. 4 flat bristle brush

1 *Start by making an outline drawing of this simple scene with a few trees, using a 2B pencil. Concentrate on the shapes of the trees, both individually and as a group (see pp. 94–97). Remember that the pencil outline will need to be visible when you lay in the underpainting, so apply it firmly.*

2 *Block in the sky with Mix A (below) and a 25-mm (1-in) flat soft brush. Change direction to achieve an even coverage. Loosely scumble on a medium tone for the middle distance using a mix of raw umber and white. The white paper modifies the applied colour.*

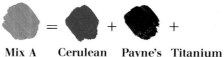

Mix A = Cerulean blue + Payne's grey + Titanium white

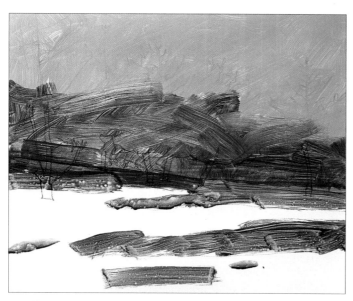

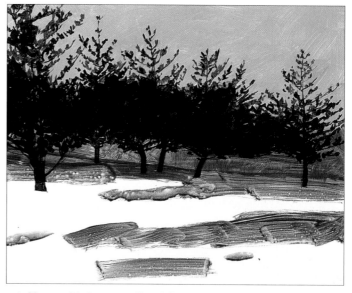

3 *The patches of grass showing through where the snow has melted add colour to the scene and, surprisingly, tell the viewer that the white surface is snow. Lay them in with sweeping strokes of a mix of cobalt green light, cadmium yellow and raw umber.*

4 *Next, add the trees. Carefully draw the skeleton of the tree branches seen against the sky using a mix of cobalt green light, Payne's grey and raw umber and a 3-mm (⅛-in) flat soft brush. Then loosely build up the foliage in the centre of the trees with dabs of paint to describe the clusters of needles.*

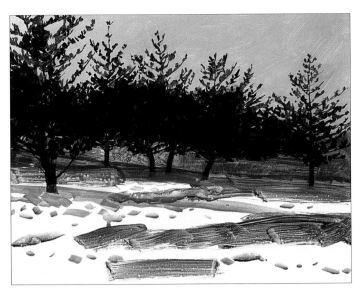

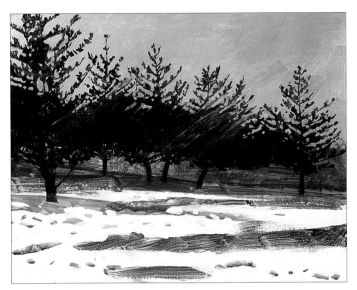

5 *In daylight, shadows on snow look blue. Acrylic paint thinned with water is an excellent glazing medium (see p. 22). Lay a glaze of cerulean blue with a little titanium white over the grassy area under the trees and on to the snow to describe cold shadows. Small patches of thinned cerulean blue give form to the hummocky surface of the snow.*

6 *Mix cerulean blue and white and use the 3-mm (⅛-in) flat soft brush to apply another layer of colour to the sky and to cut back into the trees, refining the silhouettes. Pull the sky colour across the trees using a dry brush to suggest a flurry of snow. Develop the paint layer in the snowy foreground, using white with a touch of blue to put in dabs of colour.*

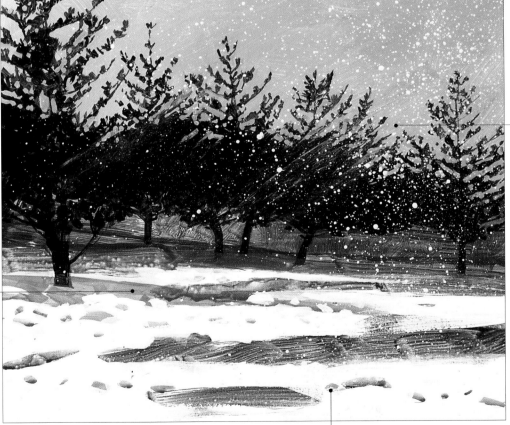

Flurries of snow are created by flicking white paint across the paper and pulling the sky colour through the trees.

A thin glaze of paint suggests the cold shadows beneath the trees.

Dabs of blue give form to the hummocks of snow in the foreground.

7 *The final step is to create the flurries of snowflakes – this looks difficult but is achieved easily with a flick of the wrist. Load a soft brush with thinned white paint and flick it over the surface. Alternatively, you can load a no. 4 flat bristle brush, hold it over the canvas and run your thumb across the tips of the bristles to create spatters of paint.*

Practice exercise: Storm and showers

Weather conditions can alter the appearance of a landscape and the mood of a painting or drawing. In this study, a coastal scene is given a dramatic edge by brooding storm clouds and scurrying showers. The bright skies beyond the storm give the drawing an eerie quality. Layers of densely applied charcoal capture the inky blackness of the thunderous clouds, while subtle blendings and streaked effects convey the lashing rain. Work through this exercise and then try to achieve the same effects using coloured media.

You will need:
- Cartridge paper, 418 x 595 mm (16½ x 23½ in)
- Willow charcoal (various thicknesses)
- Soft putty rubber
- Aerosol fixative spray

1 The landscape provides an essential backdrop for the drama of the elements of wind and rain. Start by making a simple outline drawing of the basic structures of the landscape using a thin stick of willow charcoal.

2 Lay in blocks of tone, using the side of a thin charcoal stick for large areas. Use the tip of the stick to create areas of detailed darker tone. Treat the sea loosely, using sideways marks made with the side of a piece of charcoal to indicate the lines of turbulent breakers.

3 The sky is a key element in developing the stormy mood of the drawing. Block it in, but don't develop any solid blacks at this stage. Use the side of a piece of charcoal to scumble in a dark tone for the sky. The sea takes its colour and tone from the sky, so develop the two elements in tandem.

Tip
- One of the best features of charcoal is the way in which you can manipulate it to create a range of blended and smeared effects. A soft putty rubber is used in this exercise (see Step 4), but you could also practise using a paper stump or your finger, and record the results for use in different projects.

4 *Develop the dark and medium tones across the entire picture surface. Darken the clifftop, varying the direction of your strokes. Scumble on a very light tone to suggest the texture of the rock. Using the tip of a thin stick of charcoal, draw the parallel lines of the strata on the exposed rockface. Build up a charcoal layer in the sky. Lay the edge of a putty rubber in the powdery film of charcoal in the clouds and pull it down the paper to create the effect of slanting rain.*

The white of the paper indicates the bright skies behind the storm clouds.

Dark tones were added to the clifftops where the storm clouds cast dark shadows.

The effect of slanting rain is created by 'pulling' loose charcoal down the paper with a putty rubber.

A soft putty rubber was used to dab and dash the crests of the waves to create the effect of flying foam and froth.

5 *Fix the image at this stage with aerosol fixative spray. You can then add more charcoal and build up intense, dark tones. Lay on a thick layer of charcoal for the storm clouds and darker tones on the clifftops where the clouds cast shadows. Work over the waves: dabbing, dashing, streaking and dotting the charcoal to suggest the churning waters.*

A touch of dark tone under the natural arch gives it more form and draws the eye into the picture.

77

Light and shade

THE PLAY OF LIGHT *across the contours of the landscape is a popular subject for landscape paintings. The colour, direction and strength of the light determine the appearance and mood of a scene.*

The landscape can be compared to a screen on to which light is projected. The character of the light is affected by many, and widely differing, factors.

You can set the mood of a painting and establish the quality of the light by choosing an appropriate colour for the painting surface. If you want to paint a chilly, winter's day you could select a cool grey or blue, or use a tone to set the mood. For a warm summer's evening you could select a warm yellow or pink, or tone it with a golden colour, such as raw sienna.

The character of light

There are two important aspects to light – intensity and luminosity – one of which usually predominates. You can capture the intensity of direct light in a landscape painting by recording or even exaggerating contrasts of tone, and by making the transitions between areas of light and dark appear crisp. In order to capture luminosity in your paintings, make the transitions between one tone and another as imperceptible as possible.

It is good practice to make a quick tonal study of a scene before you start drawing or painting. This allows you to see where the light is coming from and to judge whether the underlying pattern of light and dark will make a good composition (see pp. 48–51).

Using broken colour to paint light

Broken colour techniques are particularly effective for capturing the luminosity of light. Here, Derek Daniells used small touches of pure, unblended pastel to create the shimmering quality of bright sunlight.

Touches of warm colour stand out against the predominant cool tones, making the bright areas appear even more vibrant.

Blue stroked on to the 'laid' texture of the Ingres paper creates a ribbed texture through which the grey of the surface shows, creating a lively, broken effect.

Rendering tone

This tonal version of the landscape gives a great deal of information about the intensity and direction of the light. The sun is on the right and high in the sky, and the shadow cast by the standing corn is short.

Rendering tones in colour

This colour landscape conveys the same information about direction and intensity of light, but the soft blue of the sky, the warm green of the sunlit grass and the bright yellow and golds of the corn create a sunnier impression.

Shadows and shade

Shadow is an important compositional element in all landscape painting. The horizontal cast shadows of vertical objects can create compositional balance. Attached shadows – those that project from under a tree, for example – anchor an object to the surface on which it sits.

In natural light the appearance of shadows is dictated by the intensity and direction of the sunlight, by the nature of the object casting the shadow and by the amount of light being reflected back from surrounding areas. When the light is intense, shadows look dark and clearly defined, light areas are very light and the transition from one to another is sharp. When light is filtered through clouds or haze, shadows have softer, less defined edges and there is less of an effect of sharp contrast.

Shade is the dark area on the side of an opaque object that is away from the source of illumination. For example, a tree illuminated by the evening light is light on the side that is turned to the sun and darker on the other side.

The colour of shadows

Because light is reflected from other surfaces, shadows are full of reflected colour. There may be some blue reflected from the sky as well as touches of adjacent areas of local colour. Shadows usually contain some of the complementary colour (see p. 34) of the object casting the shadow, so the shadow of a green tree contains touches of red. Light and shadow change the appearance of local colour. A green tree seen close in full sunlight looks different from the same tree observed in shadow, under an overcast sky, or at twilight.

Unnatural shadows
In natural light, rendering shadows as solid, black masses looks unnatural and harsh.

Reflected colour in shadows
Study shadows carefully, and you will find traces of colour reflected from adjacent objects.

Composing with shadows

In this striking etching, Melvyn Petterson made the shadows more important than the clump of conifers that are beyond the picture space on the left. The sun was behind the artist and cast emphatic shadows on to the rising ground. By focusing on the shadows he created an image that is both a literal interpretation of the scene and an abstract pattern.

The contrast between the patches of sunlight and the shadow enhances the brilliance of the sunshine.

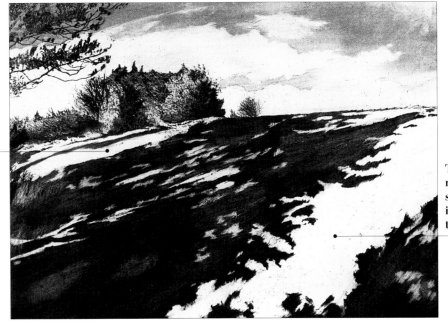

The crisply defined negatives of the sunlit areas become important shapes in the composition.

Changing light effects

The amount and character of the light in the landscape are affected by factors such as the time of day (see below), the season and weather conditions. When you are painting in the landscape, the light can change rapidly. There are several ways of dealing with this.

Start by making quick sketches in which you note, in particular, the direction of the light and the main distributions of light and dark tones. Make notes on colour, either in a coloured medium or with descriptive annotation, and take a number of photographs to use as supplementary information.

If you work quickly and confidently, you can sometimes complete a picture before the light changes. Acrylic is good for quick studies and on a sunny day watercolour dries rapidly. With oil you can work fast 'alla prima' (see pp. 114–117). With practice you will be able to remember the salient features of the scene, so that even if the light does change slightly you will be able to create an image that makes sense.

Establish the areas of light and shadow early on in the painting, then make the rest of the painting work round them. It is important that you study the scene intently, so that you can remember how the light affected colour and tone. The light, shadows and colours in the picture must be consistent.

Colour temperature

Colour temperature is important in conveying the quality of light. An object bathed in sunlight will appear warmer than the same object in shadow. For example, if you are painting a tree, mix a warm green for the areas in full sunlight and a cooler green for those areas that are in shadow (see p. 30).

Creating evening light

Here, artist Trevor Chamberlain captured the warm light of a summer evening. The corn bathed in sunlight was rendered with warm, creamy tones. For the shadows he used thinned paint, dragged across the surface so that the underlying paint layers modify the colour, creating a broken effect that gives them depth and luminosity.

The reddish shadows on the tree trunk are complementary to the greens of the foliage above.

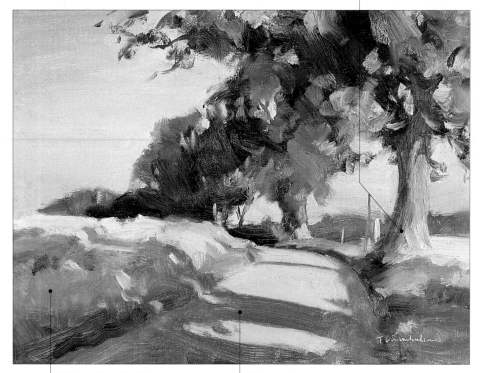

Where the shadow falls across the corn, the warm yellow light reflected back into the shadow warms it, creating a purple tone.

The stark contrast between the path bathed in sunlight and the dark shadow enhances the sense of bright light.

Time of day

Because sunlight can be warm or cool, you can paint the same subject at different times of day and achieve very contrasting effects. Morning light and winter light are cooler than the light at noon or in summer. An alternative system is to work on a painting only when the light conditions are the same – but this might mean taking a long time to complete the work.

Dawn
Even on a bright day, morning light is relatively cool. The sun casts long shadows that become shorter as it rises in the sky. Use cool colours, such as lemon yellow, French ultramarine and Prussian blue.

Creating diffuse winter light

*Here, Brian Bennett used a limited high-key palette of cool, pale
greys to describe a freezing mist that casts a veil over the
landscape. In a low-key painting the colours are predominantly
dark in tone, as in twilight or overcast conditions.*

**Carefully controlled and subtle
gradations of tone capture the
luminosity of the pale, mist-
shrouded sun.**

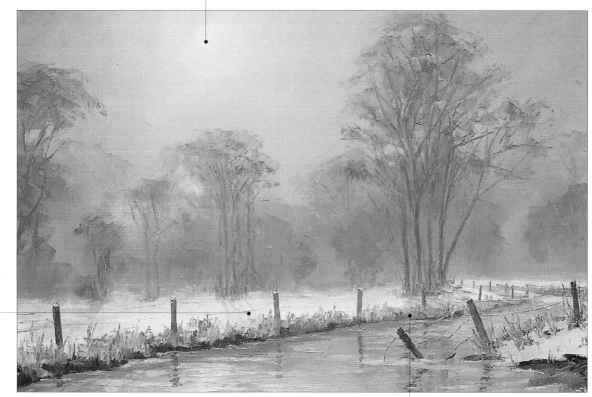

**Shadows are
pale in tone
and diffuse,
reinforcing the
impression of
weak sunlight.**

**The earth banks of the river
showing through the snow
and ice appear relatively
warm. Note the way the
contrast of colour
temperature pulls this area
forward in the picture plane.**

Noon

*At noon the sun reaches its highest point. In
summer it is almost directly overhead and
the landscape is virtually devoid of shadow;
attached shadows are cast only directly
under projecting objects.*

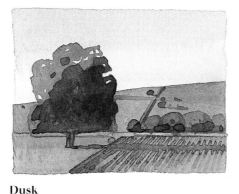

Dusk

*The setting sun casts long shadows, but these
lie in the opposite direction to those seen in
the morning. The setting sun stains the sky
red and orange and casts a warm light over
the landscape.*

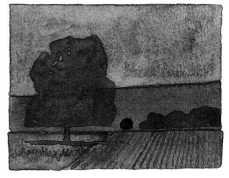

Night

*On a clear night, stars and a full moon
provide a low level of lighting. Areas not
fully illuminated by the light of the moon are
almost uniformly dark. The landscape seen
by moonlight is blue or green-blue.*

Practice exercise: Light in monochrome

This exercise, based on the intense light found in hot, sun-drenched regions, shows just how easy it is to depict light in a monochrome study. To increase the sense of sunlight, exaggerate the contrast between the areas of light and dark and make the transitions between shadows and sunlight definite. When using a monochrome medium, it is important to get the tonal values right. Start with the lightest areas and work towards the darkest areas, making the tones slightly lighter than you think they should be – it is easier to darken an area than to lighten it.

You will need:
- Cartridge paper, 305 x 405 mm (12 x 16 in)
- Graphite sticks:
 HB
 2B
 4B

1 Start by laying a pale tone on the façade of the building. Use an HB graphite stick, gripping it high up and rotating from the wrist to produce a loose but evenly scribbled tone. Make the hatching follow the structure of the building. Angle the hatched lines around the cylinder. Leave the paper white for the white clouds and the sunlight falling on the building.

2 The next darkest area of tone is the courtyard, followed by the sky, so work over these areas with the HB graphite stick. Use scribbled cross-hatching to lay in a medium tone for the courtyard. Develop the sky with denser cross-hatching to create a tone darker than that of the courtyard. Continue to assess the tonal values of different parts of the picture.

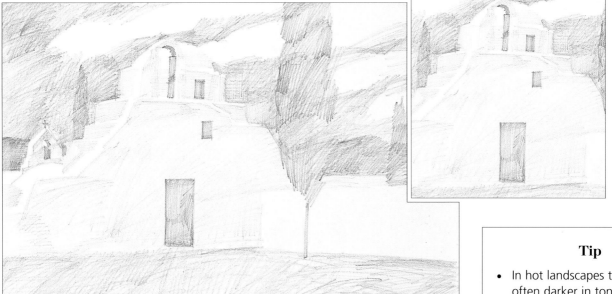

3 Block in the darkest tones, building them up gradually with the HB graphite stick (right). Develop the hills with a medium tone. Block in the trees using hatching that follows the way the branches grow. The door set into the wall is in shadow – the depth of tone indicates the amount of shadow (see inset). Don't make it too dark at this stage.

Tones from an HB graphite stick

Tip

- In hot landscapes the sky is often darker in tone than the land. If you find it difficult to judge the relative tone of the sky and the land, hold up a piece of white paper so that you can compare all three at the same time.

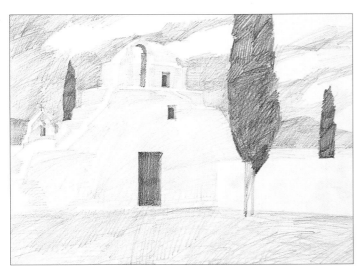

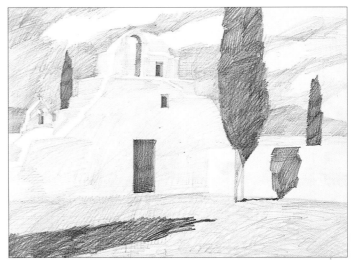

4 *Build up the dark tones on the trees and in the apertures set into the building. Hatch over the door with a 2B graphite stick (right). Develop the dark tone on the cypress tree, following the way the branches fold round the trunk. Indicate shadow and texture on the tree trunk with a few scribbled lines.*

Tones from a 2B graphite stick

5 *Cast shadows provide an important clue to the direction and intensity of the sun. Use a sharp 2B graphite stick to block in the shape of the shadow of a tree outside the picture on the left, and the shadow cast on to the wall by the tree on the right. Note the way the shadow follows and reveals the changes in direction of the planes over which it passes. The intensity of the shadow cast on the wall and the definition of its outline give a clue to the brightness of the day.*

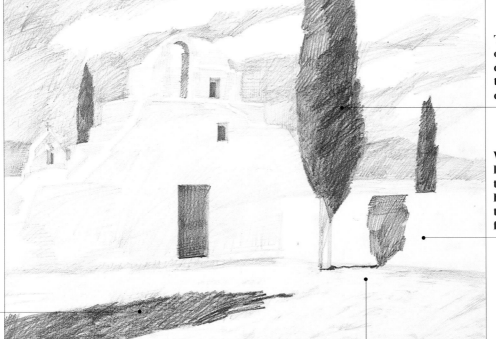

The shaded side of the tree is darker in tone than that in direct sunlight.

White paper is left to represent the brightest highlight where the building is in full sunlight.

The cast shadow of a cypress tree that is outside the picture indicates the direction of light fall.

Lighten this area with a rubber to increase the contrast between the dark shadows and the areas in full sunlight.

6 *Finishing touches accentuate the impression of bright sunlight. Though the tree is dark, there are still differences in tone between the side that is receiving the full impact of the sun and the side that is in shadow. Use a 4B graphite stick (right) to darken the shaded side – this helps you to see it as a three-dimensional cylindrical shape. Stand back and assess the drawing, checking the contrasts between the shadows and the areas in full sunlight. If an area is too dark in tone, such as the courtyard, lighten it with a rubber.*

Tones from a 4B graphite stick

Practice exercise: Light in colour

Colour gives you two principal ways of depicting light: contrasts of tone and contrasts of temperature. Both contrasts are exploited in this exercise, so that generally the shadows are dark and bluish while the sunlit areas are light and warm in colour. However, the temperature contrast is reversed in the lavender field, where the shadows cast by the bushes are rendered with a warm earth colour to contrast with the cool local colour of the plants.

You will need:
- Watercolour paper (NOT), 410 gsm (200 lb), 380 x 280 mm (15 x 11 in)
- Watercolour paints:
 - Phthalo blue
 - Winsor violet
 - Sap green
 - Yellow ochre
 - Brown madder
 - Cadmium red
 - Indian red
 - Sepia
 - Payne's grey
- Brushes:
 - No. 6 round brush
 - No. 3 round brush

1 *Mix a large wash of phthalo blue with a little Winsor violet and roll the no. 6 round brush across the sky area. While the wash is still damp apply a band of yellow ochre so that the colours blend at the junction. Lay a wash of yellow ochre and cadmium red across the bottom part of the picture, allowing the edges to bleed.*

2 *Apply a series of warm ochre and sap green washes for the background and a violet mix for the rows of lavender. Lay a pale wash of yellow ochre, creating a neat edge to define the path over the hill. Lay a grey-green wash of sap green and sepia for the hill. When dry, add some pure sap green on the right. Lay receding stripes of colour for the rows of lavender.*

3 *Mix brown madder with yellow ochre and lay a wash for the roof, working carefully round the edge with the no. 6 brush. Use a dilute solution of the same mix for the façade of the house. Build up the colour on the hillside by laying a wash of sap green. Lay a band of muted green mixed from sap green and sepia, as a background for the trees and shrubs.*

4 *Let the painting dry and then apply more detail so that the picture gradually comes into sharper focus. Develop the colour and texture on the wall of the house and the roof, and add a darker tone to the lavender shrubs so that they begin to read as solid forms. Lay a band of yellow ochre to warm the façade of the house and suggest the texture of flaking plaster. Use a wash of phthalo blue and Winsor violet for the dark tones on the lavender shrubs.*

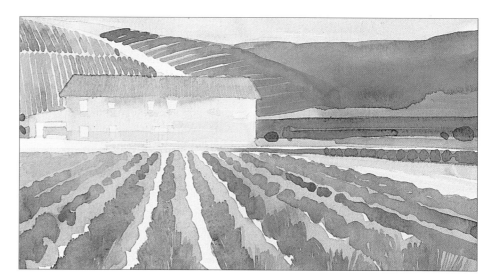

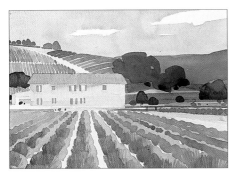

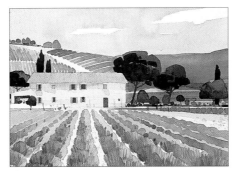

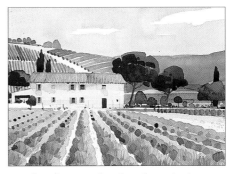

5 *Allow the painting to dry and then apply more detail, working wet on dry. Lay in the simplified forms of the trees and bushes round the house using Mix A (below).*

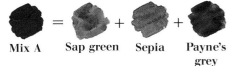

Mix A = Sap green + Sepia + Payne's grey

6 *Use a mix of Payne's grey and sepia to create the dark shadows within the lean-to building, and apply dark tones to the window apertures. Use a dark version of Mix A (see Step 5) to add dark tones on the shadowed side of the larger trees and to add small bushes and shrubs round the house.*

7 *Continue to develop the painting adding details in increasingly darker tones. Use a no. 3 round brush and a mix of sepia and Indian red to lay in the shadows on the tiles. Apply dots of a darker tone along the eaves to describe the ends of the tiles. Touches of darker tone from Mix A (see Step 5) give form to the shrubs on the hillside.*

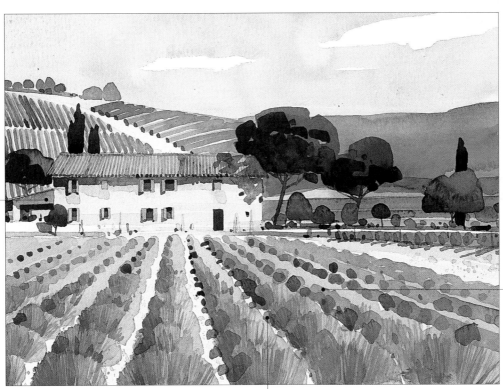

The cool purple shadow on the lean-to shed pushes it back in the picture space.

The lavender bushes cast a warm shadow that contrasts with the cool violet of the local colour.

Sap green mixed with sepia was dotted in for the soil between the bushes.

8 *By adding a few crisp, cool, dark shadows you will find that you have captured the brilliance of the sunshine. Note that all the shadows are laid in with coloured washes – not grey or black. Use Mix B (below) for the cool shadows under the eaves and the shadow cast by the tall cypress by the house.*

Mix B = Phthalo blue + Winsor violet + Sepia

Water

WATER'S REFLECTIVE QUALITY *sets it apart from any other element. Whether it is a film of water, a puddle, a river or the sea, it has an impact on the appearance and mood of the landscape.*

Water can affect our moods in many ways. The setting sun reflected in the still, smooth surface of a lake creates a luminescence that is palpable and induces a sense of serenity; a turbulent sea under a stormy sky is an exciting and invigorating sight.

Observation is the best way to study and understand water in its many guises. Devote a sketchbook to the subject, making sketches, detailed drawings, watercolours and notes whenever you have the opportunity, recording in particular light effects, shadows, reflections and the mood of each scene.

Perspective in water

Where water occupies a large proportion of the picture area there are few solid clues to recession, and it is important to make the most of the clues that water gives.

The rules of aerial perspective apply (see p. 54). The texture and pattern of waves are more obvious in the foreground – portray this by using broad brushstrokes in the foreground and smaller strokes toward the horizon. The rules of linear perspective also apply (see p. 52). Waves should appear large in the foreground and smaller as they approach the horizon.

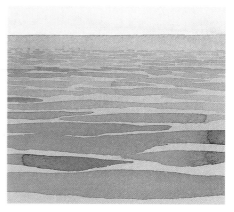

Perspective
To create a sense of recession, make waves and ripples in the distance smaller and closer together than those in the foreground. Note that the colour becomes lighter as the surface recedes.

Recession on water

You can create a sense of recession on a large area of water by introducing objects of a known size such as boats. Here, Godfrey Tonks deliberately created spatial ambiguities, using a high viewpoint, high horizon line and bright colours to 'tilt' the water surface and flatten the picture space. This effect is counteracted by the change in scale between the boats in the foreground and those in the distance.

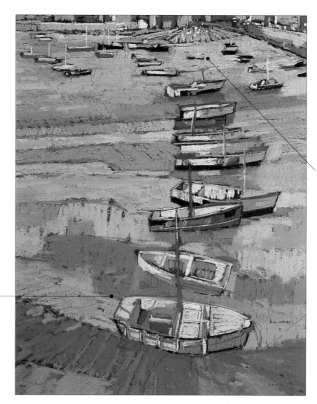

The high viewpoint and horizon line 'tilt' the water surface.

In a tall format, the bottom of a picture area is assumed to be closer to the viewer than the top.

Shadows on water

Shadows occur where a solid body, such as a tree or a boat, intercepts the light. Their position is affected by the location and strength of the sun. Shadows interfere with the reflectivity of clear water, allowing you to see 'into' the water; if a boat is casting a shadow, you will be able to see the hull under the water in the shaded area. The more churned up the water or the more sediment it contains, the clearer and more defined the shadows are.

Shadows falling on muddy water sometimes have coloured edges. The shadow edge nearest to you will be rimmed with blue, while the other side of the shadow will be rimmed with orange. Shadows are most effectively described using transparent, semi-transparent and broken colour effects (see p. 31). Colour applied with horizontal strokes will reinforce the horizontal surface of the water.

Reflections in water

Paintings or drawings of reflections are most effective when the difference between the 'real' and the reflected image is exaggerated. Observe this carefully, then generalise what you see, softening edges slightly and muting colours.

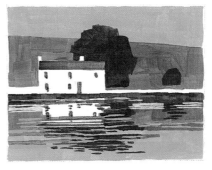

Reflections on still water
Reflections are clearest on flat, still water. They are unaffected by the light direction and appear directly beneath the object, no matter where you stand.

Reflections on ripples
Ripples fragment and blur the reflection – the water surface becomes faceted, so that each wavelet acts as a separate, tilted, curved mirror.

The colour of smooth water

Smooth water acts like a mirror, reflecting the colours of its surroundings. Here, a still lake takes green from the grassy hillside and blue from the sky above. If the surface was disturbed, the water would reflect a mixture of the surrounding colours.

River reflections

In Shirley Felts's watercolour sketch of a broad, swift-flowing rainforest river, the verdant vegetation and the sky are skilfully mirrored in its glass-smooth surface.

A few horizontal ripples emphasise the surface of the water.

A wet-on-dry technique was used to create the crisp details of the trees and their reflections.

White water

When water is churned up, air gets mixed with it, producing white foam. The trick is to get the light-ness and brightness of the broken water without making it look too solid. In most paint media you can use spattering. With watercolour, reserve the white of the paper by spattering it with masking fluid, which you can rub off later.

Colours in a wave are affected by the angles that the different parts of the wave present to the incident light (see p. 140) and the viewer. The front of the wave is almost vertical and appears greenish, whereas the back reflects the light blue of the sky. Where the wave curls over it casts a shadow, so it appears darker under its crest.

Falling water

This watercolour was painted mainly on location and finished later in the studio. Peter Folkes analysed the structure and forms of the falling water before painting it slowly and accurately. The white of the paper has been left to stand for the white water tumbling down the rocks, while thin, carefully applied washes of Davy's grey and earth colours were used for the darker waters. The artist used a good-quality, heavy watercolour paper that allowed him to wash off areas of colour and rework them.

Crashing waves

In this study of a lively sea crashing up against a sea wall, Linda Birch explored the contrast between the smooth backs of the rollers and the dazzling white foam of the breaking wave.

The wave backs were built up with flowing strokes of French ultramarine, cobalt and indigo applied wet.

A narrow band of indigo was applied wet into wet to suggest debris cast up by the sea.

Masking fluid was applied with a brush to reserve the white of the paper for the breaking water and spray.

With the masking fluid removed, a pale blue wash was laid over the outer edges of spray and foam.

How breakers are formed

As waves roll into shore, observe how the water cartwheels forwards, each wave following from another in a continuous rhythm. Breakers occur when the shelf of the sea floor interrupts the wave's circular motion and it crashes on to the beach, creating spray and foam.

The colour of water

The best way to paint convincing water is to look carefully and paint what you see rather than what you know to be there. The sea is thought to be blue, but its colour varies from inky black, through blue and green to silver and pink, and it can change from moment to moment. Large areas of smooth water reflect the sky and the water appears blue or grey, depending on whether the sky is blue or cloudy. On a pool or canal that is edged by trees and shrubs, very little of the sky is reflected, so the water is predominantly dark.

The sediments suspended in water give it colour. Rivers in flood are muddy and opaque, and mountain streams are stained brown by the peat bogs from which they originate. In shallows the underlying surface affects colour; for example, streams pick up the tawny tones of their gravelly bed.

Light on water

The ripples on water act as myriads of tilted mirrors that reflect the bright sky and the sun, making the surface sparkle with fragmented light. Small dabs of broken colour are the most effective way of creating this dazzling effect.

Light on the strand

In this oil painting of a beach at low tide, Brian Bennett captured the luminous quality of sunlight filtered through clouds by applying thin layers of carefully blended paint. He used thin glazes of white and blue for the reflections of the bright sky on the beach.

Pinks, blues and lilacs were applied as scumbles and glazes over the dark ground.

White and pale blue dabs and dashes were used for the ripples at the water's edge.

Ripples in sunshine

When a breeze ruffles the surface of the water, it breaks it up into tiny facets. Those that face the light reflect it so that a dazzling light appears to be dancing across the water. Here, Derek Daniells used small dots and dashes of pastel applied over a dark ground to create an optical mix that captures this effect.

Practice exercise: Still water reflection

This simple exercise shows you a way of rendering the reflective surface of a pool of water. Pure water is colourless – the water acquires its colour from the reflections of the sky above and from the trees and vegetation along its margins. The surface of a body of water is horizontal – here, the water-lily pads, which float on the water surface, provide a useful clue. When you have worked through this exercise in pastel, you could try it again in gouache, oil or acrylic.

<div style="border:1px solid">

You will need:
- Dark green pastel paper, 368 x 548 mm (14½ x 21½ in)
- Soft pastels:
 - Dark blue
 - Cobalt blue
 - Pale light blue
 - Lime green
 - Sap green
 - Dark green
 - Sage green
 - Yellow
 - Orange
 - Black
- Aerosol fixative spray

</div>

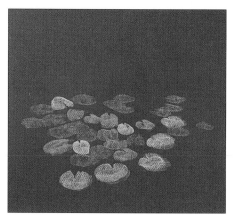

Tip

- Use a toned ground, such as the dark green paper in this exercise, to establish an immediate harmony. The colour provides a foil for light tones, such as the reflections of the sky and the dark reflections of the leaves.

1 Choose a dark green surface that suggests deep, shaded water. Start by blocking in the shapes of the water-lily pads. Apply a bright lime green fairly solidly for the leaves on top of the water. Use a sage green lightly for the pads just below the water surface, or in shadow. To create a sense of recession, make the pads that are further away smaller and more elliptical.

2 Sketch in the vegetation on the edge of the pool, using a range of light and dark greens. Place the reflection vertically below the object that is being reflected in the same colour. Leave the green of the paper to stand for the earth bank of the pool.

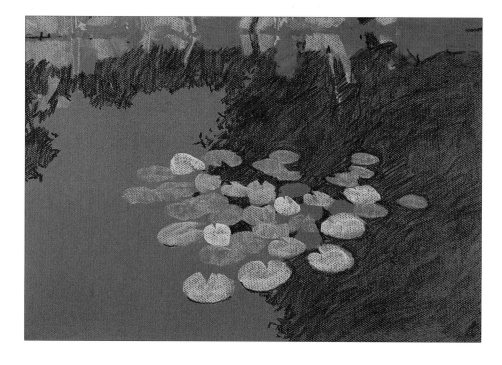

3 The trees bordering the pool are in shadow so their reflections are dark. Using black and a dark green, loosely scumble on the colour. Use a combination of the side of the stick and scribbled hatching with the tip of the stick to achieve variegated coverage. Treat the reflection of the massed foliage broadly, as if you were drawing the trees themselves. The darkest tones occur between the water-lily pads that shade the water from the light. Use the black pastel to redefine the outline of some of the water-lily pads.

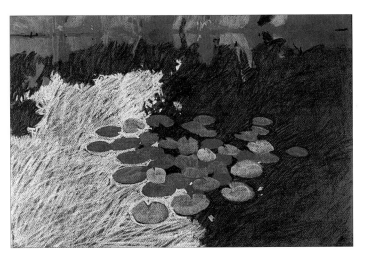

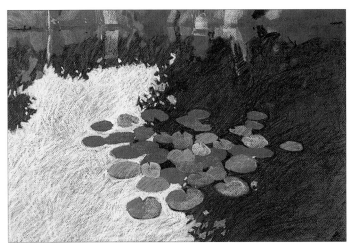

4 *Lay in the lightest tone, where the light blue of the sky is reflected in the water, with pale light blue pastel using a controlled scribble – the broken colour (see p. 31) suggests the transparency and depth of the water. Patches of pale light blue on the black area describe gaps in the trees through which the sky can be glimpsed. Fix the picture with aerosol fixative.*

5 *Work over the lightest area of the water with cobalt blue pastel to create a complex web of broken colour. Now that the water is established you can develop the various colours of the water-lily pads with sap green, lime green, sage green and yellow. Add patches of dark green in the reflection of the foliage of the tree canopy.*

To create recession, make the distant pads smaller and more elliptical than those in the foreground.

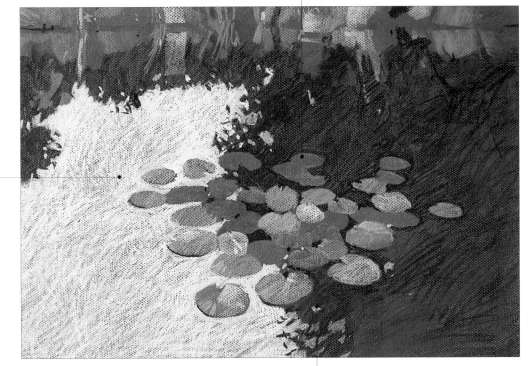

Fixative was applied before using light colours over dark.

6 *Add the finishing touches. Scumble dark blue into the dark water to suggest the depth and coldness of the water. Highlights on the water-lily pads and tiny touches of orange suggest the water-lily buds and add sparkle to the picture, bringing this area into focus.*

Patches of blue suggest gaps in the trees that overlook the pool.

Practice exercise: Breaking waves

Waves crashing on a rocky or sandy coastline provide spectacular and challenging material for the artist. This exercise will help you to understand the structure and motion of a wave, and shows you a way of capturing it in paint. The experience of working through this project step by step will give you the confidence necessary to tackle the subject on your own in the field.

<table>
<tr><td>

You will need:
- Oil sketching paper, fine grain, 405 x 510 mm (16 x 20 in)
- Oil paints:
 - Cerulean blue
 - Phthalo blue
 - Sap green
 - Yellow ochre
 - Raw umber
 - Payne's grey
 - Titanium white
- Charcoal stick
- Turpentine
- White spirit
- Brushes:
 - 6-mm (¼-in) flat soft brush
 - No. 4 flat bristle brush

</td></tr>
</table>

1 Break the subject down into simple bands – sky, sea, wave, smooth water beneath the wave, surf, beach. Outline these areas in charcoal. Flick the paper with a cloth to dislodge any loose charcoal dust that might contaminate the paint.

2 Using a soft 6-mm (¼-in) flat brush and creamy paint, lay in the dark tones using Mix A (right) under the crest of the wave. At the foot of the wave, add cerulean blue and titanium white to Mix A. Apply the paint with smooth, horizontal strokes of the brush.

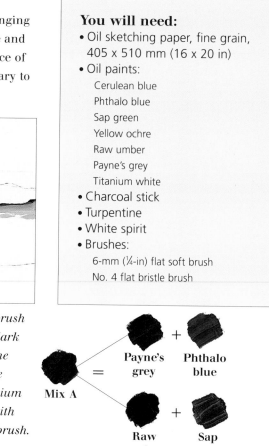

3 The white of the broken water can be represented by the white of the paper. To paint the crest of the wave, add yellow ochre and white to Mix A (see Step 2) and apply it with a no. 4 flat bristle brush. Use this mix to define the jagged edges of the foam. Use touches of the same blue-green mix to define the shallow water surging over the sandy beach. This also helps to define the white, foaming water.

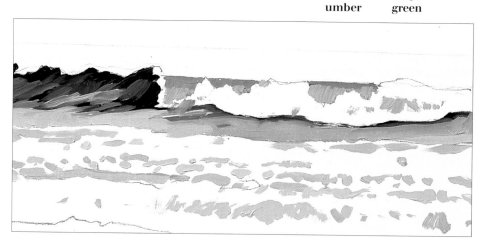

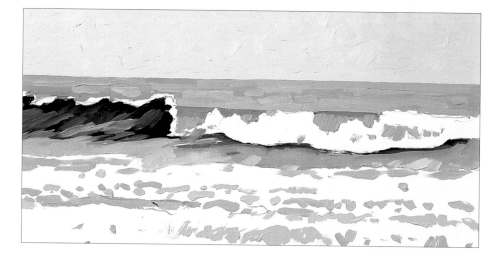

4 Lay in the main body of the sea from the wave back to the horizon with an intense blue, combining Mix A (see Step 2) with white and cerulean blue. To suggest the undulations of the sea, apply the colour thickly with the no. 4 flat bristle brush. For the sky add more white to the sea colour and apply with the 6-mm (¼-in) brush. Thin the paint slightly with a little turpentine to get a smooth coverage.

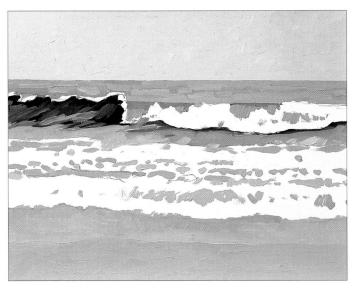

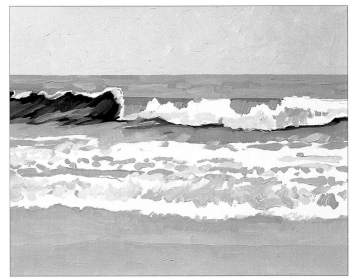

5 *Lay in the sandy beach in the foreground. Add a little yellow ochre to Mix A (see Step 2) and lay a broad band of colour for the wet sand that is covered by a thin film of water from the previous wave. Add more yellow ochre to Mix A and use it for the sand that is beyond the reach of the waves. All the principal areas are now broadly established.*

6 *Develop the foaming water surging up the beach by scumbling and scrubbing on touches of pale blue and blue-green. Create a muted pale blue from white and cerulean with a touch of yellow ochre, and a muted blue-green by adding more white and yellow ochre to the mix. Add touches of darker tone on the breaker.*

Vertical brushmarks contrast with the horizontal crest of the wave and suggest the direction and force of the falling water.

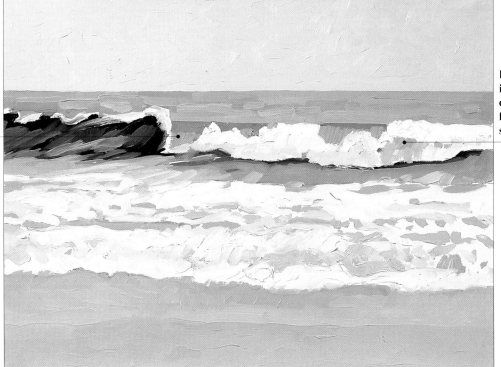

Brushmarks and impastoed paint capture the frothing, foaming sea water.

7 *For the finishing touches, suggest the texture and energy of the broken water with creamy white paint applied in a thick, rich impasto.*

Trees

TREES ARE AN IMPORTANT *source of colour, pattern and texture in landscape paintings. They also provide a vertical element to balance the predominantly horizontal ground plane, and they can be used in many ways.*

The best way to approach drawing trees is to ignore the detail and concentrate on the underlying forms. Find a place where you can see several trees of different species. Concentrate on one tree, study its silhouette and then draw it as a single, simple outline in your sketchbook. Now repeat the process for the other trees.

If the tree is in leaf, look for the shapes of the masses of foliage as they cluster round the main boughs and branches. Start by drawing these as simple outlines, then start to block in the areas of light and dark, squinting your eyes to isolate the main masses of foliage. Note that the tops of each mass, especially those on the side from which the light is coming, are lighter than the undersides.

Tree structure

Use simplified outlines as a basis for more detailed drawings, bearing in mind the structure of the tree. The boughs grow from the trunk, and the branches and twigs grow out of each other in a logical pattern, becoming thinner as they move towards the outer edge of the tree. When working in pencil, cultivate a single flowing line and use a sharp tip for the thinnest branches and twigs. With a brush, use the flat of the bristles for the thicker branches and the tip for small branches and twigs.

Tree shapes

While the illustrations here give the basic forms, the shape of a particular tree is affected by local conditions. Trees on the coast are often lopsided because they are battered by the prevailing wind, while those on rocky mountain slopes, where the soil is thin, are often stunted.

Columnar

The branches of columnar trees are all the same length and grow upwards from the main trunk, giving the tree a tall, elegant, lance-like shape.

Basic shape **Bare poplar** **Poplar in leaf**

Rounded

The branches of these trees radiate from the main trunk. Oak, beech, sycamore, ash and maple have broad, domed crowns.

Basic shape **Bare oak** **Oak in leaf**

Lozenge-shaped

In silhouette, the elm, common alder and some conifers are broad in the middle and narrow at the top. Vary the shape and size of the foliage.

Basic shape **Bare elm** **Elm in leaf**

Deciduous trees

Deciduous trees shed their leaves in the autumn. This group of trees is more varied in shape than the evergreens and most have broad, flat leaves. When a deciduous tree is in full leaf, the skeleton of the trunk and branches is underneath, giving it form. Reduce the tree to simple shapes, but be aware of the underlying structures.

Evergreen trees

Evergreen trees and shrubs retain their leaves throughout the year. The branches of conifers radiate out from a central trunk in a symmetrical pattern, and generally their shapes are more regular than those of broad-leaved trees. Holly, laurel, some species of oak and palm trees are examples of common evergreens.

Conical

Many conifers, such as spruces, have regular layers of branches that grow horizontally from the trunk, decreasing in length towards the top of the tree to produce a symmetrical shape.

Basic shape **Norway spruce**

Flat-topped

The stone pine, along with many other pines, yews and cedars, acquires this shape with age as side branches die and the tree suffers the buffetings of wind and weather.

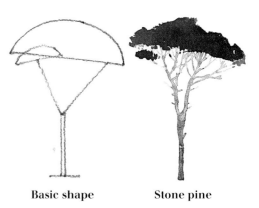

Basic shape **Stone pine**

Hatched lines describe the haze of small new twigs at the ends of the branches.

The main trunks are solidly rendered, but each successive branch is thinner than its parent.

Drawing trees in pencil

John Lidzey used a long continuous line to describe accurately the sinuous growth and flowing lines of the branches of this oak. He held a 5B pencil nearly flat to the paper, about 50 mm (2 in) from the drawing point, to create flowing, even hatching, and twisted it to create thick and thin lines.

Tree colours

Tree foliage ranges from silver, through every shade of green, to russets, yellows and blazing reds. Tree trunks also vary in colour and are rarely a dull brown. Try mixes such as viridian and Indian red or burnt umber and cobalt blue. In season, blossom and berries extend the palette to almost every colour in the paintbox. You can see this variety of colours particularly well in a mixed woodland, especially if it is viewed from above. Don't rely on proprietary greens; you will achieve a more harmonious and natural effect with a range of mixed or modified colours (see pp. 40–41). Cadmium yellow mixed with light red or burnt sienna will provide a sense of autumnal colour. Touches of complementary red enliven green foliage.

Using broken colour

In this landscape by David Carr, the artist built up a rich tapestry of broken colour using distemper (see p. 140) and pastel. The scribbles and slashes of colour combine in the eye to create gradated but complex light and dark tones.

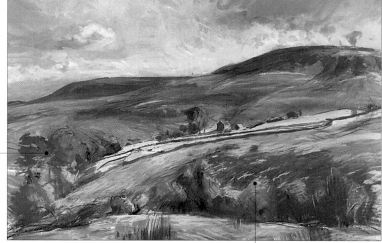

The trees were blocked in using a neutralised blue and worked over with warm and cool green pastels.

Slashes of bright yellow were added where the sun catches the top sides of leaf masses.

Seasonal changes

Deciduous trees change dramatically in appearance with the progress of the seasons, from the flush of pinks and whites in spring to the bare, dark outlines of branches in winter, all contrasting with the constant colours and shapes of the evergreens. These changes mean that you can return to the same stretch of landscape and paint it again and again, and produce pictures that are entirely different in colour, tonal range and mood.

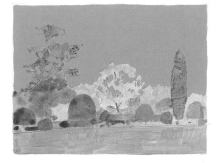

Spring
Young leaves have fresh colours. A sharp spring green can be mixed from lemon yellow and a cool blue, such as cerulean or Prussian blue, or by adding a small touch of lemon yellow to viridian.

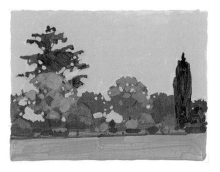

Autumn
Earth colours provide a useful palette for deciduous trees: raw sienna and yellow ochre provide golden tones, and Venetian red, Indian red and burnt sienna give a good range of russets and reds.

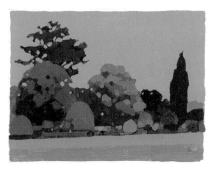

Summer
Leaf colours are generally deeper, and bright sunshine can make all colours greyer. Look hard at tones and colours, and reduce over-bright greens with a touch of a comple-mentary colour.

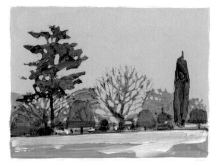

Winter
Winter makes you notice the colours of tree barks. When backlit, winter trees often look almost black. From a distance, branches coalesce to form a semi-transparent grey haze.

Composing with trees

Trees are often the largest and tallest element in a landscape. They provide an important vertical feature and can be used to divide the picture area, to link different parts of the picture and to provide emphasis and rhythm. Often a pair of trees, or a single overhanging tree, is used to frame a vista or draw attention to a particular focal point. When the sun is low in the sky, trees cast impressive shadows that can also become an important compositional element, creating a large block of dark tone to balance lighter areas or providing a visual link with one area and another.

Trees in close-up

The scenery within a wooded area is unique. In Shirley Felts's painting, there is no horizon and there are no complete outlines of individual trees. In dense woodland little light penetrates, except when the sun is directly overhead, creating shafts of light here and there.

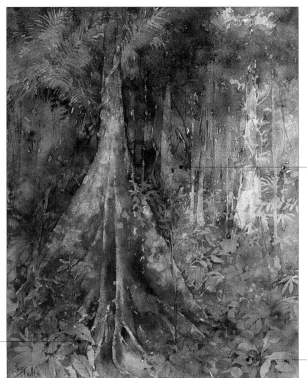

Pools of shadow and dark recesses between the trees emphasise the interior feeling.

Here, detailed rendering of leaves contrasts with a more impressionistic treatment in the background.

Filtered sunlight dapples the foliage on the forest floor.

Trees in the distance

The way you tackle trees depends on how far away they are, how much detail you can make out and how resolved you want the finished image to be. When trees are seen from a great distance – on the far side of a field, for example, or cloaking the lower slopes of a distant hill – you can make out only patches of colour, tone and sometimes texture. At this distance it is the overall shape, the mass of foliage and the colour that indicate their species. Study them through half-closed eyes and then put down what you can see. Stand back from the support to see how the trees read at a distance. If they are too emphatic, soften them by smudging. Remember that trees in the distance will be less crisply outlined than those nearer and will decrease in size towards the horizon.

Trees in perspective

Trees are useful pointers to recession and space. In this acrylic study, Richard Tratt used both linear and atmospheric perspective (see pp. 52 and 54) to create a landscape with a convincing sense of recession and depth.

Sgraffito (see p. 141) is used to describe the branches of the trees in the foreground.

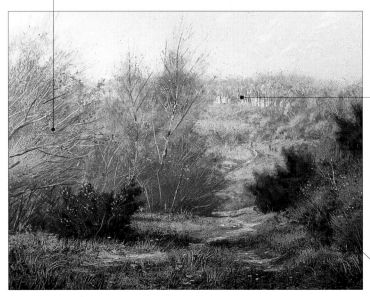

The muted tones and colours of the trees on the horizon push them into the background.

In linear perspective the trees in the foreground are bigger than those in the distance.

Practice exercise: Trees in winter

This project allows you to apply the concepts outlined on pp. 94–97. Make a copy of the drawing following the simple instructions. You will find that because the subject has been pared down to the bare essentials it is very easy to produce a convincing rendering of leafless trees. Your success will give you the confidence to make studies directly from nature. If you want further practice, make a copy of this drawing using another medium. Choose a medium tone colour for the drawing or painting surface. The dark and light tones of your drawing will make sense immediately, and the drawing will progress quickly.

You will need:
- Medium grey pastel board with a high tooth, 293 x 400 mm (11½ x 15¾ in)
- Chalks:
 Black
 Grey
 White

1 *Establish the main trunks and branches. Use the black chalk on its side to lay in the trunk of the tree in the foreground. The uneven coverage suggests the rough texture of bark. Break off a short length of chalk and use it to draw the other trunks. Use the tip of the chalk for the branches.*

2 *Use the side of a small piece of black chalk to scribble in the tree masses on the horizon. Lay broad strokes of black chalk to suggest the horizontal planes of the fields in the distance and the shadows under the trees. Lay on dots and dashes with the tip of a stick to suggest fallen leaves.*

3 *Use white chalk to establish lighter tones for the sky, highlights on the ground and texture in the foreground. Scumble on white chalk for the sky area using the side of the stick. Don't build up solid colour – allow the warm, neutral ground to show through and modify the white to create a lively surface and varied tones. Use the white chalk to 'cut back' into the branches, using the 'negative' (see p. 141) to neaten the outlines of the branches. Glaze the middle distance with a thin layer applied with the side of the white chalk. Touches of solid white add texture in the foreground and help to reinforce the sense of recession by establishing a texture gradient (see p. 55).*

4 *Develop the tracery of branches in the tree canopy. Use the tip of the grey chalk to draw the smaller branches and twigs. Turn the chalk as you work to create thick and thin lines. Build up a denser mesh in some areas to create the impression that the trees overlap in places. Apply dots and dashes of chalk to suggest the few dried-up leaves clinging tenaciously to the branches.*

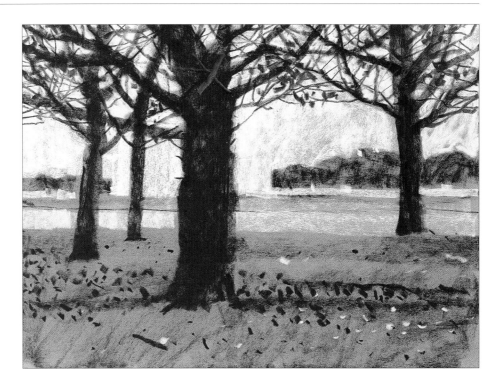

Tip

- Remember that branches become narrower as they branch away from the main trunk of the tree.

Black chalk defines the tree branches, so that they appear to stand out from the picture.

The side of the black chalk was used to draw the trunks of the trees. Grey paper shows through the black chalk to suggest the texture of bark.

Touches of white suggest the sky piercing the tree canopy.

A thin layer of white chalk accentuates the horizontal plane.

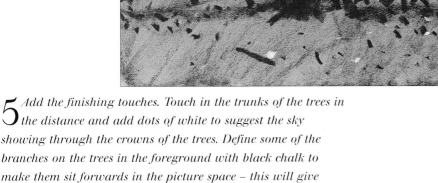

5 *Add the finishing touches. Touch in the trunks of the trees in the distance and add dots of white to suggest the sky showing through the crowns of the trees. Define some of the branches on the trees in the foreground with black chalk to make them sit forwards in the picture space – this will give volume to the tree canopy.*

Dots and dashes add texture to the foreground, adding to the sense of recession.

Practice exercise: Summer foliage

In most landscape pictures, trees appear in the middle or far distance. To depict them realistically you need to show them as broad masses. It is only when a tree is seen in close-up in the foreground that you need to show details of foliage, bark and branches. This exercise shows you a simple method of dealing with summer foliage, while suggesting the character of particular species and individual trees. The silhouette of a tree seen against a light background is as characterful as the silhouette of a human figure. Avoid the temptation to put in too much detail. When you have rendered this tree in pencil, do it again in another medium.

1 *Start by blocking in the domed crown of the chestnut tree in the foreground with the light green pencil. Build up a web of broken colour using a controlled scribble.*

2 *Using sap green, place darker tones away from the light, on the left and on the lower parts of the crown. Scribble in the leaves massed on the boughs, changing direction and varying the pressure.*

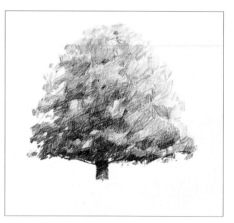

3 *Add dark shadows on the crown using a black pencil. Work on the areas that are turned away from the light. Lay in the trunk and the lower branches.*

4 *Block in the silhouettes of the trees in the distance. Remember that each tree has an individual silhouette, but don't put in too much detail. Use the same scribbled hatching, but make the marks smaller to create an illusion of recession.*

You will need:
- Cartridge paper, 300 x 400 mm (11¾ x 15¾ in)
- Colour pencils:
 Moss green
 Sap green
 Light green
 Cobalt blue
 Spectrum blue
 Deep yellow
 Orange
 Black

Tip
- Think about the character of the tree as you are drawing or painting it. Here, the tree in the foreground is a chestnut. They have a compact, symmetrical crown, dense foliage and long, palmate leaves that tend to drape downwards. The foliage forms massed shapes round the main boughs. Try and capture these qualities in your drawing.

5 *Block in the sky using the two shades of blue. Use a loosely scribbled hatching and change directions to achieve a fairly even tone. Leave the white of the paper to stand for clouds. Add darker tones on the hedgerow using sap green. For the main branches glimpsed through the leaves of the chestnut, use black pencil. Apply loose, diagonal hatching in deep yellow and orange to suggest the stubble of the field in the foreground.*

The moss green pencil was used to touch in the trunks of the distant trees.

6 *For the finishing touches, add details such as the trunks of the trees in the distance and the shadows under both these and the main tree. These touches pull the picture into focus, reinforce the horizontal planes and emphasise the illusion of recession and depth in the drawing.*

The shadow under the chestnut tree was extended and emphasised. This reinforces the horizontal of the ground plane.

Shadows were lightly suggested under the distant trees.

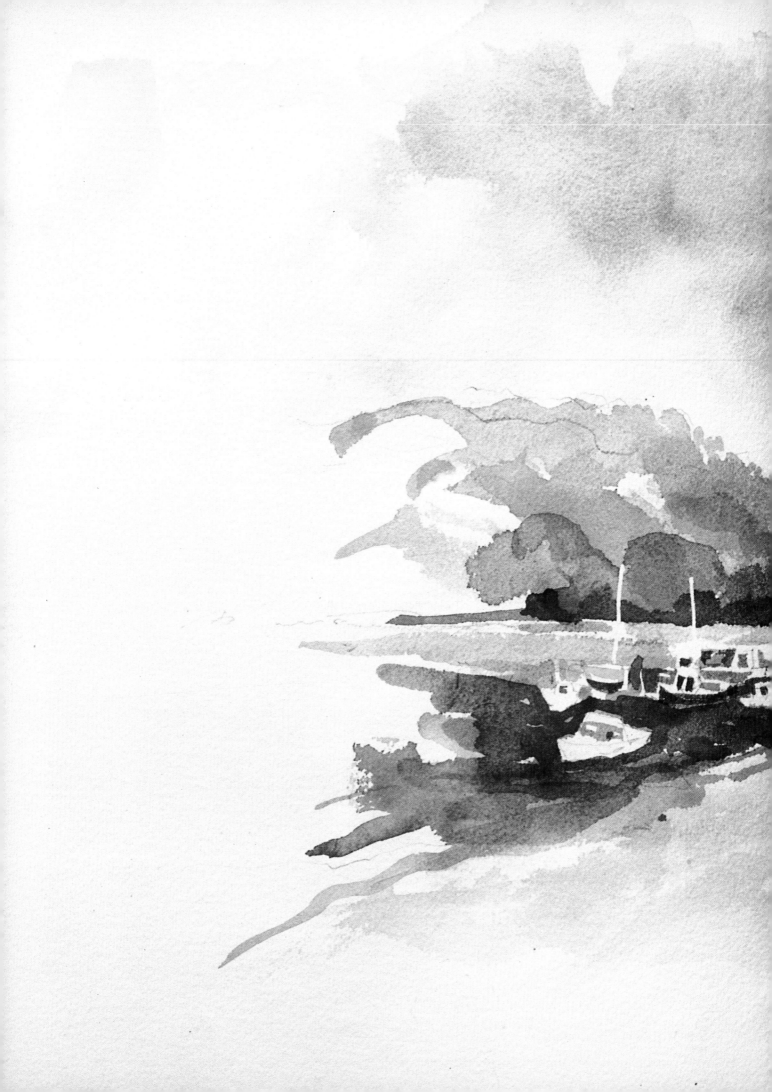

WORKING
OUTDOORS

To PAINT THE LANDSCAPE successfully you must work out of doors from time to time, working directly before the scene. This chapter gives suggestions for selecting your subject from the huge panorama of the landscape, whether you want to produce a finished drawing or painting or are gathering material to develop back in the studio.

You need to work quickly if you are to capture the effects of light and weather before they change. This chapter includes advice on making quick sketches and colour notes. Media such as watercolour and acrylic are useful as they dry rapidly. When working alla prima in oil, it is possible to complete a painting in a single sitting. This chapter also shows how coloured pencil can be used on location to create finished images that are lively and full of expression.

Analysing the landscape

WHEN WORKING ON LOCATION, *you can use different aids to help you to analyse the landscape. A viewfinder, pencil and home-made angle frame will help you to compose and record an accurate depiction of the scene.*

The first thing you need to do on location is to find your 'picture'. The sheer scale of the landscape can make selecting a view difficult; a viewfinder is an indispensable aid when you are out of doors. When you have found a view, check the composition in a quick thumbnail sketch before you start to work on the full-scale picture.

The more accurate your drawings are, the more useful they will be. Check proportion and perspective angles with a pencil, or make your own card angle frame.

Selecting a subject

A viewfinder is a frame that allows you to isolate different sections of the landscape so that you can consider their picture-making possibilities. Your viewpoint will affect what you see. Crouch down and the horizon moves towards you, creating a more enclosed landscape. Stand up and you will be able to see further. Walk around the location, and don't forget the view behind you. Use the viewfinder at different distances from your eye to change the crop.

Thumbnail sketches

Thumbnail sketches are a way of analysing your subject so that you can check where the main focus shoud be, which crop and format works well (see p. 48) and whether the composition holds together in a satisfactory way. Make several quick sketches, using pencil or charcoal, before you commit yourself to spending time on a more finished drawing or painting.

Use thumbnail sketches in conjunction with a viewfinder to translate the view to paper.

Using a viewfinder

Hold your viewfinder in front of you to see different sections of the landscape in isolation. For a tight crop hold it at arm's length; for a wide angle view hold it close to your eye.

Exploring different formats
The artist used a viewfinder made from two 'Ls' to explore the effect of different formats. He recorded the alternative compositions in thumbnail sketches that highlight the main elements.

Portrait format
The high sky is balanced by a deep foreground that draws the viewer into the picture space. This format allows you to include the entire height of the tree on the left, which gives the image a thrusting, dynamic element.

Landscape format
The balance of sky to foreground has changed, creating a more open feel. The shadows are an important element of the composition and, together with the tree on the right, balance and counteract the vertical thrust of the tall tree on the left.

Measuring methods

On location it is sometimes difficult to assess the size of the objects in the landscape. To help you to render objects accurately, establish some key relationships early on in your sketch or drawing.

In order to check and compare proportions, start with a standard measurement. Hold your pencil or pen vertically with your arm fully extended, aligning the top of the pencil with the top of the object you are measuring. Mark the base of the key measurement with your thumb. Then, still keeping your arm fully extended and without moving your thumb, use this measurement to compare against the size of other objects.

Alternatively, you can draw by eye and use this system to check the proportions as you work.

Measuring with a pencil
Here, the pencil is used to 'measure' the height of the near corner of the barn. Note that this is approximately the same as the width of the gable end, and half the length of the long side. By comparing and marking off these measurements on your drawing, it will be accurate.

Tips

- The best way of seeing flaws in a composition or inaccuracies in a drawing is to make the image look unfamiliar. There are several ways to check your drawing: you can view it reversed in a mirror – a small pocket mirror will do – or turn your drawing upside down, or you can look at the 'negative' spaces (see p. 141) between objects rather than the objects themselves.

- When you are working in the field, you may find it useful to tape lengths of cotton across your viewfinder to create a grid (see p. 49). You can then check instantly whether certain elements of the landscape fall on or near the horizontal lines of the grid.

Checking angles

When drawing structures in perspective, it is important to get the angles and slopes right to give a convincing sense of recession (see p. 52). Angles are difficult to assess by eye but easy to check using a pencil or with a home-made angle frame (see right).

Hold your pencil up to the subject and align it along the slope to be measured – a roof or the line of a receding road, for example. Carefully maintain that slope and lay the pencil on your paper to check the angle of the drawn line.

Once you have 'trained' your eye to judge the angles and slopes of receding lines, you will be able to draw them purely by eye.

Using a home-made angle frame
Cut two strips of rigid card, measuring 50 x 255 mm (2 x 10 in). Pierce them at one end and fix them together with a paper fastener. To measure an angle, hold the frame up at arm's length. Open or close the hinged jaws to match the angle being measured.

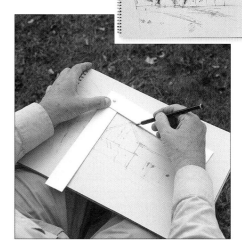

1 *Align one strip of the angle frame with a vertical, such as the side of the barn, then adjust the angle of the top strip to match the slope of the roof. You will be surprised at how acute the angles actually are.*

2 *Lay the frame on your paper, carefully maintaining the measured angle. Lay the vertical strip against a corresponding vertical and check or trace the slope of the roof. Inset: The finished sketch has a convincing sense of depth and recession.*

Making notes on location

A SKETCHBOOK IS AN *essential tool for the landscape artist. It is a source of inspiration and a place to explore themes and compositions. Use it to record details of the landscape on location that can be developed later.*

The secret to making rough sketches out of doors is to work quickly. With practice you will find that even cursory lines can conjure up the pattern of dappled light, the brooding mass of a hill or the curve of a river.

Take notes on the key features of your chosen subject – tonal values, focal points, composition and unusual details or colours. Carry a small, lightweight sketchbook and a few pencils with you on location for quick drawings. You could also use coloured pencils, pastels or a small box of watercolours for recording colours.

Tonal notes

Half-close your eyes so that you can reduce the components of the landscape to light and dark tones. With a 2B pencil, scribble in the areas of dark and medium tone, then add a few linear details. A Claude glass (see box on p. 107) is also useful for judging tone.

Compositional notes

Use your sketchbook to make quick thumbnail sketches to explore various aspects of a composition (see p. 104).

Details

You can make detailed studies of particular features, such as wildflowers, that you intend to include in a painting or drawing.

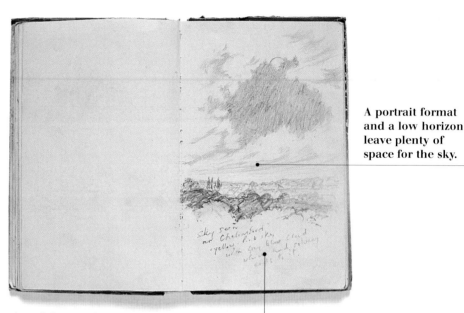

A portrait format and a low horizon leave plenty of space for the sky.

A quick pencil sketch
Melvyn Petterson used a soft pencil for this sketch of a colourful sky. He depicted the scene primarily as areas of light and dark tone, but scribbled marks and outlines conjure up foliage and rooftops with great economy.

Written notes describe the colours of the sky and clouds: 'yellow-pink sky with grey-blue cloud which had silvery ends to it'.

A thumbnail sketch of an alternative crop and format.

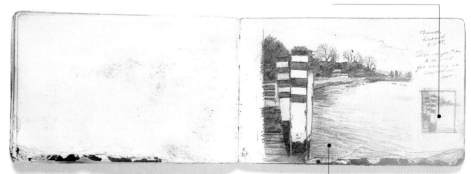

Contrasts of tone
Because the artist, Melvyn Petterson, intended to turn this detailed study of a wate...ay into a black and white print, he concentrated on contrasts of texture and tone, rendered in waxy black pencil.

The effect of light on water is achieved using carefully gradated tones.

Colour notes

You can makes notes about colour even if you don't have time to do a full colour rendering. Write descriptions on a pencil or charcoal sketch using words that conjure up the colour for you. These could be paint colours, such as 'raw umber' or 'cobalt blue with a touch of white', or they might be more descriptive – 'cabbage green' or 'wine red' for example. Alternatively, you can lay in dots and scribbles of colour at critical points on the sketch, using colour pencil, pastel or paint.

A good colour photograph is helpful, but don't rely on it too much: the camera distorts colours and flattens spatial relationships.

Recording colour

This sketch was made at the same time and location as the photographs below. The artist used coloured pencil to indicate the broad areas of colour and texture, supplemented with written reminders of specific colours in his palette.

Scribbled coloured pencil indicates the main areas of colour.

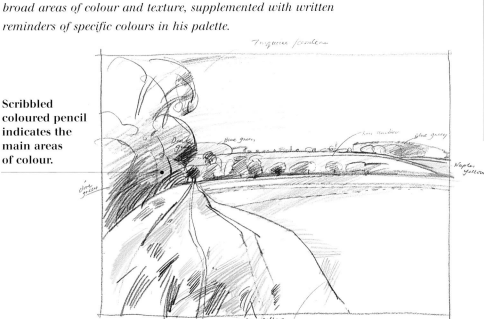

Written notes refer to the colours the artist intended to use in the finished painting.

Judging tone

A home-made Claude glass (see p. 140) will help you to assess the structure and tones of the landscape before you.

Use a small square of black perspex, or apply black paint to the back of clear perspex. Hold the perspex so that it reflects your subject. The Claude glass minimises colour, distracting detail and contrasts of light and dark.

Using a camera on location

A camera has many uses on location. You can use its viewfinder to frame views. If it has a telephoto lens you can crop in to interesting corners and details. When you return to the studio, photographs are a useful supplement to sketches made on the spot and can be used to trigger ideas. Try not to 'copy' from photographs, as the results inevitably lack the vigour and spontaneity of an image recorded on the spot.

Building up a panorama
Record a panoramic view by standing in one place and taking a series of overlapping photographs. The composite will provide you with a choice of compositions and plenty of detail.

Sketching with coloured pencils

To CAPTURE THE RICH COLOURS *and textures in this farmland landscape, the artist chose to sketch with watercolour pencils. They allowed him to work at great speed, using a combination of line, wash and linear techniques.*

Farmland and other cultivated areas provide the landscape artist with plenty of absorbing subject material. In this scene the artist was attracted by the colours and textures of the cut corn, which lend themselves to coloured pencils. You can work both tightly and loosely in pencil, giving you the freedom to record the scene expressively.

Watercolour pencils are ideal for using on location, as they give you the option of combining pencil and watercolour effects without the need for extra equipment. You can use the linear qualities of ordinary pencil to lay in lines and blocks of solid colour and to add tone and texture by stippling and hatching (see p. 10). Use a moist brush to create washes and to soften lines.

When working out of doors, be prepared for the scene to change. Here, the tractor appeared while the artist was preparing to draw. He decided to include it in his composition to provide a point of interest. Make a quick record of a moving object in case it disappears before you have finished drawing.

You will need:
- Sketchbook with a good-quality cartridge paper
- Watercolour pencils:
 Blue-black
 Cerulean blue
 Blue
 Lilac
 Grey
 Olive green
 Dark green
 Apple green
 Lime green
 Golden yellow
 Yellow ochre
 Earth brown
 Dark brown
- No. 6 round brush
- Craft knife
- Scrap paper

Getting started

Select the elements of the landscape that you wish to include in your composition. To create this image, the artist, Albany Wiseman, chose to combine the standing corn from the edge of the field with a view of the tractor as it started to plough. The row of trees and the lane are important divisions.

Harvest time

In this late-summer scene the fields of cut and uncut corn give the landscape a warm, golden cast, while the lines of stubble and the tangle of barley and grasses in the foreground provide textural interest. The yellow wheels of the tractor ploughing in the middle distance, and the red of the barn beyond the trees, create flashes of bright colour that contrast with the muted greens, browns and golds of the landscape.

The point at which the lane meets the trees, marked by a signpost, is a natural focal point.

The lane leads the eye into the centre of the picture.

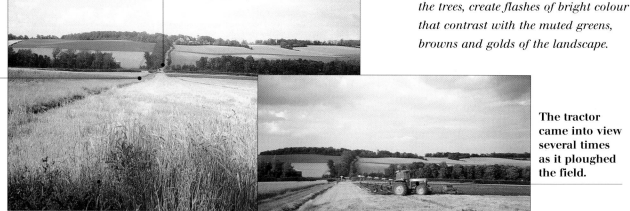

The tractor came into view several times as it ploughed the field.

This band of tall corn and grasses provides texture and interest.

Starting to draw

Begin by sketching the main areas of the subject using loose line and scribbled hatching. Look for the structure of the underlying landscape. Here, the artist divided the picture area into approximate thirds – the trees that run across the picture are located on a horizontal third and the tractor marks a vertical division.

1 *Lay in the broad outlines of the subject with an olive green pencil. Block in areas of dark tone, such as the wooded area and the trees along the lane with a loosely scribbled hatching. Indicate the uncut corn and grasses in the foreground – this area of texture is an important part of the composition. Find a shorthand to describe the various elements; dashed marks can stand for the angled heads of the barley, for example.*

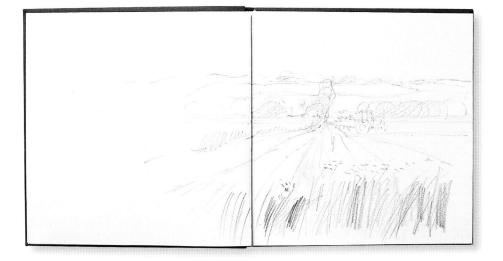

2 *Take a small no. 6 round brush and dip it in water. Work over the pencil drawing with the moist brush to blend the colour. Focus especially on the hedges and wooded areas.*

3 *Continue to work over the painting with the moist brush to create a softly modulated monochrome wash. Create soft blends of tone in the corn and grasses in the foreground. By developing contrasts of tone and texture in this area, you deceive the eye into believing that it is near the picture plane. This monochrome study gives you the opportunity to assess the composition and provides an excellent underpainting for the rest of the drawing.*

Developing the drawing

The main elements of the drawing are in place. Build up colour and texture,
working over the entire surface, but make your marks bolder in the foreground.
Start with the light tones and work towards the dark tones, laying in colours and
tones that will be modified by subsequent layers.

4 *Lay in loose scribbles with a warm
golden yellow pencil. Hold the
pencil high up the shaft and pivot it
from your wrist and elbow to get loose
but even coverage. Use short vertical
marks for the stalks of stubble and long
sweeping lines for the converging rows
of corn. Press harder for the standing
corn in the foreground to achieve a
darker, crisper tone.*

5 *Scribble in touches of sky with a
bright cerulean blue. Scribble the
colour loosely and lightly over the
yellow for the distant trees and hedges.
With a wet finger, soften and blend the
pencil marks to form a soft green. Use
your finger to create interesting blobs,
marks and blendings that describe the
shapes and forms of the trees.*

6 *With the blue pencil, add touches of
colour in the fields and along the
grassy lane. Choose a warm earth
brown for the tilled field in the middle
distance, for darker tones on the field in
the distance and for the trees that edge
the lane as it climbs the distant hill.
Add blue tones between the stalks in
the foreground.*

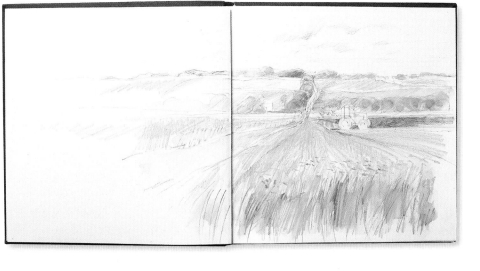

7 *Use the olive green pencil to develop the dark tones. Make the right side of the trees darker to give them form. Lay shadows along the lane, and along the base of the trees and hedges. Inset: Use a wet brush to soften the dark tones between the standing stalks.*

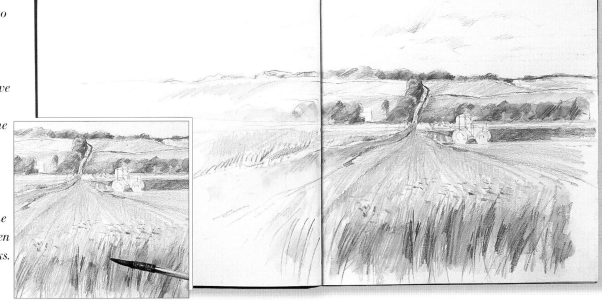

8 *Reduce any overbright areas with cooler colours, such as apple green on the field in the background and a cool grey on the reddish earth. The tractor is a key focus. Sharpen a dark green pencil and draw in the tractor body.*

9 *Lay a piece of paper with a straight edge along the base of the row of trees. With a dark blue-black pencil work briskly over the paper edge, applying the colour evenly along its length. Inset: When you remove the paper, the row of trees will have a crisp, neatly defined base.*

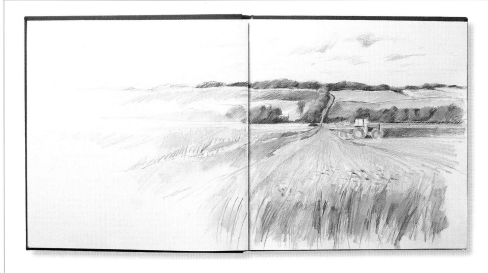

Progress report
The bright colours of the tractor and its detailed rendering provide an eye-catching focal point. The combination of linear detail and blended tones used for the grasses and corn gives dimension to the foreground. The picture works well as a sketch – but to move it towards a finished drawing, the sky needs to be resolved and the textured area in the foreground needs to be developed further.

Finishing touches

The broad structures and the important details are established. You can now apply the pencil loosely and freely, creating gestural marks and textures. Work up the sky and add more texture and detail to the patterns of corn in the foreground.

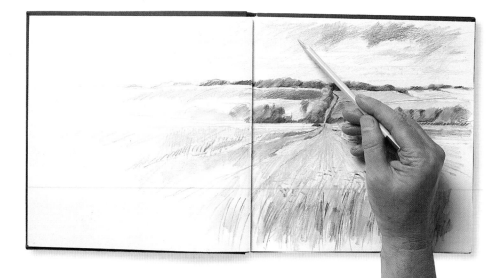

10 *Develop the sky with warm and cool colours, applying touches of warm, golden yellow where the sun hits the clouds. Here, a soft, cool lilac is scribbled over the cerulean blue. Hold the pencil high up the shaft to create a loose but controlled hatching. The marks of the pencil should be bold and intense at the top of the picture area where the sky is overhead, and smaller and lighter as it recedes towards the horizon; this creates a sense of distance.*

11 *Work over the picture, refining areas of bright colour. Dull the bright green of the field on the left with a dense application of olive green. Use a touch of grey in the sky to give it a more complex pearly quality and to give form to the thin layer of clouds. Add the fine details to the tractor, such as the shadows under the plough, the reflection in the tractor windows and the tyre treads.*

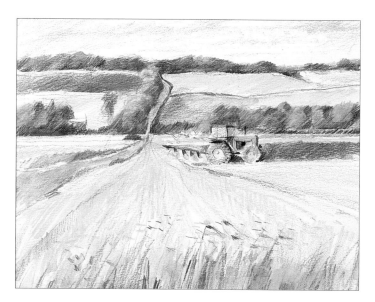

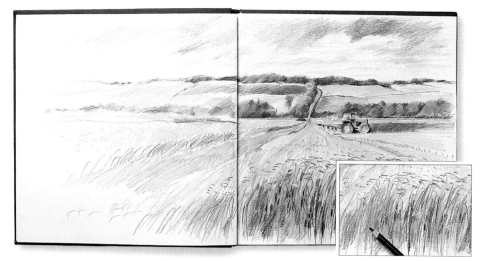

12 *Continue to work freely and loosely. Apply more colour on the left of the picture, extending it on to the left-hand page. Touches of warm earth brown help to define the stubble. Use yellow ochre and lime green to add colour interest and texture to the tangle of corn and weeds in the foreground.* Inset: *To create a sense of the spaces between the stalks, draw the negative shapes with a dark brown.*

13 *Use the tip of a craft knife to 'sgraffito' (see p. 141) in some highlighted stems and whiskery heads of corn. Use the same technique to scratch out the seagulls following the plough and the signpost at the junction of the lane and the hedge – a key intersection and focal point.*

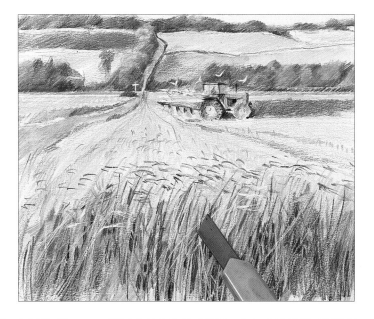

The Finished Drawing

The drawing was made on the spot, so the portability and flexibility of the medium was a great advantage. The artist worked in a square sketchbook, but took his image across the gutter to give a landscape format. The linear character of the medium allowed him to use line and hatched and scribbled tone to create an image full of gestural marks and colour. He used a brush to create an establishing tonal wash, giving him an underpainting over which the colour pencil was worked. By exploiting the precision of a sharp point he created fine details, such as the tractor and the heads of grain, while sgraffito was used for the birds, the signpost and some of the heads of corn. In other places he used a looser, more impressionistic style.

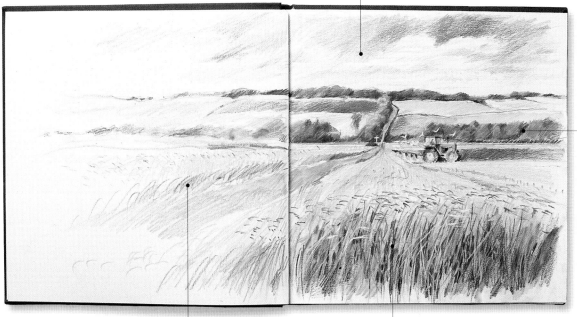

Playing off warm and cool colours gives the sky luminosity and depth.

Softly blended watercolour pencil yields subtle colours and smudged shapes.

Here, the loose pencil marks are more impressionistic.

The detailed texture of the grasses makes them stand out on the picture plane.

Alla prima sunset

ALLA PRIMA, *or 'direct', painting is a technique that allows the artist to complete a picture in a single session. It is especially useful for capturing transient light effects, as in this demonstration by Melvyn Petterson.*

When working alla prima you can use oil paint out of doors to record the fleeting effects of light and weather on the landscape. The traditional layered method of using oil paint is slow, as the paint film is built up from successive layers and each layer needs to dry before the next is applied.

The alla prima painting method uses oil paints applied in a single opaque layer, often thickly impastoed (see p. 18). It is ideal for working out of doors; you can complete the painting on the spot or work wet into wet back in the studio (applying fresh paint into

wet paint). To transport a wet canvas back to the studio, tape a second canvas of approximately the same size on top, separated by small pieces of cork in each corner.

To work alla prima you must organise your thoughts before you start. Avoid complicated colour mixing; a limited palette will give the painting an inherent harmony. You can use a selection of brushes with a clean brush for each new colour. This saves time and ensures that your colours stay fresh. For a finished painting in a short space of time use a small canvas – 355 x 405 mm (14 x 16 in) at the most.

You will need:
- A small primed canvas, 355 x 255 mm (14 x 10 in)
- Oil paints:
 Cadmium lemon
 Cadmium yellow
 Yellow ochre
 Cadmium orange
 Cadmium red
 Alizarin crimson
 Cerulean blue
 Cobalt blue
 French ultramarine
 Prussian blue
 Lamp black
 Titanium white
- Turpentine
- Brushes
 No. 2 long flat bristle brush
 No. 2 filbert bristle brush
 No. 3 round bristle brush
 No. 6 round bristle brush
 No. 6 filbert bristle brush
 No. 8 soft synthetic brush
- Cotton rag

Getting ready

Set yourself up at a good viewing point about a quarter of an hour before the sun starts to set. Have your canvas already primed. Lay out your colours on the palette and have a selection of brushes on hand. Take photographs – they will provide useful reference if you decide to do a more resolved study later in the studio.

Sunset in Turkey

In this glorious Mediterranean sunset, delicate pinks and mauves are set off by complementary shades of orange and gold. The landscape in the foreground becomes a velvety black silhouette against the fiery sky. The effects are transient; colours ebb and flow as the sun disappears.

Seen against the light, the landscape is a dark and anonymous silhouette.

The feathery clouds of a mackerel sky show flecks of colour.

On the horizon, a deep mauve band complements the yellows and golds.

Starting to paint

Start by laying a medium tone on your canvas. This simplifies and speeds up the painting process and makes it easy to judge your tones. The underlying colour gives the image an immediate sense of unity.

1 *To tone the ground, apply dabs of lamp black and yellow ochre directly from the tube in alternated rows across the canvas.*

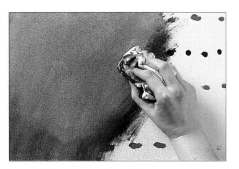

2 *Using a rag dipped in turpentine, blend the paint on the surface to give a medium tone. By manipulating the paint you can create darker areas to correspond to the land mass.*

3 *To lighten the toning in the top part of the painting, wipe off the paint film with a clean piece of turpentine rag, suggesting the outline of the hills in the foreground.*

4 *With a no. 2 long flat brush and a violet mixed from French ultramarine and alizarin crimson, delineate the dramatic silhouette of the land seen against the setting sun. Use lean paint thinned with turpentine for these early stages, as it is easy to paint over. Work loosely and freely – the underdrawing is merely a guide and will not be part of the finished image.*

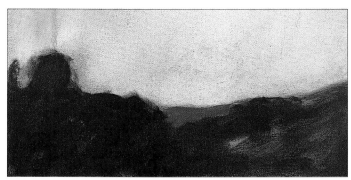

5 *The setting sun is so dazzling that the land appears as simple forms. Block in the foreground with Mix A (below). By adjusting the proportions of this mix you can create a range of warm and cool dark tones. Apply the paint quickly, scumbling it on with a no. 6 filbert brush. For the slate-grey passage in the centre, add cerulean blue to mix A.*

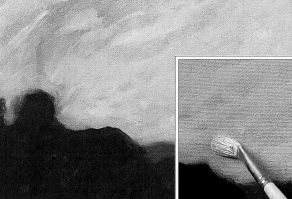

6 *Block in the sky using a sharp yellow mixed from cadmium lemon and titanium white.* Inset: *Scumble this colour on, working briskly with a no. 6 filbert brush. Work across the canvas, but allow the underlying toning to show through to create a lively optical mix.*

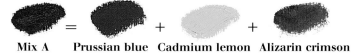

Mix A Prussian blue Cadmium lemon Alizarin crimson

Developing the picture

Once the sky and land are established, concentrate on the colours of the sunset. When working directly from the subject, it will take only a few minutes to reach this stage. The sky will be changing as you work – paint what you see as you see it.

7 *Using Mix B (below), apply a salmon-pink blush just above the horizon, with a no. 6 filbert brush. Add more yellow for a tangerine shade, or more red for a deeper orange. Add wedge-shaped segments of white where the blue of the sky shows between the radiating fan of clouds. Work quickly. Use a no. 2 filbert brush loaded with white paint to locate the sun.*

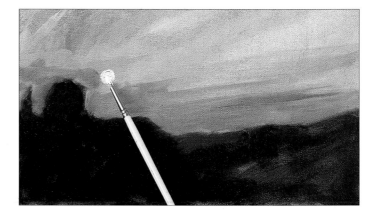

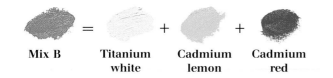

| Mix B | = | Titanium white | + | Cadmium lemon | + | Cadmium red |

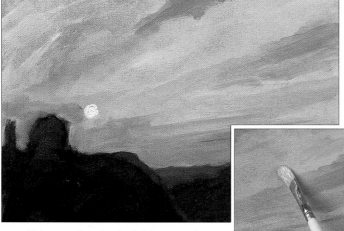

8 *Skim a mix of cobalt blue, cerulean blue and white where the sky shows through. Use Prussian blue mixed with cadmium yellow for green, and with alizarin crimson for a purple to develop the foreground. Inset: Scumble on details of the mackerel sky with a mix of cadmium lemon and cadmium orange and a no. 6 filbert brush.*

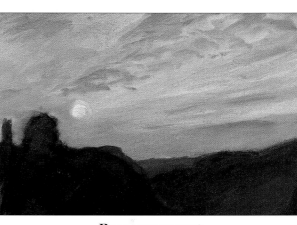

Progress report
The intense orange of the mackerel sky dominates the entire picture surface. Note how the harsh lemon and patches of orange vibrate against each other, emulating the effects of light. The painting is now broadly established and you can start to add telling details.

Finishing touches

To complete the painting, add some darker tones to the sky area and some lighter, warmer tones to the land area. These touches will give form to the clouds and pull the two parts of the picture together.

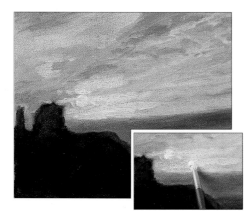

9 *Add a band of blood-red paint, mixed from cerulean blue, alizarin crimson and cadmium orange, just above the horizon. Inset: With a mix of cadmium lemon, cadmium orange and white, and a no. 6 round brush, start to apply the paint more thickly using impasto (see p. 18). The texture will enhance the effect of scattered light round the sun.*

10 *Add intensity to the slivers of blue sky with a mix of cerulean blue and white. Load a no. 8 synthetic brush with alizarin crimson and drag it across the top of the paint surface to create streaks of colour.*

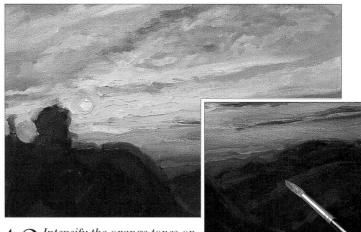

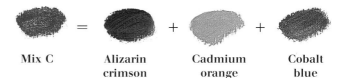

11 *Continue to build up the mackerel sky. Add pink-orange highlights with Mix B (see Step 7). The focal point of the picture is the area round the sun. Continue to build up a rich impasto using a creamy mix of cadmium lemon and titanium white applied with a no. 3 round brush. Try to ladle on the paint rather than scrubbing it on: the colour should be fresh rather than overworked.*

12 *Intensify the orange tones on the underside of the clouds and drag streaks of orange back through the ribbed crimson near the horizon. Soften the edges of the sky areas with a duck-egg blue mixed from cerulean blue, cadmium lemon and white.* Inset: *Apply Mix C (below) where the sun catches the edges of the hills.*

Mix C = Alizarin crimson + Cadmium orange + Cobalt blue

The Finished Painting

In this alla prima sketch, the paint was scumbled on at great speed in response to the changing effects of the light. In the later stages the paint was applied more thickly and opaquely with a loaded brush – the marks of the brush and the texture of the paint capture the excitement and spontaneity of the subject. Working on location, it is possible to complete a canvas like this in 15 to 20 minutes.

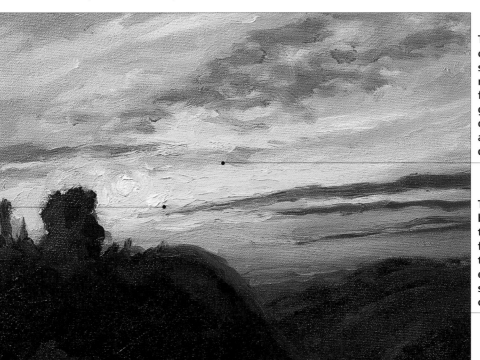

The diagonals of alternating sky and cloud radiating out from the sun give the composition an internal dynamic.

Impastoed passages express the energy with which the image was created.

The rays of the setting sun glancing across the slopes of the mountains link the land with the sky.

The contrast between the dark foreground and the bright sky enhances the sense of light.

Watercolour sketch

THE SPONTANEITY OF *watercolour applied wet into wet (see p. 14) lends itself to moody skies and reflected light. Use it on location to achieve a quick sketch that is a fresh and immediate depiction of the changing scene.*

A harbour scene offers a variety of light effects in the sky, the sea and on the wet shoreline. Unpredictable blendings of watercolour capture the subtle gradations of the sky and the changing shapes of clouds with a deftness that cannot be matched in any other medium. With watercolour the transparency of the paint film allows the white paper to shine through, so that light appears to be trapped within the painting.

In watercolour, the paper is the only white. Masking and wax resist (see p. 141) are techniques that allow you to retain the white of the paper. Masking fluid protects the paper while you paint so that you can work freely over the mask. When the painting is completely dry the mask can be removed to reveal the pristine white of the surface beneath. Wax resist exploits the antipathy between wax and water. The waxed areas stay on the surface and repel the watercolour paint, leaving them to show as white. Wax resist is less precise than masking fluid.

In this project the artist used masking fluid to retain the fine white lines of the boat masts, and wax resist to describe the light dancing on the ripples of water, adding loose, interesting patterns and textures in the foreground.

You will need:
- Sketchbook suitable for watercolour washes
- Watercolour paints:
 Cerulean blue
 Cobalt blue
 Payne's grey
 Sap green
 Viridian
 Raw sienna
 Burnt umber
 Alizarin crimson
 Naples yellow
 Chrome lemon
- Brushes:
 No. 4 squirrel mop brush
 No. 4 sable brush
- 4B pencil
- Reed pen
- Masking fluid
- White candle
- Eraser

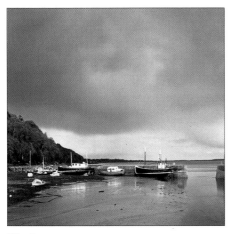

Harbour scene

The curved hulls of the beached boats draw the eye, and the horizontal thrust of the jetty is echoed in the line of the horizon, but both are counter-balanced by the vertical masts. The ripples and reflections in the translucent water will be a main theme of the painting.

Starting to sketch

Locate the main elements of the subject, redrawing if necessary. Ensure that the headland, the jetty and the areas of sky and water fit on to your sketchbook and work as a composition before you draw the boats in more detail. The artist, Albany Wiseman, chose a landscape format to accommodate the jetty and the boats, and worked across the gutter of the sketchbook.

1 *Start to sketch the scene using a 4B pencil. Avoid a half-way split of the picture area – here the horizon is below the half-way division, while the stronger horizontal of the jetty is more or less on the one-third split.*

2 Apply some masking fluid with a reed pen to cover the masts and some of the highlights below the boats. Masking fluid can be difficult to remove – a pen is easier to clean than a brush.

3 With a white candle, 'draw' squiggles in the foreground to represent the ripples of light on the shore. The waxed surface will repel the water-colour to create lines of white through the paint.

4 Wet the sky area of the painting with water and lay in scattered patches of Payne's grey. Next, add dots of cerulean blue using a no. 4 squirrel mop brush; the colours will mix on the surface. Add some Naples yellow near the horizon above the hill. Tip and tilt your sketchbook to create random blendings of colour. Note that the darker colour is laid on to create a diagonal that leads from the top left down to the horizon on the right; this helps to create a sense of recession towards the horizon and will mirror a corresponding diagonal thrust in the water.

Developing the picture

The sky is now broadly established and sets the mood for the painting. Work on the rest of the image, but constantly refer back to the sky to ensure that the different parts of the painting work together.

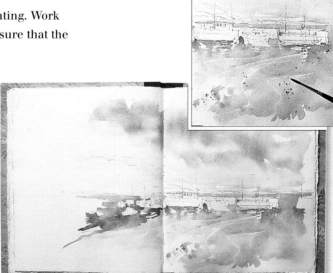

5 Wet the paper with water and flood raw sienna into the foreground. Using a no. 4 squirrel mop brush, apply viridian to the area from the horizon down to the sea. The colours will blend together in the foreground.

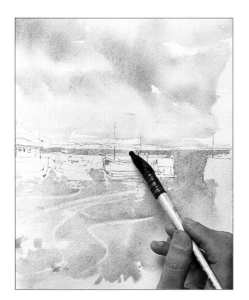

6 Apply a mix of burnt umber and raw sienna for the darker areas and the shadows. Mix sap green and raw sienna for seaweed on the left, working wet into wet. Inset: With a no. 4 sable brush, flick the burnt umber mix over the foreground.

7 *For the greens in the middle distance use a mix of sap green and raw sienna, laying in the colour with a no. 4 squirrel mop brush. It holds a great deal of paint yet comes to a good point for detailed work. Add chrome lemon to this mix for the brighter greens. Apply Mix A (below) with the point of the brush for the denser areas.*

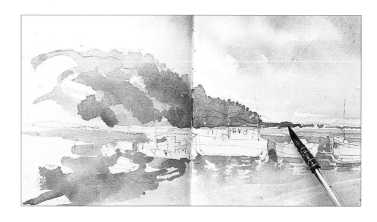

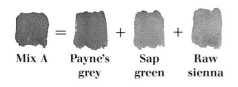

Mix A = Payne's grey + Sap green + Raw sienna

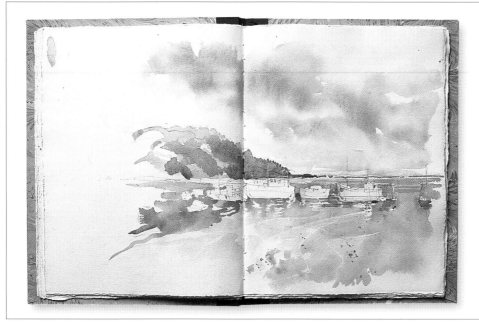

Progress report

All the elements of the composition have now been established. At this stage stand back and review the picture. The random blendings of paint in the foreground reflect the dark clouds of the sky above. The stormy mood of the sky needs to be enhanced further, and the main focus of the painting – the boats in the centre – needs refining.

Finishing touches

Continue to build up the sky and water. Work up the boats and the jetty in the middle foreground. Add just enough information so that the boats 'read' without over-working the image. Bringing this area into focus pulls the entire painting together.

8 *To give the sky more impact, lay a wash of alizarin crimson, cobalt and Payne's grey on to damp paper. Add a wash of bright cerulean blue over the foreground to reflect the sky above.* Inset: *Lay a wash of sap green and Payne's grey for the hillside with a no. 4 squirrel mop brush. Use the tip for details. Allow the work to dry – hard edges give form to the trees and shrubs. Mix cobalt blue, burnt umber and Payne's grey for the shadows.*

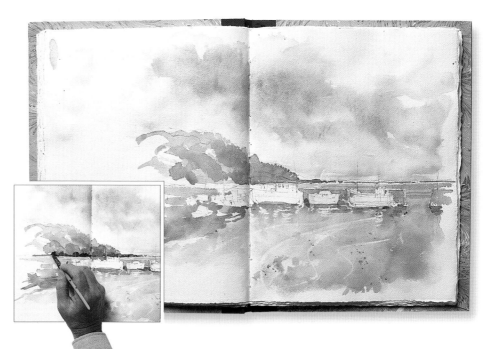

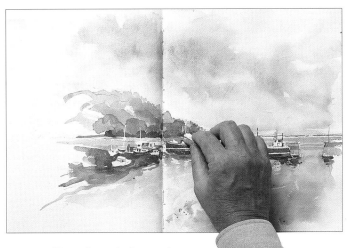

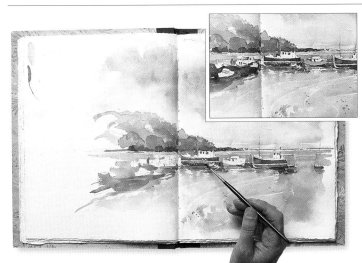

9 *With a no. 4 sable brush and the dark 'shadow' mix from Step 8, add the structures of the boats.*

Inset: *Half-close your eyes to pick out details, such as a lifebelt, that will read clearly. Add these details in alizarin crimson, chrome yellow and cobalt blue – tiny flicks of colour provide an exciting contrast with the cool blues and greens elsewhere.*

10 *Allow the painting to dry. Remove the masking fluid by gently rubbing it with your fingertip or with an eraser. Beneath the mask the white of the paper has been protected from the paint layers. The thin, bright lines of the masts stand out against the surrounding colour.*

The Finished Sketch

For speed, Albany Wiseman used watercolour washes to build up a detailed and colourful sketch. He tipped the sketchbook so that colours flowed into one another, creating random mixes on the paper. These soft blendings quickly captured the amorphous, changing quality of the sky. The depth and transparency of the water is suggested by the soft edges of wet-into-wet washes and is reinforced by the surface reflections and ripples. For these the artist exploited the hard edges of paint applied wet on dry, squiggles of candle wax and spattering. The result is an accurate description that has a pleasing decorative quality.

Pure colours dropped onto wet paper were allowed to run and flow together.

The white masts were easily achieved using masking fluid.

Bright touches of colour lead the eye across the picture.

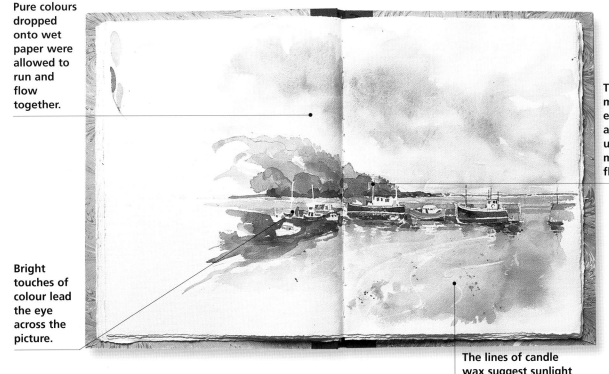

The lines of candle wax suggest sunlight on ripples.

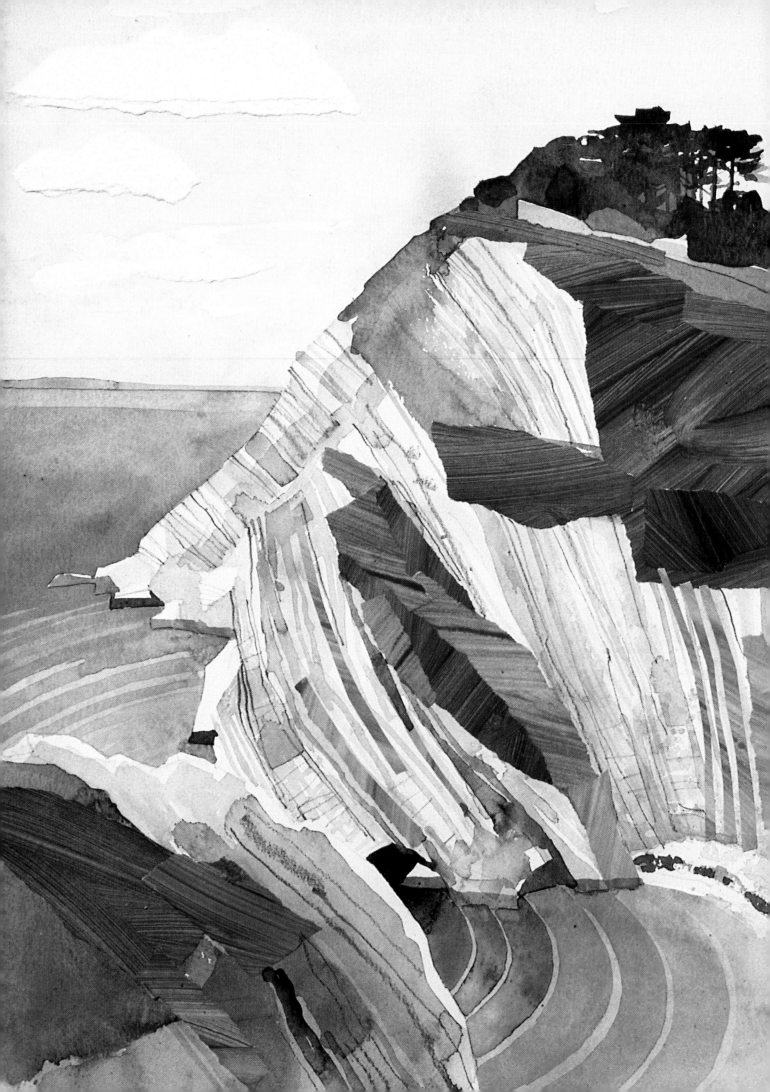

WORKING IN THE STUDIO

ALTHOUGH YOU LOSE the immediacy of drawing or painting on location, working at home or in the studio has many compensations. It is comfortable and convenient, and all your materials and equipment are close to hand. You can spend as much time as you need on a project – setting it aside, returning to it, letting it evolve over time. You can experiment, explore different themes and rework the image as much as you like.

The projects in this chapter give advice on finding subjects, exploiting your sketches and photographs and evolving images that have a unique and personal twist. The inspiring projects include a large charcoal developed from a tiny sketch, an acrylic using collage and a pastel study of a garden still life that will encourage you to look for subjects close to home.

View from the studio

L OOK AROUND YOU WITH *the eyes of an artist – you will find that there are rewarding subjects right on your doorstep. Your garden or street seen from a door or through a window can be painted time and time again.*

Working close to home has many advantages. You don't have to pack a travelling kit or protect yourself from the weather, and because you are familiar with the subject you can experiment with different media and techniques, searching out new interpretations, themes and moods. If you concentrate on a small corner of your garden, you will find that certain aspects of the subject become more significant.

In this project the artist chose the pattern of light and shade as his theme – the pots, plants, trellis and paving providing the backdrop.

Pastel is an ideal medium for depicting light. Small dabs and dashes gradually build up to create a film of broken colour (see p. 31) that shimmers with light. The secret of this technique is to start by applying the pastel very lightly and thinly, dusting off surplus pigment if the colour becomes too dense. Once you have established the broad forms of the image, the patterns of light and dark and the main areas of local colour (see p. 28), you can start to apply the pastel with more pressure, creating areas of solid, vibrant colour.

Starting to draw

Decide on a viewpoint and study the subject carefully, noting in particular the play of light. Start by establishing the tones in the shadows and the unmodified local colours of the plants to create an underpainting or 'ghost' image.

You will need:
- Warm grey pastel paper, 460 x 330 mm (18 x 13 in)
- A range of pastel colours
- Eraser
- Piece of bread
- Clean tissue or cloth

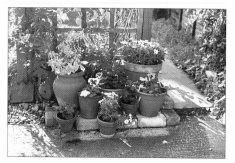

Garden still life
This picturesque cluster of pots and colourful plants was visible from the artist's studio. Derek Daniells was attracted by the sunlight falling across the pots and paving, and the shadows cast by the trellis and vegetation behind them.

1 *Half-close your eyes in order to isolate the darkest tone – the shaded areas between and around the pots. Lay these in using a dark green-grey pastel. As you lay in areas of dark tone, the locations and shapes of the pots will begin to emerge.*

2 *Lightly indicate local colours. Use a pale straw pastel for the bamboo in the large pot, dark green for the foliage, pale burnt sienna for the terracotta pots and touches of cadmium and magenta for the flowers.*

3 *If there is too much build-up of pastel, you can reduce it by lightly dusting the surface with a piece of tissue. This softens and blurs the colour, and ensures that the whole painting progresses at the same pace.*

4 *Add dark tones at the base of the plants. Apply strokes of light yellow for the warm highlights on the pots. If the colour becomes too dense you can lift it off with a piece of bread. Bread is softer than an eraser and will not damage the paper surface.*

5 *Work across the entire picture surface, adding dabs and dashes of local colour for the flowers and foliage, stroking on the colour with delicate touches of the pastel stick. Indicate the location of the trellis in the background. Add a glaze of yellow to the front edge of the step. Inset: With a dark green-grey pastel, touch in the dark shadows around the foliage using the negative (see p. 141) to define the leaf shapes. Don't press too hard – lay on a thin film of colour over which you can develop succeeding layers of colour.*

Developing the picture

The underpainting is broadly established, setting the tonal range for the picture and providing an indication of the main areas of local colour. Develop the outer edges of the picture. At this point the artist extended the picture to the left and right.

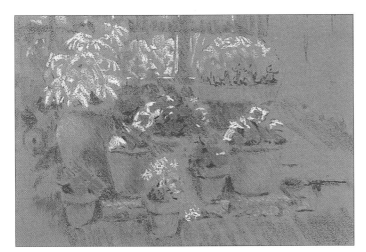

6 *Work over the entire picture surface, noting where the local colour is reflected in the shadows. Start to develop the background through the trellis. Work tentatively, as this area should sit back when the picture is finished.*

7 *Add touches of dark colour, such as burnt sienna, under the rims of the pots. Use a lighter colour where the light reflects off the rim. Develop the areas at the sides of the picture, adding a pale blue for the flowers on the right and a cool blue-green for the foliage.*

8 *Lay in patches of dappled sunlight using an intense cadmium yellow to define the shadows cast by the trellis. Skim the pastel to create 'broken' coverage.*

9 *Working over the entire surface, apply the pastel with more pressure.* Inset: *Use a bright green pastel to create the effect of sunlight filtering through the foliage.*

Progress report

Stand back from the drawing and review it through half-closed eyes. Check the logic of the pattern of light and dark, sunshine and shade, across the painting. The splashes of light in the foreground should relate to the light falling across the plants and pots. Look also at the way the marks of the pastel read. They should suggest in a simplified form the shape and direction of growth of the leaves of each plant, and from a distance should describe the overall texture of each plant.

Finishing touches

The contrast between the areas of light and dark needs to be developed. Go over the drawing, adding highlights in the brightest areas and touches of cool, reflected colour in the shadows.

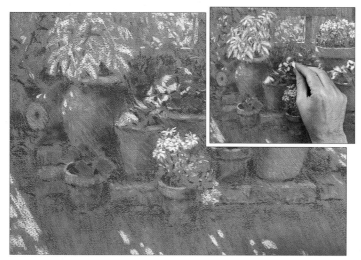

10 *Develop the shadowed area in the foreground by adding contrasting touches of warm and cool colours – olive green, pink, lilac and blue. These streaks of colour vibrate in the eye, giving the shadows depth and luminosity.* Inset: *Use cadmium yellow pale to depict where the sunshine splashes on to the foliage.*

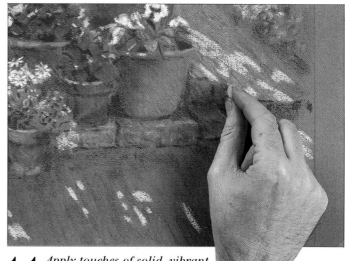

11 *Apply touches of solid, vibrant colour to the flowers, pressing the pastel into the paper to achieve a rich impastoed effect (see p. 18). Develop the cool tones in the shadow on the path with a light blue. Apply the pastel with feathery strokes to create a delicate mesh of broken colour.*

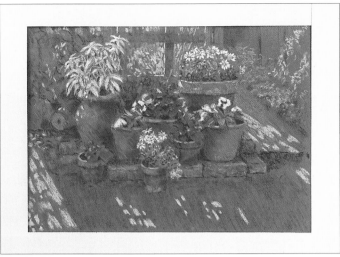

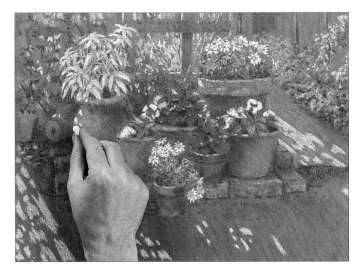

12 *In order to assess the overall impact of the colours and tones, the artist dropped a simple 'frame' made from two L-shaped pieces of card around the image. The pale, neutral colour of the card frame made the colour of the paper read as part of the painting and helped to isolate the image from its surroundings.*

13 *Continue working over the entire picture surface, intensifying the colours. Overlay patches of sunlight on the ground and on the sides of some pot, with cadmium yellow pale, to suggest the transparency of light and prevent the lit areas from looking too solid. Work carefully, standing back to check the impact of these adjustments.*

The Finished Drawing

In this evocative image the artist captured the warmth and stillness of
a sunny summer's day. By cropping in tightly to the worn and weathered terracotta
pots, he created a closed and intimate world. Sunlight filtered through trellis and foliage
created a dappled pattern that emphasised the ground plane and provided a clue to
linear recession within a relatively shallow picture space. Optical colour mixing
(see p. 31) is perfect for this subject, as individual touches of pure pastel colour
coalesce in the eye to recreate shimmering light.

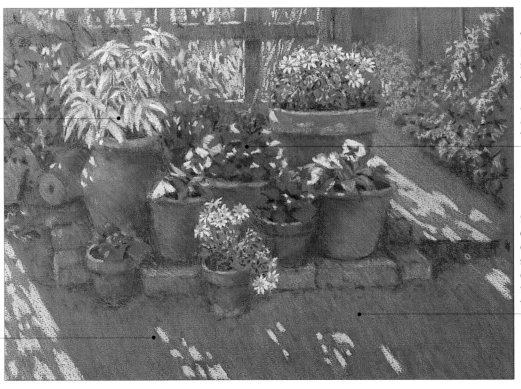

An intense yellow indicates the bright sunlight reflecting off the leaves.

Warm grey pastel paper shows through the pastel marks and provides a unifying tone.

Shadows cast by the pots establish the ground plane.

Strokes of colour applied over the grey surface give depth and vibrancy to the shadows.

Working on a large scale

WORKING ON A *large scale in the studio gives you the opportunity to interpret a familiar landscape in new ways. In this project, artist Melvyn Petterson uses the versatile medium of charcoal to convey a wintry scene.*

Painting or drawing a landscape in the studio encourages you to be creative, drawing on reference material and your memory of the scene. If you put away your preconceptions you will produce a work that retains a sense of place, and is fresh and imaginative.

This project uses a small sketch made on location as the basis for a much larger finished work. As the information in the sketch is limited, you are forced to draw on memory, experience and imagination so that the drawing takes on a life of its own. You will find that you develop a dialogue with your own creation; the marks that you make will indicate what you should do next. When working on a large scale, step back and assess the entire picture from time to time. It is easy to pay too much attention to areas of detail and lose sight of the way the picture is developing.

Charcoal is the ideal medium for a large-scale project – it gives an immediate response, is easy to apply and is capable of a range of tones and marks (see p. 11).

> ## You will need:
> - Hot-pressed 300 gsm (140 lb) watercolour paper, 1.52 x 2.44 m (5 x 8 ft)
> - Willow charcoal in assorted thicknesses
> - Hard eraser
> - Putty rubber
> - Graphite powder
> - Graphite sticks
> - Craft knife
> - Stumps
> - Sponge
> - Soft brush
> - Aerosol fixative spray

Getting ready

Make a small, detailed sketch of a familiar scene. Take photographs for reference and be prepared to draw on your memory and impressions. For a large-scale work, make sure that the composition has a feature that will hold the viewer's interest and that there are focal points to lead the eye round the picture area.

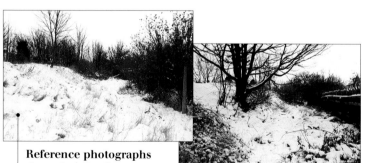

Reference photographs show details of grass and snow-laden branches.

In the foreground, the white of the paper stands for the snow.

Wintry landscape

This area behind the artist's home is a hummocky wasteland, crossed by footpaths. He knows it well and has made many sketches. A snowfall gave it an entirely new appearance, masking the untidy areas and imposing a monochrome harmony that made it unfamiliar.

The composition divides into three bands: the sky, the central band of trees and shrubs, and the snowy foreground.

The snowy path in the middle of the picture is a key feature that draws the eye into the scene.

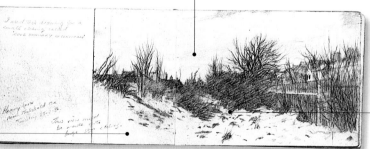

Starting to draw

Firmly pin or tape a large sheet of paper to the wall. Place the sketch close by so that it is easy to refer to. At this scale it is important that the composition is well constructed and has an inner dynamic to retain the viewer's interest.

1 Use a stick of charcoal to sketch the outlines of the central band of the composition, then start to suggest the main areas of tone.

2 Continue to establish the areas of medium and dark tone using a thick piece of charcoal. Inset: Use the side of the charcoal to block in large areas of tone.

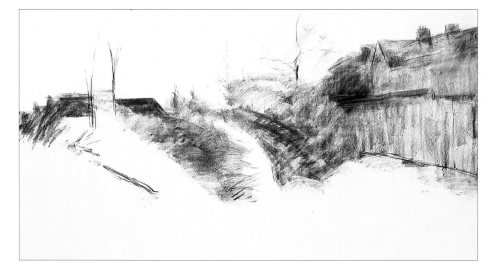

3 The important central swathe of the drawing is now broadly established using different tones – smudged medium tones for the bushes and crisper lines for the buildings and trees. The main masses are blocked in and the verticals are indicated.

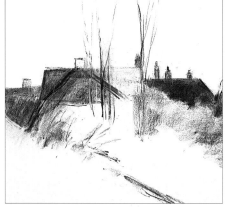

4 Next, indicate areas of darker tone to help to define the spatial relationships. The dark tones and crisp edges of the rooftops on the left bring this area forwards, while lighter tones and the blurred edges of the bushes appear to recede.

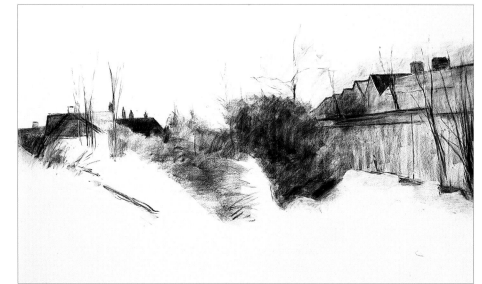

5 Continue to work up the dark tones all over the drawing. Develop the dark bushes alongside the snowy path in the centre, using broad strokes made with the side of the charcoal stick (see Step 2). Next, draw the saplings on the right using the tip of a thin stick of charcoal.

Developing the picture

Stand back and consider the composition. You may find it useful to look at it in a mirror – the reversed image allows you to see things more objectively. Start to add details, such as the tree branches and the tufts of grass poking through the snow.

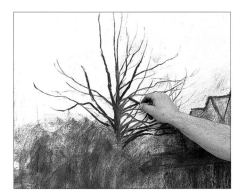

6 *Use a graphite stick to add small branches and twigs to the central tree. Because graphite is greyer than charcoal, it sits back in space, giving the canopy of the tree volume.*

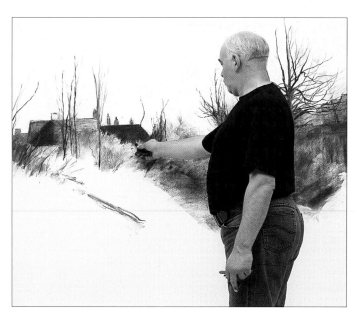

7 *Continue to work all over the drawing, adding detail. Here, the bushes in front of the house are defined by drawing into the dark roof behind. Use a thin stick of charcoal to indicate the pattern of roof tiles and to draw the saplings in front of the house.*

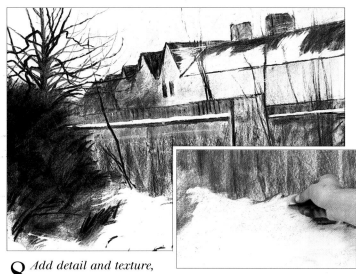

8 *Add detail and texture, such as the tufts of grass showing through the blanket of snow. The snow on the roofs and along the fence is created by working back into the charcoal with a putty rubber. Inset: Use the rubber to show how the snow laps up against the fence.*

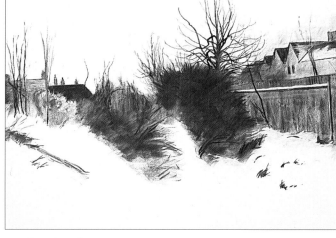

9 *Develop the central part of the picture. Use a combination of line and tone to create a sense of recession along the central path and through the overhanging bushes. Note the rich, velvety quality of the charcoal in the bushes and the crispness of the bare twigs of bushes and trees against the sky.*

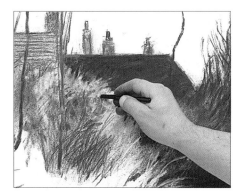

10 *Using a graphite stick, draw details of twigs and leaves in the bush in front of the house. Use generalised textural marks that will read at a distance.*

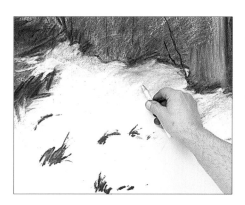

11 *To suggest the shadow at the foot of the wooden fence, use a paper stump to softly smudge and blend the charcoal, creating soft medium tones.*

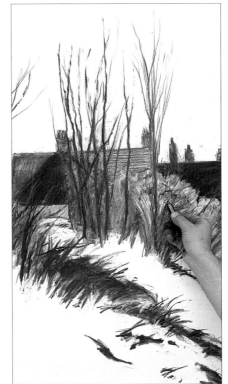

13 *Keep all the different parts of the picture progressing at the same pace. Stand back from the drawing at regular intervals to assess the overall effect. Add more detail where necessary. Here, the artist uses a graphite stick to add more texture and detail to the bushes on the left (see Step 10).*

12 *With a clean, hard eraser pull out details of snow-covered grasses from the dark tone to the left of the central mass. Use the same technique to draw back into the grass so that the white paper stands for slivers of snow. Here, the artist returned to the shaded area beneath the fence and is using an eraser to create highlights in the snow.*

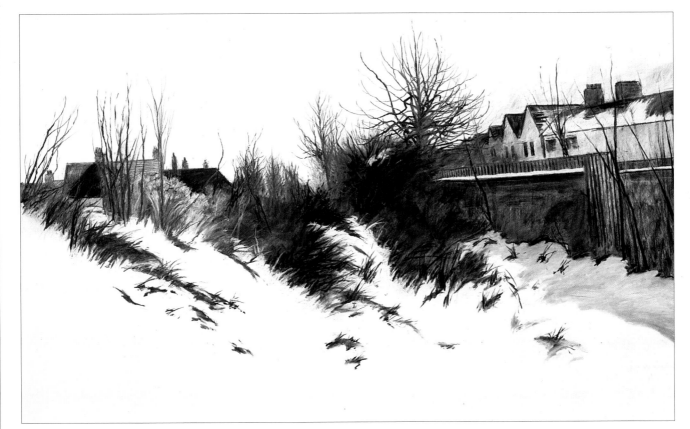

Progress report
The central passage of the drawing has been taken to a high degree of finish. Only the foreground and sky remain to be resolved and details to be refined. Rendering snow is easy on a white surface – you simply leave the white paper to stand for the snow. To capture the snowiness of the scene you need to develop the foreground, add the clumps of snow trapped on the thicket of bushes in the centre and finally add a brooding, snow-laden sky.

14 *Using a small stick of charcoal, add more windows to the houses on the right, and with an eraser 'draw' suggestions of frames, curtains and reflections. Draw sinuous charcoal lines for the screen of branches.*

15 *For the snow trapped on the bushes, press a clean, hard eraser on to the paper, then twist and lift it to 'pull' off the charcoal. If the eraser gets clogged with charcoal dust, cut off the dirty section with a craft knife.*

16 *Add tussocks of grass. Where they appear too strong or distracting, soften them by rubbing gently with your finger. By generalising these areas you suggest shadows and ensure that they blend with the rest of the drawing.*

17 *Bring the drawing into sharper focus. Small details can be very telling; add slivers of snow to the central tree with an eraser. Add more detail to the snowy path by drawing grasses and emphasising the bushes on the left.* Inset: *Here, charcoal was used to achieve delicate gradated tones, solid blacks and crisp lines.*

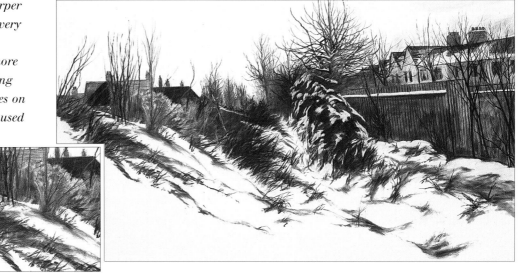

Finishing touches

Leave the sky until last, as it completes and encloses the landscape and also sets the mood. Clouds are an important part of the composition – use them to lead the eye into and around the painting. Decide where to place the sun in the sky.

18 *Put some graphite powder into a dish, dip a large sponge into the powder and lay it on to the paper. Here, the sky is dark and overcast on the right, becoming lighter on the left. This creates variety, and the dark rooftops and trees seen against the light sky enhance the sense of recession into the background. The progression from dark to light leads the eye across the picture area.* Inset: *Apply the graphite powder generously – using bold, sweeping strokes.*

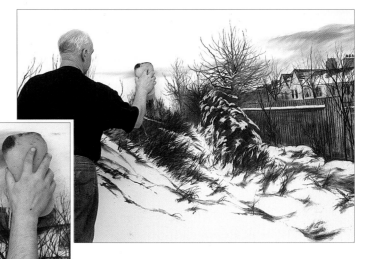

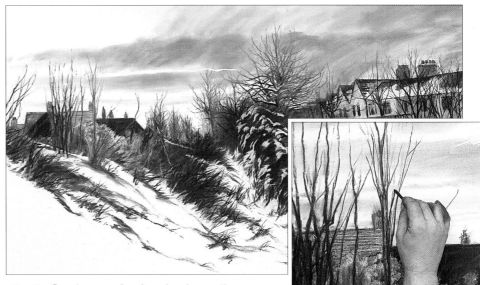

19 *Use a hard eraser to lighten dark areas, create crisp edges and define the shapes of the clouds. Take out slivers of graphite powder to suggest the cold, silvery light in this area of the sky.*

20 *Continue to develop the sky until you achieve a satisfactory effect. Cut the sponge to create interesting shapes in the sky. You can also use a soft brush to build up areas of dense tone, to blend and to soften. Inset: When applying the graphite powder you will smudge some twigs and branches silhouetted against the sky. Redefine them with a thin stick of charcoal.*

The Finished Drawing

This large and impressive drawing works on many levels. It is a convincing landscape, and also an atmospheric and evocative description of a cold winter's day. The spatial relationships are clearly defined, leading the viewer over the hummocky ground and round the shrubs to the houses beyond. The drawing is made more enjoyable by the choice of medium. The picture has a variety of textures – passages of velvety black tone and dark calligraphic lines are set against softly gradated greys.

Charcoal gives dense, velvety blacks.

Crisp linear marks describe grasses seen against snow.

Graphite powder is grey rather than black – ideal for a lowering, snowy sky.

Soft tones against dark tones suggest recession.

Smudged charcoal gives depth and shadow.

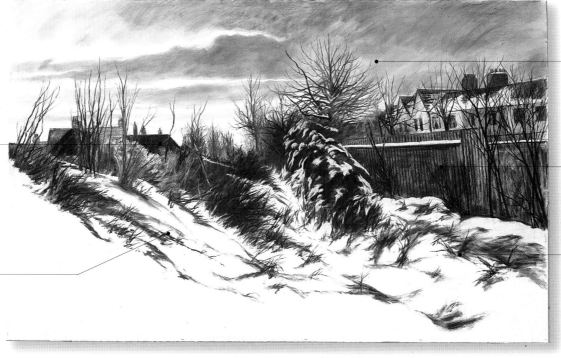

Using collage

COLLAGE IS *ideal for working in the studio, where you can draw on a range of already prepared materials. Here, Ian Sidaway combines acrylic paints with torn paper to create an exciting interpretation of limestone cliffs.*

A collage is made by assembling assorted materials, such as paper, fabric and dried leaves, and gluing them on to a flat surface to create a picture. The collage process is very different from that of painting or drawing. Handling pieces of paper or objects forces you to be bold; you cannot refine details in the same way as painting or drawing. When planning the composition you have the freedom to move the elements around, assessing the impact of shapes, textures and colour relationships. You can cut, tear, add and take away until the final gluing stage.

Collaged images can be built up quickly and, because this technique is direct and spontaneous, they rarely look laboured. First paint your chosen surfaces in a range of colours, as the artist did in this project, or print patterns using crumpled paper or a sponge, or splatter with a brush. In this painting, the artist used collage as an extension of the paint.

Getting ready

The artist wanted to use both flat paint and collage to create more than a literal translation of the scene. He made a sketch on the spot and took photographs, and then worked up different ideas in the studio. He planned his composition by making a series of thumbnail sketches.

Tumbled and twisted rock forms

The beds of clays and limestone of this English coastline were folded and tilted by tectonic forces. The hardest rocks are on the seaward side, shielding against the invading waves. The jutting headland, funnel-shaped cove and striated rockforms provide a textural and structural challenge for the painter.

Because collage is quick, you can try several compositions at one session.

A line and wash sketch records the broad structures and details of rock patterns.

A colour photocopy can distort shapes and colours – variations you may include in your finished image.

Starting to paint

Collect scraps of discarded paper and paint textures and patterns on to them. For this image, a range of greens and ochres is most useful. Use brushes and knives, try printing with crumpled paper, and splatter paint with an old toothbrush.

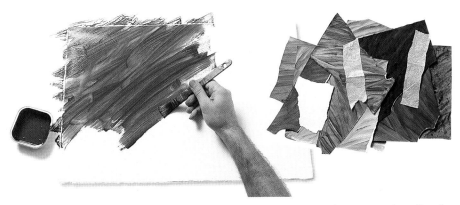

1 *Create a range of painted papers in different colours to suit your project. Brush a rich green mixed from Payne's grey and sap green on to watercolour paper using a 25-mm (1-in) hake brush. Work quickly to create a 'brushy' texture. Inset: Collect scraps of painted paper, tissue paper and plain paper for the collage.*

2 *Pencil in the main outlines. Indicate the water in the inlet, the crescent of beach and rock layers. Work freely to develop shapes and patterns.*

3 *Use a mop brush with a wash of cobalt and Winsor blue for the sky, leaving gaps to represent clouds. Inset: For the greenish-blue of the water in the inlet, flood a touch of sap green into the wet blue paint.*

4 *With the mop brush lay a wash of yellow ochre and sepia, then scrub colour on to the land area to give texture. Add a touch of cadmium red to yellow ochre and scrub on this mix, working wet into wet (see p. 14) for a variegated effect. These pale ochre mixes help reduce the glare of the white paper.*

5 *Next, block in areas and 'draw' with the paint. Begin by using a sap green, sepia and yellow ochre mix to define the trees on the headland, pulling wet paint across the paper to create the shapes. Note how blocks of grass green wash outline the white chalk footpath.*

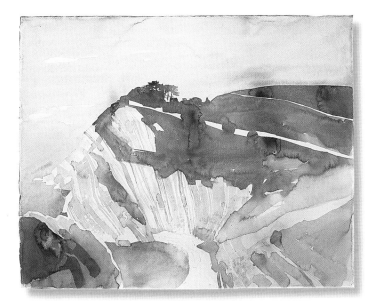

6 *Next, carefully render the patterns of the folded rocks. Make a large amount of wash from Mix A (below). Using a no. 7 brush, start to lay in stripes of colour. Sometimes use the tip of the brush, sometimes the flat of the brush to create a variety of stripes. Work confidently and quickly to ensure that the lines are even. For the foreground, use a no. 12 brush with broad strokes. Allow to dry.*

| **Mix A** | = | **Yellow ochre** | + | **Sepia** | + | **Payne's grey** |

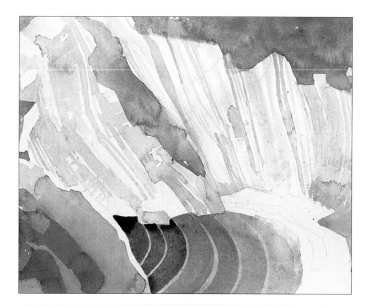

7 *The deep, blue-green water of the inlet is the focal point of the painting. To give this area more emphasis, lay bands of colour using a no. 4 flat brush and a wash of Mix B (below). Before you lay each band add a bit of water to the mix so that the bands grade from dark to light as the water gets shallower. Leave a gap between each band.*

Mix B	Cobalt blue	Winsor blue

8 *Add further detail to the rocks using a piece of stiff card dipped in a mix of sepia and a little cadmium red. Hold the card steady and use the thin edge to 'draw' a line.*

9 *To create the line of seaweed, mask the beach with two pieces of torn paper. Sponge a sepia wash over the narrow curve of exposed beach. Allow to dry, then remove the mask.*

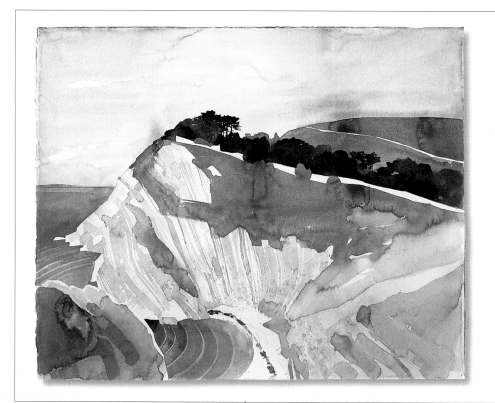

Progress report

All the main elements of the composition are now established. The dome-like shrubs on the headland were emphasised with a dark green mix of sap green, sepia and Payne's grey. The tip of the no. 7 brush was used to create their undulating outlines, and throughout suggest the tracery of branches. At this stage, stand back and study the painting through half-closed eyes. Although the composition fills the picture area, it lacks contrast between one area and another, and the texture of the rock strata is understated.

Developing the picture

To introduce more drama, elaborate the varied textures of the bare rock and the
undulating grassed areas. Do this by applying prepared papers, and by working on
the paper with a graphite stick and painting with a small brush.

10 *Select a prepared paper, tear out
a shape and cover an area
loosely to see if the addition enhances
the picture. Tear the paper into pieces
roughly the size and shape you require.
Don't use scissors, as torn edges have a
softer, organic feel. Inset: Lay the torn
paper on to the picture. Move the paper
round until you are happy with the
position. Glue in place using an acrylic
medium or adhesive. Mask an area of
the beach and spatter with a dilute Mix
A (see Step 6) to suggest pebbles.*

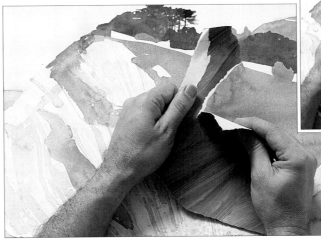

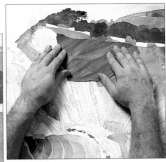

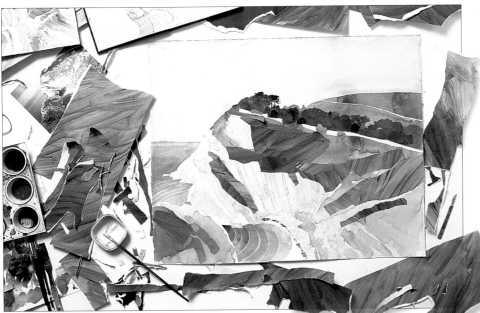

11 *Tear some prepared paper scraps
into narrow strips, allowing
more than you need so that you can
select those that work best. Lay the strips
on to the painting and stand back to
judge the effect. Try to achieve a good
balance; too few collaged pieces will
look sparse, too many may look
contrived. Visualise the headland as a
series of planes that abut each other.
Overlay strips of paper to create
interesting patterns.*

12 *When you are satisfied with the
effect, stick the strips of paper
down, using a no. 4 flat brush to apply
the acrylic medium adhesive. Continue
to add paper to the slopes of the
headland, experimenting with different
patterns and shapes.*

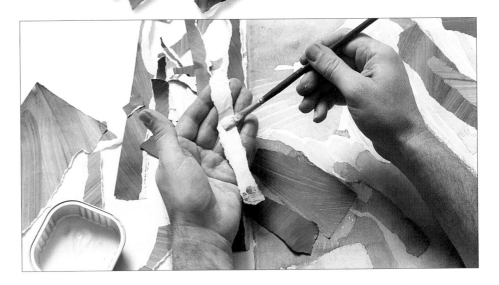

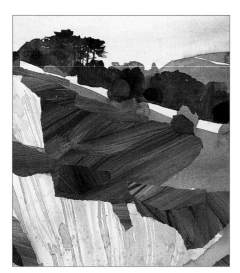

13 Add tree and shrub shapes in darker shades of green. Collage makes the picture look more abstract, and gives the surface a decorative quality. Painted papers in varied colours retain the picture's underlying unity.

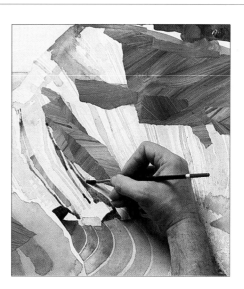

14 Next, develop the surface of the rocks to keep pace with the rest of the picture. Add painted texture with a dark version of Mix A (see Step 6). Using a no. 7 brush, paint in stripes alongside the pieces of collage.

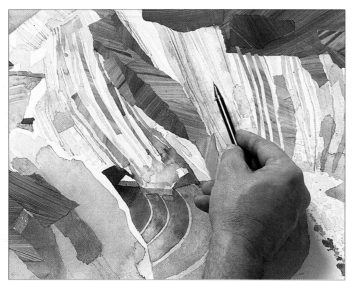

15 The linear nature of the rock formations lends itself to a linear medium. Graphite stick has the sensitivity of a pencil, but feels more direct and chunky. Hold the stick loosely in your hand to create a naturally flowing line, twisting the stick to create random thick and thin lines.

16 Continue to develop the painting, moving between collage and paint and allowing what is already on the surface to dictate what you do. Try to see the image as both a representation of a particular scene and as an abstract assemblage of colour, tone and shape. Inset: Tear small pieces of white tissue paper and lay them on to the sky. When glued in place they become transparent and modify the underlying blue of the sky very subtly. Stand back to assess the effect. You could create clouds by building up more layers of tissue.

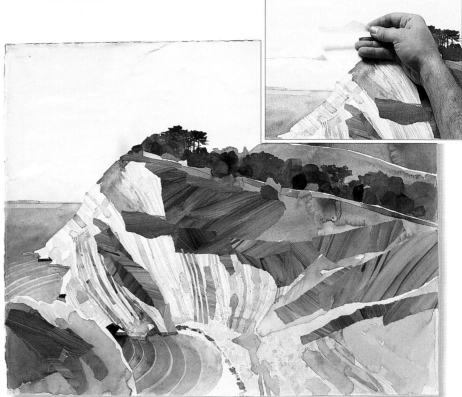

Finishing touches

The sky is still a little weak in comparison to the rest of the image, and needs to be tied in more effectively. The rocks are such a strong feature that they could be enriched with further applications of paint and graphite line work.

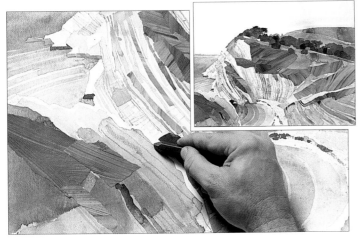

17 *Using a graphite stick, embellish the rocks with a variety of thick and thin lines to delineate the rough edges of the exposed strata. Inset: For a similar effect, bands of warm ochre mixed from yellow ochre, sepia and cadmium red were added to the foreground.*

18 *Add clouds to balance and complete the composition. Use thick watercolour paper in differing sizes, and tear the edges to give a gradated edge. The three-dimensional quality of the torn edges suggests the fluffiness of the clouds.*

The Finished Painting

The unique geology, bold land masses and varied but strong textures lend themselves to a combination of paint, graphite and collage. The collage process allowed the artist to experiment, to accentuate and to simplify, so that although the finished image is a recognisable and accurate depiction of this part of the coastline it has a quality that could not have been achieved in any other way.

Clouds were carefully placed to interrupt the thrust of the rock formation and lead the eye back into the painting.

Collage, line and painted detail were used to describe the geology and provide visual interest.

Carefully gradated bands of colour suggest the increasing depth of the water.

Bands of warm colour bring this part of the painting forwards and emphasise the sense of recession.

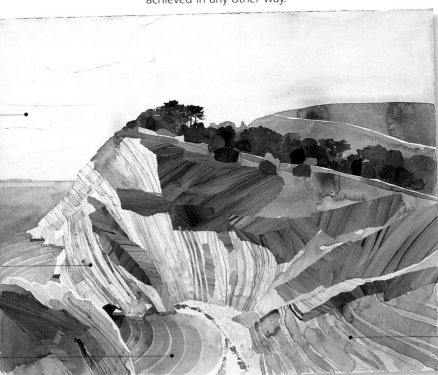

Glossary

Abstract art: art that is not primarily concerned with the naturalistic representation of real objects – contrasts with figurative art. Aesthetic values depend on qualities such as patterns of colour and tone.

Advancing colours: colours that appear to come forward in the picture space. Warm colours and dark tones appear to advance. Cool colours and light tones appear to recede.

Aerial perspective: a system that creates the illusion of depth and three dimensions on a flat, two-dimensional surface by imitating the way that the distant landscape appears bluer and less distinct.

Aerosol fixative spray: liquid that is sprayed on pastel or charcoal drawings to provide a protective film.

Alla prima: a direct method of painting. Paint is applied in a single layer and the painting is completed in a single session.

Blending: merging adjacent colours or tones so that they grade imperceptibly into each other.

Blocking in: roughly establishing the composition at an early stage. It allows the artist to judge the composition and provides a guide for subsequent layers. *See also* **Underpainting**.

Broken colour: various techniques in which unmixed colours are laid side by side or overlaid. They blend in the eye to create another colour. *See also* **Optical colour mixing**.

Claude glass: a convex black mirror in which the landscape is reflected with muted colour and tone, and simplified detail. It is named after the artist Claude Lorrain (1600–1682).

Complementary colours: colours that are opposite each other on the colour wheel. They offer maximum contrast to each other when placed side by side, but neutralise each other when mixed.

Cool colours: colours that contain blue and lie in the green-violet half of the colour wheel.

Cross-hatching: a form of shading where parallel lines are drawn in a criss-crossed pattern. *See also* **Hatching**.

Diluent or thinner: a liquid that is added to a paint to thin it. Water is the diluent for watercolour and acrylic; turpentine and white spirit are the diluents for oil paint.

Distemper: water-based paints in which glue (such as rabbit's skin glue) or casein (milk protein) are used as the binder.

Drybrush: a mottled or broken colour effect achieved by dragging a brush with very little paint on it across the painting surface.

Drying oil: a vegetable oil that dries to form a tough film. Oils such as linseed, poppy and safflower used in oil paint are examples of drying oils.

Ferrule: the metal collar that holds the fibres of a brush and attaches them to the handle.

Figurative art: representational art – contrasts with abstract art.

Fugitive: a pigment or dye that fades on exposure to daylight.

Glaze: a thin film of transparent colour laid over a dried paint layer.

Ground: a coating applied to a painting or drawing surface.

Hatching: shading using a system of regular, parallel lines. By varying the thickness or closeness of the lines it is possible to create a range of tones.

Hue: the attribute of a colour that distinguishes it from any other. Hues are derived from the pure colours round the colour wheel (primary, secondary, tertiary).

Impasto: a technique in which paint is applied thickly so that it holds the mark of the knife or brush.

Impressionism: a nineteenth-century realist art movement. The Impressionists worked out of doors and used optical colour techniques to capture the fleeting effects of light and atmosphere.

Incident light: the light that is directly striking an object.

Key: the predominant tone of a painting. In a high-key painting the colours are light in tone; in a low-key painting, the colours are mostly dark in tone.

Linear perspective: a system of geometric perspective that creates the illusion of three dimensions on a picture surface by using converging lines and vanishing points to create receding planes.

Local colour: the inherent colour of an object or surface, unmodified by

the effects of light, atmosphere or adjacent colours.

Mask: (1) Tape, paper or fluid applied to an area of a painting in order to isolate it from the drawing or painting process. Masks can also be used to create defined edges. (2) A card frame used to isolate a section of a composition.

Medium: (1) The material used for a painting or drawing. (2) A substance added to paint in order to change the way it behaves; for example to make it thinner.

Mixed media: the use of different materials in the same work of art.

Monochrome: a drawing or painting executed in a range of tones of a single colour.

Negative space: the spaces between the main elements of the subject.

Optical colour mixing: the effect created when overlaid colours 'mix' in the eye rather than on the palette. Used by the Impressionists to create convincing atmospheric effects. *See also* **Broken colour**.

Palette: (1) A surface on which paint is mixed. (2) A selection of colours used for a painting.

Picture plane: an imaginary vertical plane that defines the front of the picture area and corresponds with the surface of the painting.

Pigment: a substance that imparts colour to paint. It may be produced synthetically or derived from natural substances such as clays or plant materials.

Plein air: painting out of doors, directly from the subject.

Primary colours: colours that cannot be made by mixing others. The primaries are red, yellow and blue.

Priming: a layer of paint or other material applied to the surface, to prepare it to receive pigment.

Resist: a material that is applied to a painting surface to protect it from liquids such as paint or ink. Masking fluid is most commonly used as a resist in watercolour; candle wax and oil pastel can also be used to resist watercolour.

Retarder: a medium that slows the drying time of a paint – particularly useful with acrylic paint which has a fast drying time.

Scumbling: a technique in which a thin layer of opaque paint is dragged over an existing layer of colour to create an uneven layer. The base layer shows through the scumbled colour to create a broken effect.

Secondary colours: the intermediate colours that can be mixed from pairs of primary colours. The secondaries are orange, green and violet.

Sgraffito: a technique of incising pattern or texture into a surface using a pointed tool.

Size: a weak solution of glue used to seal canvas or paper to render it impervious to paint.

Spattering: texture created by flicking paint from a brush.

Staining: applying a film of transparent colour to a surface to provide a coloured ground. The term is also used to describe the film of colour. *See also* **Toned ground**.

Stippling: dabbing the tip of a pencil, pen or brush on to the painting surface to create a pattern of dots. Stippling can be used for texture or to build up tone.

Tertiary: the intermediate colour between a secondary and a primary. A tertiary is created by mixing a primary with an adjacent secondary. The tertiary colours are yellow-orange, red-orange, red-violet, blue-violet, blue-green and yellow-green.

Thumbnail sketch: a small, quick sketch used to explore different compositions in the field.

Tone: the lightness or darkness of a colour.

Toned ground: a ground that has been covered with a thin glaze of colour by staining.

Underdrawing: a preliminary drawing that provides a guide for subsequent stages. It can be executed in a drawing or paint medium.

Underpainting: the preliminary blocking-in of the main forms and masses of a composition. Often executed in monochrome.

Vanishing point: in linear perspective, the point on the horizon to which parallel lines appear to converge.

Warm colours: colours in which red or yellow are dominant. They lie in the red-yellow half of the colour wheel.

Wash: a thin film of dilute watercolour paint applied to the painting surface.

Wet on dry: a watercolour technique in which paint is applied to a dry surface. The painted areas dry with crisp edges.

Wet into wet: a watercolour technique in which paint is applied to a wet surface or into a wet wash. It gives blurred edges and blended colours.

Index

Acknowledgements

The author and the Publishers would like to thank Ian Sidaway for his imaginative illustrations and advice; George Taylor for photography and culinary contributions; the owners of Letheringham Lodge, Suffolk, for their hospitality during the location shoot; Chromacolour International, Daler Rowney, Frank Herring & Sons, Green and Stone, Phoebus Editions, Pro Arte, Royal Sovereign, Spectrum Oil Colours, Stuart R Stevenson and Winsor & Newton for providing materials.

Also, many thanks to Hilary Bird, Liz Dean, Lisa Dyer, Ian Kearey and Alison Lee for their invaluable help.

Picture credits

With thanks to the artists who provided the step-by-step demonstrations: Brian Bennett, pp. 56–61; Derek Daniells, pp. 124–127; Melvyn Petterson, pp. 114–117; 128–133; Ian Sidaway pp. 42–45, 134–139; and Albany Wiseman, pp. 108–113; 118–121.

All illustrations and practice exercises by Ian Sidaway, except sketches on pp. 104, 105, 107 by Albany Wiseman. pp. 42–45, 'Using greens', photographed by Mark Gatehouse.

These illustrations reproduced by kind permission of the following: p. 65, John Constable, 'Study of Clouds', Ashmolean Museum, Oxford; p. 40, Provence, Images Colour Library; p. 31, Claude Monet, 'Impression: Sunrise, Le Havre', Musée Marmottan, Paris/Bridgeman Art Library, London.

The author and Publishers are grateful to the following artists for permission to reproduce copyright illustrations:

Alastair Adams
p. 39, 'Boats at Barmouth', acrylic, 255 x 205 mm (10 x 8 in)

Caroline Bailey
p. 51, 'Terracotta House', watercolour, 432 x 533 mm (17 x 21 in)
pp. 62–63 and p. 73, 'Armadale Pier', watercolour, 508 x 635 mm (20 x 25 in)

Brian Bennett
p. 18, 'Windy sky', oil, 508 x 762 mm (20 x 30 in)
p. 81, 'Peover Eye, Winter', oil, 406 x 610 mm (16 x 24 in)
p. 89, 'Passing shower, Charmouth', oil, 610 x 914 mm (24 x 36 in)

Linda Birch
p. 88, 'Sea at Sandgate, Kent', watercolour, 210 x 297 mm (8¼ x 11¾ in)

Francis Bowyer
p. 38, 'Sunlit bay, Syros', watercolour, 380 x 280 mm (15 x 11 in)
p. 48, 'The Olive Tree', watercolour and gouache, 380 x 255 mm (15 x 10 in)

David Carr
p. 66, 'Castleton, Summer Clouds', distemper and pastel, 1220 x 1525 mm (48 x 60 in)
p. 96, 'Hambleton Hills, Yorkshire', pastel and gouache, 660 x 1016 mm (26 x 40 in)

Trevor Chamberlain
p. 14, 'Dusty sheep track, evening', watercolour, 533 x 737 mm (21 x 29 in)
p. 35, 'Depth of Winter, River Beane', oil, 178 x 255 mm (7 x 10 in)
p. 80, 'Evening cornfields', oil, 178 x 255 mm (7 x 10 in)

David Curtis
p. 65, 'Everton from Barrow Hill', oil, 255 x 305 mm (10 x 12 in)

Derek Daniells
p. 12, 'Canal, Stoke Bruerne', pastel, 305 x 255 mm (12 x 10 in)
p. 78, 'Secret Garden', pastel, 305 x 355 mm (12 x 14 in)
p. 89, 'Boats, Porthleven', pastel, 432 x 458 mm (17 x 18 in)

Timothy Easton
p. 39, 'Passing storm over iris field', oil, 305 x 355 mm (12 x 14 in)
p. 72, 'Bridge over the willow tree', oil, 405 x 405 mm (16 x 16 in)

Shirley Felts
p. 87, 'The Essiquibo River', watercolour, 153 x 405 mm (6 x 16 in)
p. 97, 'Mora Tree', watercolour, 560 x 380 mm (22 x 15 in)

Peter Folkes
p. 50, 'Towards Northington, Candown Valley', watercolour, 343 x 533 mm (13½ x 21 in)
p. 73, 'Sudden shower in Wales', watercolour, 380 x 305 mm (15 x 22 in)

p. 88, 'Pistyll Waterfall, Wales', watercolour, 560 x 380 mm (22 x 15 in)

Helena Greene
Title page and p. 34, 'The Ridgeway', oil over acrylic washes, 394 x 510 mm (15½ x 20 in)

Tessanna Hoare
p. 11, 'South Downs', charcoal, 760 x 914 mm (30 x 36 in)

Brenda Holtam
p. 28, 'Christchurch Park Triptych, Midday', oil, 165 x 153 mm (6½ x 6 in)

John Lidzey
p. 10, 'Yaxley in the snow perhaps!', pencil sketch
p. 95, 'Road to Redgrave', pencil sketch

Melvyn Petterson
p. 25, 'Richmond Park, Winter', oil, 405 x 305 mm (16 x 12 in)
p. 79, 'Spring, Humberstone', etching, 405 x 510 mm (16 x 20 in)
p. 106, (top) 'Sky, near Chelmsford', pencil sketch, (bottom) 'Thames, Richmond', pencil sketch

Bill Taylor
p. 17, 'Winter in Unthank', gouache, 685 x 458 mm (27 x 18 in)
p. 30, 'Kirkstone', watercolour, 280 x 178 mm (11 x 7 in)

Robert Tilling
p. 67, 'Evening Light', watercolour, 660 x 533 mm (26 x 21 in)

Godfrey Tonks
By courtesy of Llewellyn Alexander (Fine Paintings) Ltd, London:
pp. 26–27 and p. 31, 'Evening in the Ardeche', pastel, 533 x 205 mm (21 x 8 in)
p. 86, 'St Ives Harbour', pastel, 510 x 405 mm (20 x 16 in)

Richard Tratt
p. 41, 'Maiden Castle', oil, 405 x 510 mm (16 x 20 in)
p. 50, 'August's Wild Tangle', oil, 914 x 914 mm (36 x 36 in)
p. 97, 'North Downs Way', acrylic, 458 x 610 mm (18 x 24 in)

Phil Wildman
p. 22, 'Acropolis, Athens', acrylic, 405 x 510 mm (16 x 20 in)

Albany Wiseman
pp. 8–9 and p. 13, 'Château d' Arboras', pen and ink, 380 x 305 mm (15 x 12 in)